P9-CKT-555

FRONTIERS OF SPACE

Herbert Friedman, General Editor

PLANET EARTH

THE VIEW FROM SPACE

D. JAMES BAKER

Harvard University Press · Cambridge, Massachusetts, and London, England · 1990

This book is printed on acid-free paper, and its binding materials
have been chosen for strength and durability.

Library of Congress Cataloging-in-Publication Data
Baker, D. James.
 Planet earth : the view from space / D. James Baker.
 p. cm. — (Frontiers of space)
 Includes bibliographical references.
 ISBN 0–674-67070-1 (alk. paper)
 1. Earth. 2. Astronautics in astronomy. I. Title. II. Series.
QB631.B34 1990 89-48870
525—dc20 CIP

From space, we see a small and fragile ball
dominated not by human activity and edifice
but by a pattern of clouds, oceans, greenery,
and soils. Humanity's inability to fit its doings
into that pattern is changing planetary systems,
fundamentally. From space we can see and
study the Earth as an organism whose health
depends on the health of all its parts.

—World Commission on Environment and
 Development, *Our Common Future*,
 1987

FOREWORD BY HERBERT FRIEDMAN

In 1983, following a workshop on global change in the terrestrial environment, the National Research Council issued a report calling for a "bold, 'holistic' venture in organized research" into "the physical, chemical, and biological workings of the Sun-Earth system and the mysteries of the origin and survival of life in the biosphere." The report emphasized the potential of new remote-sensing technologies for expanding our knowledge of global systems and global change.

In the ensuing years, we have become more acutely aware of our progressive destruction of the environment and the urgent need for an international plan of action. A case in point is atmospheric pollution, which destroys the Earth's protective ozone layer and accelerates greenhouse warming. Global change threatens all nations, rich and poor, indiscriminately.

Although natural disasters are beyond human control, better scientific understanding, and thus more informed prediction, could moderate their effects. In 1982–83, for example, El Niño, a massive climate upheaval in the Pacific Basin characterized by a dramatic shift in sea surface temperature, directly or indirectly caused hurricanes and floods in regions as far apart as California and Ecuador and produced widespread drought in Australia, South Africa, India, and Indonesia. In the hardest-hit countries, hundreds of millions of people suffered and the damage approached ten billion dollars. Yet even though we know that El Niños occur in a quasi-cyclical pattern, scientists neither foresaw this catastrophic event nor recognized it until it was fairly well developed.

Likewise, soil erosion may be the greatest hindrance to sustained

food production worldwide, yet we seem to have learned precious little about the causes of repeated dust bowls in the southwestern United States or how to mitigate future recurrences. Half of the topsoil of Iowa, one of the nation's great grain-producing regions, has been eroded in the last century. In India, nearly one-third of the land is barren. Deforestation and the replacement of grassland with row crops contribute significantly to erosion rates in many parts of the world. Clearly, the study of land use patterns in agricultural development and of changes in biota as seen from space could provide us with the critical insights necessary for effective environmental planning.

These examples are but a small sample from the many global environmental concerns that D. James Baker discusses in *Planet Earth: The View from Space*. He has been an active participant in the remarkable development of remote sensing in recent years and in the enormous effort now under way to deploy the powerful capabilities of space technology in studying the Earth. His knowledge of the oceans and the atmosphere is encyclopedic, and his familiarity with the space-based program popularly known as "Mission to Planet Earth" wide-ranging. His book will be a valuable resource for all serious students of the environment and a handbook for political decision makers who must set the course for international cooperation.

CONTENTS

ACKNOWLEDGMENTS

I thank Herbert Friedman for his suggestion that I prepare this book for the Frontiers of Space series. I also thank W. Stanley Wilson for introducing me to remote sensing and educating me in general on the subject. Ichtiaque Rasool and Moustafa Chahine provided me with a broad overview that would have been difficult to achieve in any other way. Otis Brown, John Dutton, John McElroy, Pierre Morel, Gerald North, Thomas Pyke, Robert Stewart, Paul Uhlir, W. Stanley Wilson, and Carl Wunsch provided useful technical discussions and detailed and helpful reviews of the manuscript. H. Frank Eden provided useful discussions about the material presented here and collected much of the material on non-U.S. space programs. I have also had very useful technical discussions with Francis Bretherton, Kevin Burke, Dixon Butler, Michael Freilich, Lee Fu, Tim Liu, Thomas Malone, Berrien Moore, Ned Ostenso, William Patzert, Barry Raleigh, Jack Sherman, Byron Tapley, Robert Thomas, Shelby Tilford, Ron Tipper, William Townsend, and Victor Zlotnicki. Special thanks go to Emily Lind Baker, Rebecca Grimes, and Ron Tipper for careful reading and help in preparation of the manuscript. For the illustrations, I am particularly grateful for the time and help provided by Flo Ormond and Janice Hostetter of the National Aeronautics and Space Administration (NASA) and Paul Friday of the National Oceanic and Atmospheric Administration (NOAA). Most of the photographs and line drawings in this book came from the NASA and NOAA archives and are reproduced by courtesy of those agencies.

PLANET EARTH

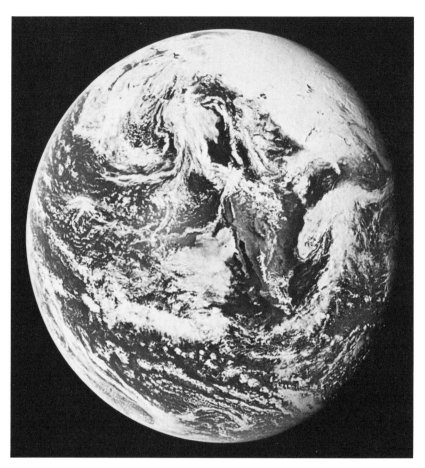

Figure 1. This photograph of the Earth was taken from the Apollo 10 spacecraft.

1

PLANET EARTH AND GLOBAL CHANGE

When the lunar missions of the early 1960s beamed back photo-graphs of Earth—a small blue and white sphere floating in space—we saw our planet as never before from a truly global perspective. Only with the advent of satellites in the 1950s, coupled with advances in ground-based technology in the last three decades, has it become possible to measure atmosphere, ocean, and land surface conditions on a worldwide scale.

This book looks at remote sensing by satellites and its role in observing and predicting environmental change. I have endeavored first to provide an explanation of how remote-sensing technology works and then to survey what the future holds for scientific exploration of the Earth from space.

Although remote-sensing satellites and manned space missions have already gathered a great deal of data about the global environment, our study of the Earth is only beginning. Major problems remain unresolved, and questions far outnumber answers. Can we make long-term weather predictions? Will the sea level rise? How will increasing amounts of carbon dioxide and other gases affect climate? Can we modify weather and climate? Can we predict volcanic eruptions? Earthquakes?

In the 1950s, when atmospheric scientists began to use global measurements from ground-based devices to provide data for the new digital computers, the first real progress in weather prediction was made. But because the data were ground-based and hence not comprehensive, and because the computers then available were relatively slow, a twenty-four-hour prediction took more than twenty-four hours of com-

puter time. Today, with global satellite observations and high-speed computers, five-day forecasts can be made in less than two hours, and three-day forecasts in less than one.

Yet even these modern weather forecasts are limited in scope. We still have difficulty in predicting the quantity and location of rainfall. Rapidly developing hurricane-force storms, like the one that swept across Europe in the fall of 1987, continue to evade existing prediction systems. At the same time, the successful prediction of climate change over periods longer than a few months has not yet proved possible, and prediction of other types of environmental change, such as earth-quakes and volcanic eruptions, remains poor. The recent discovery of a "hole" in the ozone layer—a major decrease in the stratosphere over the Antarctic continent—underscores the limitations of our predic-tions. The ozone hole is one of the largest environmental changes observed in the last decade, yet neither observations nor models of stratospheric processes prepared us for its occurrence.

How can we achieve better predictions? To begin with, we will have to survey a broader range of Earth processes and take many more measurements—of the atmosphere, the ocean, solar energy, plant ac-tivity, and the motion, temperature, and deformation of the continental crust, to name only a few. We will also need a new generation of computers that can handle not only atmospheric processes but also physical, chemical, and biological processes that occur in the ocean and on the land. Even more important, we will have to reach a better understanding of the links among all of these processes—of the com-plicated ways in which the Earth functions as an interacting system.

An apt illustration of the interlinkage of the Earth's systems is the apparent relationship between the El Niño phenomenon—a periodic fluctuation of temperature in the tropical Pacific Ocean—and the drought of 1988 in the United States. The most common characteristic of the El Niño cycle is the midwinter appearance, every four to ten years, of warm water off the South American coast near the equator. This warmer water decreases the amount of nutrients in the water and thus the number of fish available to the local fishing industry. But in 1988, and presumably in other years as well, there was a movement at the equator of a large patch of unusually cold water, which appears to have displaced the warm equatorial water and caused it to move farther north, into a region north of the equator called the intertropical conver-gence zone. There, the warm water intensified the already heavy cloud

and rain activity, creating severe storms over the northern tropical Pacific Ocean. These in turn shifted the jet stream—winds high in the atmosphere—farther north than usual. The displaced jet stream blocked the normal southward movement of Canadian storm systems; in the absence of storms, a large, dry, high pressure system developed over most of the United States, which set off the drought. Once started, the drought tended to feed on itself, as evaporation at the Earth's surface decreased and surface temperatures increased, making cloud formation and rainfall even more difficult.

Another recent discovery of an interlinkage in Earth's systems is the powerful effect that phytoplankton might possibly have on the atmosphere and therefore on climate. Phytoplankton—microscopic plants covering large areas of the ocean—produce dimethyl sulfide, which can provide nuclei for clouds over the ocean. These clouds reflect heat from the sun and prevent it from reaching the Earth, thus contributing to global cooling. Even more important, plankton are a major part of Earth's biological system that absorbs carbon dioxide and emits oxygen in the process of photosynthesis. Nearly half of the photosynthesis that occurs on Earth takes place in the ocean. The absorption of carbon dioxide by the ocean's plantlife is now thought to be a significant factor in controlling the amount of carbon dioxide in the atmosphere. If phytoplankton were dramatically depleted, carbon dioxide levels would increase and make the Earth more vulnerable to greater global warming—the "greenhouse effect." This occurs because carbon dioxide molecules in the atmosphere allow the sun's shorter-wave radiation to reach the Earth but absorb and reradiate the longer-wave infrared radiation that the Earth reflects from its surface. The result is atmospheric warming, in a process loosely analogous to the way glass allows light to enter a greenhouse but traps infrared heat.

But photosynthesis is of course not the whole story that explains why Earth has not succumbed to a runaway greenhouse effect as has occurred on its sister planet, Venus. Many other coupled processes must be invoked if we are to understand why Earth's climate has remained amenable to life for almost four billion years, while Venus has not. For example, one reason that Earth has relatively modest amounts of carbon dioxide in its atmosphere is that most of the carbon dioxide flowing out of its interior becomes buried in ocean sediment. Water in the oceans has thus been an essential factor in controlling carbon dioxide levels in the atmosphere, and thereby in controlling the

temperatures that, in turn, make liquid water possible. Venus, in contrast, has high concentrations of carbon dioxide in its atmosphere, extremely high temperatures, and no oceans. The greenhouse effect on that planet has made it incompatible with life.

Liquid water on Earth also interacts with carbon dioxide in the atmosphere to transform rocks into essential inorganic nutrients for plants, which take up carbon dioxide and produce oxygen. Oxygen is also released into the atmosphere through the dissociation of water molecules by the action of sunlight. Without oxygen from these sources, ultraviolet-shielding ozone would not exist in the stratosphere, and life on land would be impossible. Waterless Venus has very little oxygen and no ozone shield.

Earth is a life-sustaining habitat because of critical balances and interactions among many factors like these. Were there not processes at work that limit the effects of other essential processes, Earth would become a lifeless desert. Today, we are beginning to recognize that, as population grows and development increases, humankind may be affecting many of Earth's delicate balances by changing the concentration of chemicals in the atmosphere. Industrial development, the use of fossil fuels, and the widespread burning of forests are believed to be major potential causes of higher levels of carbon dioxide and other gases that are changing the atmosphere and may eventually alter Earth's climate.

In 1896 Svante Arrhenius, a Swedish chemist, calculated that if the concentration of carbon dioxide in the atmosphere doubled, the temperature of the Earth would increase by between 4 and 6 degrees Celsius. This was the first prediction of what has come to be called the greenhouse effect. The British meteorologist G. S. Callendar speculated in 1938 that a warming trend was already under way, although the data did not then confirm this claim. In 1958 C. D. Keeling and others began to measure atmospheric carbon dioxide at the South Pole and at Mauna Loa in the Hawaiian islands and were able to chart a steady increase. If the input continues at current rates, by the middle of the next century the amount of carbon dioxide in the atmosphere would be twice that of the preindustrial level.

Measurements of gases such as methane, nitrous oxide, and chlorofluorocarbons, which, because of their much more complex molecular structure, affect the amount of solar radiation the Earth receives even more than does carbon dioxide, show that they too are increasing in the

atmosphere and at an even greater rate. Methane, generated primarily by bacterial decomposition of organic matter and by wood burning, has increased steadily with global population. More widespread use of nitrogen-based fertilizers has raised nitrous oxide levels. At current rates, these and other trace gases could cause as much warming as carbon dioxide by early in the next century. Many of them also contribute to the destruction of the ozone layer. Other harmful gases, such as sulfur dioxide, which contributes to acid rain and smog, are also increasing in the atmosphere as a result of industrialization.

A major factor causing increases in carbon dioxide and other atmospheric gases is the destruction of tropical rain forests, which reduces the amount of leaf area in the tropics and hence the amount of carbon dioxide absorbed. It is estimated that the cutting and burning of tropical forests contributes about 20 percent of the carbon dioxide added to the atmosphere each year. An area in China the size of Italy has been denuded of forests in the last thirty years. The World Watch Institute has reported that in less than a decade, forest cover within a hundred kilometers of India's major cities dropped by 15 percent or more—near Delhi by 60 percent—mostly because of firewood cutting. The World Resources Institute and the International Institute for Environment and Development have reported that the world's tropical forests are being destroyed at the rate of fifty-four acres per minute. Around the world, twenty-eight million acres of tropical forest and other woodlands are lost annually. As these forests are cut down, the planet's greatest storehouse of biological diversity is being lost. And once the forest cover is gone, heavy rainfall causes soil erosion. Sediments are carried downstream where they silt up reservoirs, clog irrigation systems, and threaten habitats. Desertification is often the eventual result of the world population's growing demand for more agricultural land and firewood. The World Resources Institute notes that more than 60 percent of the world's productive drylands have suffered losses of biological productivity. In sub-Saharan Africa, more than 80 percent of dry rangeland is already desert.

When our best climate models take all these factors into account, they predict substantial climate effects: a doubling in carbon dioxide levels, for example, will lead to major changes in the polar regions as ice caps recede. Sea levels could rise, and coastal areas could experience local flooding and even inundation. We are also discovering that such long-term changes can have short-term effects. There is some

evidence, for example, that global warming could cause more frequent and more intense storms and droughts.

The predicted change of a few degrees may seem small, but it constitutes a rise in global mean temperature as great as any in the history of life on Earth. Although existing global temperature measurements do not show with certainty the occurrence of global warming, the trend appears to be in that direction. The consensus of most experts is that we will see some warming; the only question is how much and precisely when.

Our growing awareness of the potential impact of global warming has been a major factor in focusing world attention on climate change and on effective ways to monitor it. The 1980s witnessed the four hottest years on record, and 1988 marked a watershed in public awareness of environmental issues. The United States sweltered through the hottest, driest summer since the 1930s, and Gilbert, the century's strongest hurricane, swept through the Caribbean. Drought-induced crop failures in the USSR, China, Australia, and Latin America reduced the world's cereal crops to the lowest level in forty years. The U.S. Department of Agriculture estimated that another large crop failure in one of the world's food-producing regions could result in widespread food scarcities, pushing up prices in the industrialized world and propelling developing nations toward starvation. The Endangered Earth made the cover of *Time* magazine as "Planet of the Year," a dramatic acknowledgment of growing public concern. Since 1988, whole issues of magazines like *Scientific American* and *National Geographic* have focused on the global environment, and daily newspapers regularly report on the environment and on projections of future climate change. Clearly, environmental issues could become as important in the twenty-first century as energy issues or the threat of nuclear war are in the twentieth.

Environmental change is inevitable. Nations must now explore ways to respond. For the first time, we have enough of the necessary technology, and the international will, to begin. In the United States' budget for fiscal 1990, the Congress included funds to initiate a comprehensive, long-term program of research on global climate change. Over four hundred members of Congress, responding to constituent interest, submitted more than two dozen bills relating to various aspects of environmental protection and prediction. In Britain, Prime Minister Thatcher, in a speech to the Royal Society in September of

1988, warned that humankind, through increasing industrial emissions, might unwittingly be conducting a massive experiment with the system of the planet itself, and cited protection of the environment as one of the great challenges of the late twentieth century. Soviet leader Mikhail Gorbachev called attention to environmental issues, and the need for international concern, in his historic speech to the United Nations late in that same year.

Such concern is not limited to the major industrial nations. As the Brazilian scientist Umberto Cordani, president of the International Union of Geological Sciences, stated in his address to the 1989 International Geological Congress in Washington, D.C., "Damage to the environment and the many problems related to it are now a major worldwide concern. The challenges cut across the divides of national jurisdiction, and political decisions on the management of resources and land-use planning are crucial. Possible solutions to environmental issues are becoming more and more complex and dependent on the cooperation of a multitude of sectors, but first and foremost, that of science."

International cooperation on these issues until recently focused primarily on scientific planning and programs, but governments are beginning to recognize the need to take direct action on some issues even as research continues. In 1987 an international protocol curtailing the production of ozone-destroying chemicals, such as chlorofluorocarbons, was signed in Montreal, and to date it has been ratified by thirty-nine nations. In a further move, eighty-one nations meeting in Helsinki in May 1989 called for a complete phasing out of chlorofluorocarbons by the year 2000 and a ban on halon, another destructive chemical. In recent years conservationists have been energetically pursuing the concept of "debt-for-nature swaps," by which developing nations would agree to reduce such practices as tropical deforestation in exchange for having a portion of their international debt assumed by interested third parties like the World Wildlife Fund. Bolivia, Costa Rica, and Ecuador have already entered into such agreements, and other nations are expressing interest. And finally, the Intergovernmental Panel on Climate Change, cosponsored by the World Meteorological Organization and the United Nations Environment Program, is reviewing the current state of our knowledge about climatic change and considering ways to mitigate potentially adverse consequences.

Even now, there is talk of "atmospheric engineering"—initiating

artificial climate changes that would help alleviate the problems we have begun to identify. It has been proposed, for example, that to save the ozone layer we could fire ozone pellets into the atmosphere, release ozone from aircraft or balloons, or eliminate ozone-destroying chemicals with high-powered lasers. To counteract the greenhouse effect we could farm vast quantities of microorganisms that absorb carbon dioxide, we could shield the Earth from a fraction of the sun's rays with giant mirrors in space, or we could harvest energy in space with vast solar collectors and then beam it back to Earth with lasers, in order to lessen our dependence on the burning of fossil fuels. But these solutions are more fanciful than realistic. What we *can* do right away is to observe what is happening on our planet using the latest technology and to incorporate these measurements into new models for predicting changing environmental conditions.

Within the scope of this book I cannot address the entire field of environmental measurement. I will concentrate on observation, because it gives us a basis for understanding by providing both direct indications of change and a way of testing models and predictions. And I will focus on just one aspect of observation—remote sensing by satellites—because the ability of satellite-borne instruments to make both regional and global measurements of the Earth is crucial to the comprehensive monitoring programs of the future.

From their vantage point in space, satellites provide a unique set of "eyes" that can describe global phenomena. Today we use satellite measurements to anticipate weather hazards such as hurricanes, cyclones, and tsunamis—the destructive waves generated by earthquakes under the sea—and to forewarn threatened nations. (See Figure 2, for example, which shows two hurricanes near the United States in 1980.) Weather forecasters can even predict with greater certainty when and where lightning will strike the ground. Airlines use real-time satellite weather data to help determine the quickest, safest, and least turbulent flight routes. Satellite-borne instruments can measure the changes in land surface temperature around volcanoes in order to monitor potential volcanic activity. With infrared images from the Landsat satellite, for example, scientists were able to correlate "hot spots" with later eruptions in the Andes. Thus, these data may provide a basis for predicting volcanic eruptions. Satellites can also monitor the aerosols emitted in volcanic eruptions, which can have major effects on the atmosphere.

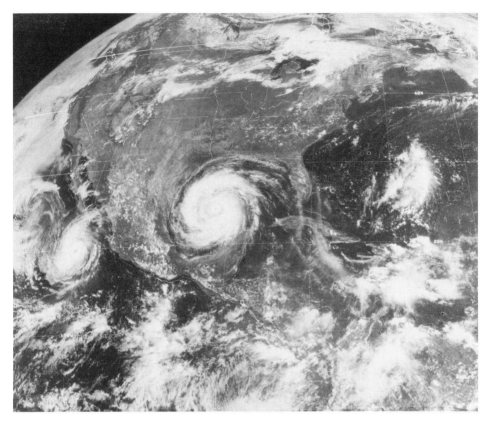

Figure 2. NOAA geostationary weather satellite view centered on the United States on August 8, 1980. Hurricane Allen completely covers the western Gulf of Mexico, while Hurricane Isis is off the west coast of Mexico.

Over the land surface, satellites enable us to monitor crops and vegetation, to see the effects of drought over large regions, and to measure forest fires and deforestation over millions of acres of sparsely inhabited and wilderness terrain. Over the ocean, satellites can now measure temperature (see Plate I), ocean waves, and currents on a global scale and track the biologically productive areas of the ocean most likely to harbor feeding fish. Even the motion of the continents can be detected using accurate satellite positioning systems that can make direct measurements of the slip along geologic faults and of slow continental drift. Satellite-borne instruments are used to detect and

measure geological land forms and minerals, biological characteristics, and agricultural use patterns.

If, as some climate models are now predicting, mean sea level rises as much as a meter by the end of the twenty-first century, satellite-borne instruments will provide much of the relevant information about surface temperatures on land, oceans, and ice sheets, the distribution and extent of sea ice and snow, the amount of summer melting on polar ice sheets, and the extent and surface elevation of the ice sheets in Greenland and Antarctica.

Satellite measurements can even help us look into the past. In the very arid regions of the world, satellite radar can penetrate several meters below the surface to reveal ancient river valleys, desert basins, and bedrock structures. These data are useful in archaeological and geological exploration and in surveying for groundwater supplies.

If the satellites now in the planning stages in several countries are launched in the mid- to late 1990s, we will have put in place an unprecedented Earth-observing network for monitoring global environmental change. Through the concurrent development of numerical models that can run on high-speed computers, we will be able to achieve significant advances in our understanding of the state of the Earth—its changes, feedbacks, and interactions—and in our ability to predict global trends over periods extending from years to centuries.

The 1987 listing of Earth satellites published by the Royal Aircraft Establishment of the United Kingdom underscores the complexity of the subject. It documents no fewer than 2,869 launches between 1957 and 1986, from more than a dozen sites around the world, and provides details on the more than 17,000 extant satellites and satellite fragments now orbiting the Earth. In 1989, the number passed 20,000. Obviously, my coverage cannot be comprehensive, but I have tried to give a fair sense of the range of the topic through specific examples.

My overall hope is that this book will convey a sense of urgency. I am convinced that our future survival depends on how wisely we manage our environment and our limited resources, and that remote-sensing technology will be a major factor in that effort.

2

HOW REMOTE SENSING WORKS

Remote-sensing satellites extend our ability to observe the Earth. The instruments on such satellites are sensitive to a broad range of electromagnetic radiation, from ultraviolet to radio waves. This chapter will discuss how satellites orbit the Earth to provide a platform for remote sensing and how their instruments work, and conclude with a brief chronology of satellite remote sensing through the 1980s.

Our use of satellites for remote sensing is based on fundamental physical principles. Isaac Newton's work on motion and gravity in the seventeenth century showed how satellites could orbit the Earth. In fact, Newton included a drawing of possible Earth satellite orbits in his book, *System of the World*, published in 1728. James Clerk Maxwell's synthesis of electromagnetic wave theory in the nineteenth century prepared the way for the development of remote-sensing instruments. In the twentieth century, quantum mechanics has explained precisely how light and other electromagnetic radiation interact with matter (Feynman, 1985).

Although the idea of artificial Earth-orbiting satellites dates back as far as the last century, they became a reality only with the development, beginning early in this century, of powerful launch vehicles capable of putting payloads into orbit. Sputnik I, the first artificial satellite, was launched into Earth orbit by the USSR in 1957, initiating the space age. The United States quickly followed with Explorer I in 1958. The recognized potential of this new technology played an important part in the development of the International Geophysical Year (IGY), the first global-scale experiment in studying the Earth, held in 1957–58. High-level atmospheric exploration by small Earth satellites was pro-

Figure 3. The symbol of the International Geophysical Year (IGY) as adopted in 1955. The Earth is encircled by a satellite orbit to show the hope that such technology might in fact be a part of that study.

posed as a possible item for inclusion on the IGY agenda early in the planning stages. The IGY logo (Figure 3) showed a satellite circling the Earth, even though none were as yet in orbit (Chapman, 1959).

In late 1957, those nations attending a conference on the IGY Rockets and Satellites program in Washington, D.C.—not only those that intended to launch such systems but also those that planned to track and use the data—heard about the successful launch of Sputnik I on the evening before the last day. By the end of 1958, the USSR had launched three satellites and the United States four, providing upper atmosphere data of interest to IGY participants. The most striking outcome of the U.S. satellite flights was the discovery of the Van Allen radiation belts, a region of intense particle radiation extending upward from a few hundred miles above the Earth. Although these flights were not a preannounced part of the U.S. IGY program, they made highly important contributions to the final results (Newell, 1980).

In fact, developments began to move so fast that by the early 1960s the term *artificial satellite* was replaced in space jargon by the shorter word *satellite,* and references to the moon used the term *natural satellite.* (An analogy can be found in music. Today the term *guitar* com-

monly refers to the more recent electric guitar, and the term *acoustic guitar* to the instrument that has existed for centuries.)

Even with these new ideas and advances in rocketry, remote sensing from satellites would not have progressed beyond photography without one more innovation: microelectronics. The development of low power, solid-state, integrated circuits allowed the construction of instruments that required little power and were small enough to be carried on board satellites, and opened the way for modern computers, which are essential to data-processing. Solid-state physics also led to the development of solar cells, which can supply a continuing power source for satellites and their instruments.

■ FORCES AT WORK AND TYPES OF ORBITS

Orbit Mechanics

In order to understand satellites and remote sensing, it is necessary to review some of the basic physics and mechanics of satellite orbits and sensing instruments. The discussion that follows attempts to provide a brief description of the terms that will be used in later chapters, but it is far from comprehensive. Readers who want to delve further into this subject are urged to consult the reference list at the end of the book.

How do satellites stay in orbit? The basic idea involves simple mechanics. As we know from swinging a ball on a string, to keep the ball moving around in a circle it is necessary to continue to provide an inward pull. As Newton noted, the tendency of the ball (its "inertia") is to move in a straight line. The pull from the string forces the ball to deviate from a straight line and go around in a circle. The faster the ball rotates, the more force is required to pull it inward to its circle. This inward pull is called "centripetal acceleration." The outward reaction is called "centrifugal force."

The natural satellites that move around the planets, like Earth's moon, are held in orbit by the planet's gravitational force. Gravity, an attractive force, provides the necessary inward pull, or centripetal acceleration, to keep the satellite moving in an orbit around the planet. Without gravitational attraction, the satellite would tend to go off in a straight line into outer space.

The inward gravitational pull between the planet and its satellite is in balance with the outward centrifugal force. For the sake of simplicity here, we will assume that the satellite moves in a circle. Strictly speaking, the orbits are not circular, but elliptical, with the central body at one focus of the ellipse. But for most purposes (excluding the very elongated ellipses noted later for some specialized satellites), the orbits are close enough to circles for the argument to be essentially correct. The plane defined by the Earth's equator is the "equatorial plane"; the plane defined by the Earth's orbit around the sun is the "plane of the ecliptic."

Now, since these forces depend on a number of factors, including the distance between the satellite and the planet, the mass of the planet, and the speed of rotation of the satellite, there are many possible periods of satellite rotation. Kepler's third law, which results from equating the gravitational and centrifugal forces, can be used to calculate the period of rotation for a particular set of parameters. For example, given its distance and speed, the moon orbits the Earth once a month, while Jupiter orbits the sun once every twelve years.

Each time satellites orbit the Earth, they provide a different—and unique—combination of coverage in space and time for remote sensing. Orbits close to the Earth, known as low earth orbits, are good for high resolution measurements and for active techniques that use radar and laser pulses. The inclination of the plane of the orbit and the field of view of the instruments determine the coverage. The National Oceanic and Atmospheric Administration (NOAA)'s polar-orbiting weather satellites, at an altitude of about 870 kilometers above the surface, orbit the Earth in a period of about one hundred minutes; the wide field of view of the instruments provides near-global coverage twice a day. This is a typical orbital period for this kind of weather- and land-observing satellite. In contrast, the Landsat satellites, at a similar altitude and orbital period, take sixteen days to cover the Earth because of the narrow field of view of their instruments.

As the distance between the satellite and the Earth increases, more of the Earth's surface comes into the field of view, and the orbital period increases. The greater distance means that the instruments need greater resolution and light-gathering power. At a distance of roughly 36,000 kilometers the orbital period is one day. A satellite orbiting in the equatorial plane at this distance from the Earth, and in the same

direction as the Earth rotates, stays over the same surface location at all times. This orbit is called "geostationary." It provides coverage of a region comprised of roughly one-fifth of the planet between 70 degrees north and south latitude and allows continuous measurement of processes taking place within the view of the satellite. The operational weather system of five geostationary satellites provides continuous coverage of the Earth from this orbit. Examples of orbits are shown in Figure 4.

Types of Low Earth Orbits

Equatorial and Tropical. Orbits can be at different angles relative to the equatorial plane of the Earth. The orbit exactly in the equatorial plane is called an "equatorial" orbit. In such an orbit, satellite-borne instruments would miss all of the Earth that cannot be seen from directly over the equator. If the angle of the orbit to the equatorial plane is increased slightly, the satellite instruments can cover tropical areas. An example is the Tropical Rainfall Measurement Mission (TRMM) discussed in Chapter 4, which aims to define tropical rain cells with dense sampling in the tropics. This satellite, with an inclination of about 35 degrees and a height of only 325 kilometers, will give very high resolution, better in fact than the operational weather satellites, because it is closer to Earth. Near-equatorial orbits are also used for astronomical observations and as transfer trajectories to other planets in the plane of the ecliptic.

Polar. Orbits with inclinations close to 90 degrees to the equatorial plane are called "polar" orbits, since the satellite can view polar or near-polar regions. Orbits with lower inclinations are referred to by their angle of inclination as measured from the equator to the orbit. The point at which a satellite crosses the Earth's equatorial plane from south to north is known as the "ascending node"; the point passed as it crosses the plane from north to south is known as the "descending node." The point directly beneath the satellite is called the subsatellite point or "nadir." The polar orbit is ideal for global or near-global coverage. As the satellite in polar orbit rotates around the Earth from one polar region to the other, the Earth rotates beneath it. The orbit

Polar

N

Gilmore Creek,
Alaska

Wallops
Island,
Virginia

CDA
Stations

530 Miles

Equator

28.8°
Earth Rotation
Per Orbit

Orbit Path

S

Orbit Plane
Rotates Eastward
1° Per Day

Geostationary

Figure 4. Opposite and above: polar and geostationary orbits for NOAA satellites. Note that the polar orbit rotates one degree per day; this is to make it synchronous with the sun. The geostationary satellite stays continuously above one spot on Earth.

period and the instrument field of view determine how long it will take to cover the full globe (see Figure 5).

Polar orbits are often selected to be "sun-synchronous." In this case the satellite is in an orbit that is always the same in relation to the sun. This does not mean that the satellite orbit remains fixed in space; rather, it must move to compensate for the Earth's rotation around the

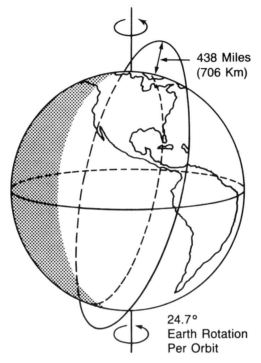

438 Miles
(706 Km)

24.7°
Earth Rotation
Per Orbit

Figure 5. Details of the sun-synchronous polar orbit used by the Landsat satellites.

sun, about one degree per day. Figure 6 shows how the orbit moves to provide this compensation. If in the spring the orbit has a certain angle in relation to the sun, then as the year continues that angle must stay the same, so that the satellite always remains in the same relation to the sun. Thus the satellite will always pass over a certain area at the same time of day, which is important for instruments that use sun illumination for measurements of, for example, ocean color or land vegetation. But this in turn means that some mechanism must be found to cause the satellite orbit to move, or "precess," as the Earth goes through its yearly cycle.

The precession of the orbit can be achieved by using the effects of the Earth's gravity field, which is not uniform. If the Earth were a homogeneous, perfect sphere, it would be difficult to cause precession

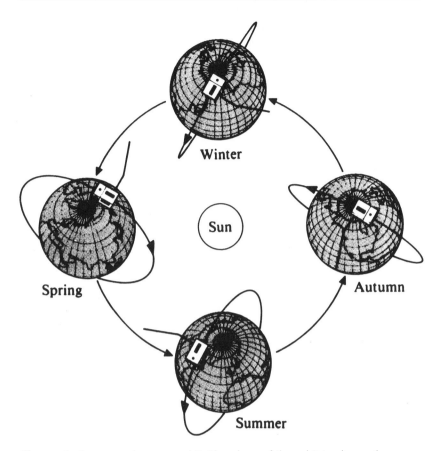

Figure 6. A sun-synchronous orbit. The plane of the orbit is always the same in relation to the sun, regardless of the season of the year.

in satellite orbits. But because of its own daily spin, the Earth is slightly "oblate," flattened at the poles and bulging at the equator. This extra material at the equator pulls on the satellite as it rotates around the Earth and causes the orbit plane to drift slowly from its original position. The drift is directly proportional to the cosine of the angle between the orbital plane and the equatorial plane—maximum when the two coincide and zero if the orbital plane is exactly 90 degrees (a polar orbit)—and inversely proportional to the orbit height.

If the orbit inclination is less than 90 degrees as measured between

the equatorial plane and north in a counterclockwise direction, the precession is to the west, in a clockwise direction that is opposite to that of the Earth's rotation around the sun (a "prograde" orbit). If the orbit inclination is more than 90 degrees, then the precession is to the east, in a counterclockwise direction that is the same as that of the Earth's rotation around the sun (a "retrograde" orbit). By adjusting the height of the orbit and its inclination relative to the equatorial plane, it is possible to adjust the rate of the retrograde precession to compensate exactly for the Earth's rotation around the sun so that the satellite orbit is always the same in relation to the sun.

The oblateness effect also causes the point of closest approach ("perigee") to move in the orbit plane, so that the altitude over a given target varies from day to day. But this altitude change can be eliminated because the oblateness of the Earth is not symmetrical from northern to southern hemispheres (Casey, 1989). The small differences cause long-term changes in the point of closest approach and the eccentricity of the orbit. By choosing the right location of the perigee and the right eccentricity, an orbit can be found that results in a nearly constant altitude. For example, the sun-synchronous orbit of the proposed polar platforms for the Earth Observing System (see Chapter 5) has a point of closest approach near the North Pole.

This "frozen orbit," sun-synchronous with a constant altitude, is used by many polar-orbiting remote-sensing satellites. The NOAA polar-orbiting weather satellites are sun-synchronous, with an orbit height of 870 kilometers and an inclination of about 99 degrees. Landsat, France's new Satellite Pour l'Observation de la Terre (SPOT), and Japan's Marine Observation Satellite-1 (MOS-1) have similar orbit parameters. The National Aeronautics and Space Administration (NASA)'s Nimbus-7 is also sun-synchronous, with an orbit height of 955 kilometers and an inclination of 99.5 degrees. The proposed polar platforms for the Earth Observing System have a design orbit height of 705 kilometers and a perigee point near the North Pole.

A satellite's coverage capabilities depend on its orbit height and its sensors' field of view. The density of the grid traced out by the subsatellite track is determined by the time required for the satellite to come back to the same point. The longer the time allowed for the satellite to repeat, the tighter the grid. As previously noted, because of the narrow field of view of its instruments, Landsat requires sixteen

days to achieve full coverage of the entire Earth. The Japanese MOS-1 satellite instruments cover the Earth in seventeen days. The wide field of view of meteorological satellites gives them full coverage twice a day.

Since the sun-synchronous orbit is fixed relative to the sun, the satellite track crosses the equator (or any other reference point) at a fixed local time known as the "equator crossing time." This fixed time is adjusted according to the parameters to be measured: for ocean color, for example, the sun should be overhead at the equator crossing time for best measurements; for vegetation measurements, the best time is in the morning, before local cloud buildup, while afternoon crossing times are best for timely delivery of weather forecasts.

Sun-synchronous orbits are not always required. For different sun illuminations, or for measuring the tidal effects of the sun, an orbit *not* in synchrony with the sun is necessary. The TOPEX/POSEIDON satellite jointly sponsored by the United States and France is designed to measure sea surface height with great accuracy in order to provide reliable measurements of waves, tides, and ocean currents. Since the sun is one of the principal drivers of tides, the designers of the mission did not want an orbit that would always be at the same position in relation to the sun. If it were, the satellite would register the tidal effect of the sun as a constant sea surface elevation, thus producing a false signal. For this kind of data it is essential that the satellite be in a "non-sun-synchronous" orbit, one that is not synchronous with the sun—or with any other major driver of ocean surface height. In the case of TOPEX/POSEIDON it was also necessary to provide satellite tracks that cross at an angle of about 45 degrees so that sea surface slopes in both east-west and north-south directions could be measured. In addition, the satellite tracks had to extend as far north and south as possible in order to cover as many ocean currents as possible. The final choice of orbit was one with an altitude of 1,330 kilometers (to minimize atmospheric drag on the satellite) and an inclination near 65 degrees. A further example of a non-sun-synchronous orbit is that used by the Earth Radiation Budget Satellite (ERBS), which is currently measuring incoming and outgoing radiation from Earth. The orbit chosen here had an altitude of 610 kilometers and an inclination of 56 degrees.

Other satellite measurements that do not require sun-synchronous

orbits include the measurement of gravity. Since the gravity field of the Earth depends only on its internal structure, it is not necessary to have sun-synchronous measurements. Moreover, for gravity measurements, the closer to the Earth the better, because small changes are more easily detected there. The optimal orbit for full coverage seems to be at a height of about 160 kilometers, which is as close to the Earth as a satellite can get without excessive atmospheric drag and risk of burning up, and an inclination of 90 degrees.

Geostationary. If a satellite is moved farther from the Earth, it experiences a weaker gravity field. The centripetal acceleration necessary to keep the satellite in orbit is smaller, and the rotation period longer. At the distance the moon is from the Earth, the rotation period is one month. In between the Earth and the moon, it is possible to locate a distance at which the rotation period is exactly equal to the one-day rotation period of the Earth. A satellite in that orbit, at that distance in the equatorial plane, moving in a counterclockwise sense, moves around the Earth at exactly the same speed as the Earth itself rotates. The satellite thus stays in the same place above the Earth all the time (see Figure 4). This orbit is called a geostationary orbit.

We know that the Earth rotates once around its axis every twenty-four hours. But it actually rotates a little faster than that, since it is simultaneously rotating around the sun in its yearly orbit. The satellite rotation for geostationary orbit takes this into account by using the "sidereal day," which is just slightly shorter (by a factor 364/365) than twenty-four hours, or 86,164 seconds. Using the sidereal day, we can calculate that the height of the geostationary orbit must be 42,180 kilometers from the center of the Earth, or 35,800 kilometers from the surface of the Earth. It happens that Deimos, a small moon of Mars, is not far from the "Mars-stationary" orbit for that planet.

The geostationary orbit is of great interest not only for Earth-observation but also for communications. Arthur C. Clarke, a pioneer in satellite communications, reports that in 1928, when an Austrian, Captain H. Potocnik (writing under the name Hermann Noordung), developed detailed engineering specifications for a manned space station, he placed it in a geostationary orbit (Clarke, 1984). In 1945, Clarke himself proposed a set of geostationary relay satellites that could provide worldwide coverage. Today, the geostationary orbit is

so crowded with broadcast, communication, and observation satellites that locations are allocated by an international committee.

For remote sensing, the geostationary orbit offers a particular advantage: almost an entire hemisphere can be viewed at the same time. But it also has several disadvantages: the satellite is very far from Earth, and thus it is more difficult to make accurate measurements; and satellites in geostationary orbit are located in the Earth's equatorial plane, which allows them only an oblique view of the polar and near-polar regions. As a result, a complete remote-sensing system must also include satellites in both near-Earth polar and tropical orbits.

The present set of geostationary satellites designed for meteorological purposes numbers five, two operated by the United States (one currently not working), and one each by the European Space Agency (ESA), Japan, and India. (These are discussed in Chapter 3.) The full geographic coverage of the U.S. Geostationary Operational Environmental Satellite (GOES) system and the full five-satellite system is shown in Figures 18–22 in Chapter 3.

Other Types of Orbit. Satellites are not confined to polar or geostationary orbits. As I have already noted, the laws of physics provide for elliptical satellite orbits, with the planet at one focus of the ellipse. In some cases, very elongated elliptical orbits are preferable. Much of the USSR lies in high latitudes, and as a result, the Soviets cannot use the usual geostationary communications satellites, which orbit in the equatorial plane. For this reason, Soviet communications satellites are placed in an elliptical orbit (called the Molniya orbit). It has its highest altitude (long axis) and hence slowest orbital speed over the USSR and its lowest altitude (short axis) and hence fastest orbital speed over the opposite side of the world. This means that the satellite spends most of its time over the USSR and only a small fraction of time over the rest of the world. The lack of continuous coverage from one satellite means that several satellites must be used to provide continuous communication.

Satellites in elliptical orbits are also used to focus on a particular target. Elachi (1987) notes that a satellite in an orbit with an ellipticity of 0.7 and a semimajor axis of 26,635 kilometers (that is, a point closest to the Earth of 7,990 kilometers and a point farthest from the Earth of 45,275 kilometers), a period of 12 hours, and an inclination of 63.4

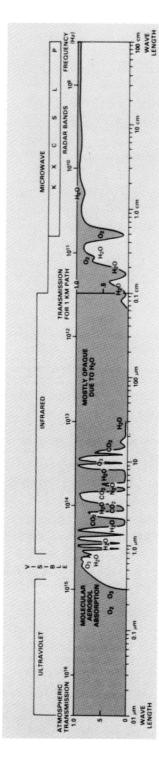

Figure 7. The electromagnetic spectrum showing the range of wavelengths and frequencies from ultraviolet to microwave and the atmospheric transmission of the various wavelengths. Note the "windows," or areas of high transmission, in the visible and microwave regions.

degrees would spend over 80 percent of its time over Europe and the north central Pacific and less than 20 percent over the rest of the world. Elliptical orbits are also used to study other planets. In these cases, low-altitude, high-resolution imaging is carried out while the satellite is close to the planet, and global broad-scale measurements are carried out at the higher latitude, where the satellite stays for a longer time. Such elliptical orbits are widely used by the military in putting short-lived satellites into orbit to examine specific areas of military interest.

■ SATELLITE SENSORS AND THEIR DATA

The Electromagnetic Spectrum

A satellite is a platform or "bus" that carries instruments. Remote sensing requires instruments that can sense what is happening on Earth, which they do by using electromagnetic radiation. While it is not possible to provide a detailed discussion of the nature of electromagnetic radiation in a short book like this, I will mention a few useful facts. Briefly, electromagnetic radiation consists of electric and magnetic influences or fields that are generated by rapid oscillation of electrons in atoms or in a conducting material. Light is one manifestation of electromagnetic radiation. Radio waves are another. Electromagnetic radiation propagates through space as waves, but it also behaves like particles, or photons. An understanding of the interaction between electromagnetic radiation and matter is essential for the interpretation of remotely sensed data. For our purposes here, I will simply mention that electromagnetic radiation is the means by which we sense the Earth remotely (for further explanation see Feynman et al., 1964).

 In space, all electromagnetic radiation travels at the speed of light, currently known to very high accuracy as 299,792,458 meters per second or close to 3×10^{10} centimeters per second. Electromagnetic radiation is characterized by wavelength or frequency. Short wavelength radiation is the most energetic. The range of wavelengths or frequencies is called the "electromagnetic spectrum," which includes on the very energetic and short wavelength side X rays, the ultraviolet, and the visible spectrum, and on the less energetic and long wavelength side the infrared, microwaves, and radio waves.

 Figure 7 shows the range of the electromagnetic spectrum from ul-

traviolet to microwave, including wavelengths, frequencies, and transmission through the atmosphere. For convenience, wavelengths are measured in micrometers (one millionth of a meter) in the ultraviolet, visible, and infrared regions of the spectrum, and in centimeters in the microwave and radar regions. Frequencies are measured in hertz, the unit for one cycle per second. The energetic, low wavelength range of radiation, which includes X rays and the ultraviolet so valuable to astronomy, is mainly used in remote sensing to detect the presence of radioactive materials and to sense the composition of the upper layers of the Earth's atmosphere (and the upper atmosphere of other planets). These wavelengths are not useful for measurements within the Earth's atmosphere because most X rays are absorbed by the atoms and molecules that make up the atmosphere, its clouds, and other constituents. It is only toward the near ultraviolet—wavelengths greater than 0.3 microns—that the atmosphere begins to transmit the radiation to a degree useful for remote sensing.

As is evident from Figure 7, in the visible range the absorption of radiation by the atmosphere occurs in a series of narrow wavelength intervals or "spectral bands." The electromagnetic energy is absorbed by the molecules of the atmosphere, causing them to vibrate (vibrational excitation), to rotate (rotational excitation), or to change the energy state of their electrons. Moving toward the infrared, the number of these absorption bands increases until in the mid-infrared there are only a few regions of transmission. In the far infrared, absorption is almost total, because of the extensive rotational excitation of molecules.

At the longer wavelengths of microwaves in the range of centimeters, absorption of radiation by the atmosphere generally becomes very low. In this region, the main effect of the atmosphere on electromagnetic radiation is to slow its speed, much as glass affects light passing through it. Because of the low absorption in this region of the spectrum, a very valuable part of remote sensing is done with instruments that operate in the microwave range.

Some instruments work by sensing radiation that is naturally emitted or reflected by the surface or from the atmosphere. Others sense signals transmitted from the satellite and reflected back to it. In either case, it is important to know how radiation interacts with matter in these various wavelength bands. At the shortest wavelengths, in the gamma-ray and X-ray regions, the major use is to map radioactive

materials, like those found on the moon. In the ultraviolet region, hydrogen and helium can be detected. In the visible and near-infrared regions, it is possible to measure the surface chemical composition, vegetation cover, and biological properties of matter at the surface. In this range of wavelengths the color of the light is related to composition of materials: red rocks are rich in iron oxide, and green sea water is rich in chlorophyll. Geologists can use such information to pinpoint geological formations typical of ore-bearing material or of petroleum deposits, while oceanographers can use the chlorophyll data to locate ocean regions of high biological productivity. In the mid-infrared region, geological features such as quartz or basalt have absorption properties related to the crystal structure of silicates that can indicate different kinds of geological formations. In the far infrared, emissions from the Earth's atmosphere and surface are related to atmospheric and surface temperature and variable atmospheric constituents such as water vapor and oxygen. Radiation in the microwave region can penetrate through clouds, so that remote-sensing instruments can collect information on atmospheric constituents, the surface temperature of land, ocean, and ice, surface physical properties, and water in the atmosphere—the latter to map rainfall. Microwave measurements can also detect soil moisture in the first few millimeters of soil. Very long radio wavelengths are used to measure surface physical properties and effects in the ionosphere. Radio waves will also penetrate beneath the surface in dry areas.

Remote-Sensing Instruments

Satellite-borne remote-sensing instruments operate in two ways: by sensing the radiation that comes from the Earth or by sending pulses of radar or light to Earth that are then reflected back to the satellite. Another type of satellite sensor consists of a passive mirror in space, which reflects laser pulses from Earth for accurate positioning and geodetic measurements.

We classify remote-sensing instruments as either "passive" or "active." Passive instruments collect information about the space environment in which they travel and record the radiation (of various wavelengths) emitted by the Earth and by the sun. Generally, such instruments consist of a telescope or other focusing device, arrays of detectors for different wavelengths, and electronics for operating and

processing data. They also include devices for calibration, so that the sensor is regularly aimed into deep space, at the sun, or at special on-board lamps or other radiation sources held at a known temperature. The telescope is designed to map the Earth through a regular scanning pattern; it can also be directed at specific areas of interest as the satellite travels in its orbit. Data can be transmitted to special data relay satellites or Earth stations as they are collected, or stored on board the satellite to be transmitted later.

Active instruments produce and send pulses, or short bursts of radiation, from the spacecraft toward Earth; the reflected pulses are collected by a suitable sensor on the spacecraft. The timing of the pulse and measurements of its shape when it returns reveal a great deal about a whole range of parameters, including the height of the satellite, cloud details, and the shape of waves on the surface of the ocean. These instruments require both transmitting and receiving devices and always use more power than passive instruments. The synthetic aperture radar on Seasat, for example, operated at a peak power level of 800 watts, whereas the thematic mapper on Landsat operates at less than 300 watts and the Advanced Very High Resolution Radiometer on the NOAA satellites requires only 30 watts. The data rate from these instruments varies, but it can be very high. Since the synthetic aperture radar produces an enormous amount of data, too large to be stored on board current satellites (future satellites will be able to accommodate high data rates), it must be transmitted to a local ground station as soon as it has been collected over a particular area.

Passive Sensors (Imagers and Sounders). The simplest type of imaging system is the framing camera, which takes a snapshot just as an ordinary camera does. The first remote sensing from balloons and aircraft was done with cameras—the recovered film provided the images. Although the technique is simple, the recovery can be difficult if the film must be retrieved separately, but even so, much of the remote sensing done today by both aircraft and satellites, including the collection of intelligence information, is done in this way. Photography offers several advantages: the information is not broadcast on communication channels but is fully protected (assuming that it can be collected), and very fine grain film provides very high resolution (defined as the size of the smallest object that can be distinguished). Astronauts have used hand-held cameras to photograph the Earth for almost twenty-five

years, beginning with the Mercury missions in the early 1960s. Most of the photographs are in natural color, although both black-and-white and infrared film have also been used. In terms of resolution, a good rule of thumb is that a 100-mm focal length lens used from the Space Shuttle altitude (about 300 kilometers) offers spatial resolution similar to that of the Landsat Multispectral Scanner (approximately 80 meters), and a 250-mm focal length lens has resolution similar to that of the Landsat Thematic Mapper (approximately 30 meters).

But photography also has several disadvantages: the range of wavelengths that can be sensed is limited, and because the data are collected on film rather than digitally, they cannot be used immediately, nor can they be transmitted or processed by computer until they have been converted to a digital format, which involves some loss of resolution. Accordingly, there has been an intensive effort to develop instruments that can overcome these limitations. We now have instruments that can sense radiation from the Earth, the sun, and deep space in wavelengths over the full electromagnetic spectrum. And much of the data can be provided in real time—within a few hours of collection.

At this point a few definitions are in order. Instruments known as radiometers or spectrometers use a telescope (or another optical scanning device) to provide an image of the surface. Filters (or other similar devices) separate the different wavelengths of the radiation that is sensed into bands or channels, each of which includes a narrow range of wavelengths. Because the resulting data are synthesized into images of the surface for each wavelength band, these instruments are also known as "imagers." There are two basic styles of imagers, "scanning" and "pushbroom." A scanning imager uses a movable scanning mirror that scans the Earth below from side to side and projects the image through filters onto a single detector. The instruments on the Landsat satellite, the Multispectral Scanner and the Thematic Mapper, operate in the scanning mode. The newer SPOT camera used in France's Earth remote-sensing system operates in a pushbroom mode. In this case, instead of a scanning mirror a linear array of detectors covers the whole image in the across-track direction. Although this requires many more detectors, it eliminates the need for moving parts. The detectors act like a pushbroom, because they do not need to sweep from side to side.

Landsat-4, which carries the Multispectral Scanner and the Thematic Mapper, operates in a near-polar orbit at an altitude of 705

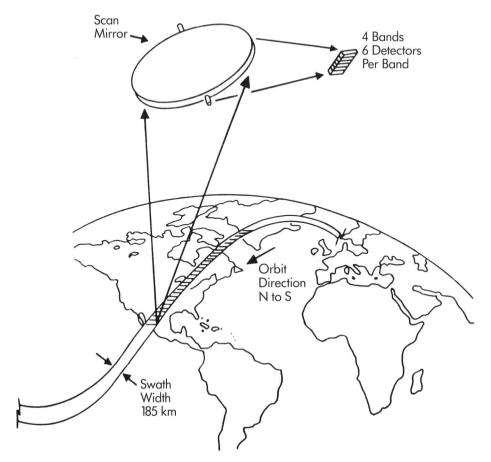

Figure 8. Schematic representation of the Multispectral Scanner Sensor (MSS) used on the Landsat satellites. The scan mirror moves the image across the width of the swath; the detectors provide information about different wavelengths.

kilometers. The "swath width," or width of the portion of the Earth observed, allows complete coverage of the Earth in sixteen days. The optics of the Multispectral Scanner, illustrated in Figure 8, include arrays of detectors for various wavelength regions. The telescope and optics provide a resolution of 80 meters from the altitude of the satellite. The high accuracy of these systems requires state-of-the-art materials: the Thematic Mapper has a beryllium scan mirror, an ultralow-

expansion lightweight primary mirror, and a graphite epoxy telescope tube.

Careful calibration is essential in achieving reliable data. The detectors must be regularly exposed to radiation of a known brightness to measure any change in signal (called instrument "drift") due solely to the instrument. In the Thematic Mapper, calibration is provided by two sources: the known radiation from a tungsten filament light bulb and from the sun. The sun calibration is used to test for any long-term changes in the tungsten lamp calibrator.

The Thematic Mapper operates with seven wavelength bands, which were selected to provide a maximum amount of information. The shorter visible ranges are for mapping coastal water color, differentiating between soil and vegetation, and measuring the reflectance and absorption of chlorophyll. Longer wavelength bands are used to determine vegetation moisture and the evaporation of water from plants, as well as for geological applications, such as the identification of rocks. A similar instrument, the Coastal Zone Color Scanner, was used on Nimbus-7. It too was a multichannel scanning radiometer with a rotating mirror. Here, the choice of wavelength bands was optimized for detecting the absorption of chlorophyll, other organic material in water, surface vegetation, and surface temperature.

In the microwave region the Earth's atmosphere and clouds are essentially transparent, making passive sensing especially productive. One of the most useful applications of microwave sensing is in mapping ice cover, particularly for sea ice, since the emission of microwaves is very different for water and for ice, even at the same temperature. Microwave measurements can be made even during the dark polar winter or when the surface is obscured by clouds. It is also possible to measure soil moisture by using microwaves, since the microwave emission of wet soil is different from that of dry soil (although the current degree of accuracy of this measurement is not high). And since surface emission of microwaves depends on temperature, sea surface temperature can also be measured this way. Accurate measurement of soil moisture and surface temperature is made more difficult by the fact that microwave emission is also dependent on surface properties such as roughness. At higher frequencies, microwave measurements can detect rainfall and water vapor in the atmosphere.

Microwave radiometers frequently operate in an imaging mode. The

beam is scanned either mechanically or electrically. One common imaging mode is a conical scan, in which the antenna rotates around an axis, pointing at a constant angle from the nadir. This gives circular coverage, which is advanced along the surface of the Earth by the motion of the satellite. An important advantage of this system is that the total path of the radiation through the atmosphere is the same for all angles and the angle of incidence is constant, making it easy to compensate for any effects of the atmosphere on the signal. The Scanning Multichannel Microwave Radiometer on Nimbus-7 is of this type, with an angle of 42 degrees from the vertical. Microwave instruments are calibrated by alternately providing views to deep space (a cold source) and views to devices in the instrument itself (a warm source).

Another type of instrument is the "sounder," which provides information about a particular property as a function of height within the atmosphere. There are three ways in which such an instrument can work: by occultation, by scattering, and by emission. Occultation or "limb viewing" is probably the simplest of these. The instrument on the satellite looks out at an angle through the atmosphere at the sun or a star (see Figure 9). The absorption of light from the sun or star provides information on the properties of the atmosphere at different heights, after correction for the different horizontal lengths traveled. The advantage of this technique is that the radiation travels a much longer path than in vertical sounding, so that even very weak emission or absorption signals can be detected. Moreover, the height measurement is direct, as opposed to the indirect measurement from vertical sounding. A disadvantage of this technique is that occulted objects are not always available for viewing, and thus coverage in space and time is poor.

A second mode of sounding is scattering. One of the main applications of scattering is in detecting rain. As a radar pulse interacts with a rain region, echoes are returned that are proportional to the radar backscatter of the rain particles. As the pulse propagates deeper into the rain cell, additional echoes are returned at later times. Thus, a time analysis of the returned echo provides a profile of rain intensity. The measurement of backscattered solar ultraviolet radiation with spectrometers can reveal both the profile and the total amount of ozone in the atmosphere.

The third sounding method uses the fact that the emission of radiation from an atmospheric constituent like oxygen at any particular

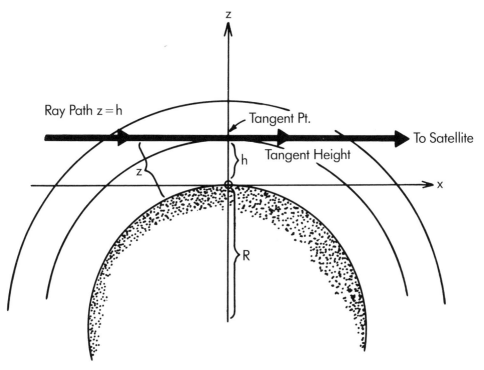

Figure 9. "Limb viewing" of the atmosphere by satellite. The path of rays from stars or the sun goes through the limb of the atmosphere and then to the sensing satellite. The long distance traveled makes even small absorption or emission signals detectable.

emission band depends on the vertical location of that constituent in the atmosphere. If the total emission is measured as a function of frequency, the temperature at different heights can be inferred; if the temperature at different heights is known, other properties can be inferred.

Active Sensors (Imaging and Nonimaging). Active sensors use radiation in the visible, infrared, or radio parts of the spectrum. Radio wave systems, called "radar" (from *ra*dio *d*etection *a*nd *r*anging), were developed prior to and during World War II for detection of ships and aircraft. The systems that work in the visible and infrared are called "laser" for *l*ight *a*mplification by *s*timulated *e*mission of *r*adiation. There are two types of active sensors: imaging and nonimaging. Exam-

ples of imaging sensors include real aperture radars and synthetic aperture radars. Examples of nonimaging sensors include altimeters and scatterometers.

With the development of lasers it has become feasible to use laser ranging for accurately measuring the distance between two objects that are very far apart. A beam of light is directed at an object in space and the reflected signal is recorded. The time of travel is equal to the distance to the object divided by the speed of light. Because travel time can be measured very accurately, ranging is very precise. Laser ranging to space was first carried out to satellites in the mid-1960s. Laser ranging to the moon was first carried out in 1969, after the astronauts of Apollo 11 left a laser reflector on the moon's surface. But such signals are extremely small. It is estimated that out of the 10^{20} (hundred billion billion) photons emitted by a single series of ten laser shots to the moon, only one is detected (Langley, King, and Shapiro, 1981). Laser reflectors do provide a way to study the rotation of the moon and the Earth and the varying distance of the moon from the Earth. Lunar laser ranging was instrumental in the discovery of the nearly 50-day oscillation in the length of a day and its correlation with a similar oscillation in the atmosphere (Langley, King, and Shapiro, 1981). Laser ranging has proved so useful for surveying and mapping that a number of countries have decided to put satellites with laser reflectors in orbit close to the Earth. In fact, fourteen satellites so equipped have already been put into orbit.

Radar can also be used to provide information about the subsurface properties of the Earth. Subsurface sounding depends on how much absorption of the radar waves occurs in the soil or other surface material. If the soil is dry, the radar can penetrate as much as a few meters. Large areas of the Egyptian desert have been mapped to show subsurface features, including former paths of rivers, desert basins, and bedrock structures (Elachi, 1982, 1987). Radar is not strongly absorbed by ice and thus can be used to measure ice sheet thickness. The depth of the Antarctic and Greenland ice sheets has been measured using radar instruments on aircraft.

Stewart (1985, 1986) and the TOPEX Science Working Group (1981) provide an example of a nonimaging sensor in their discussion of satellite altimeters. Satellite altimeters measure the height, or altitude, of the instrument above the Earth by sending out a pulse of radiation and then measuring the time it takes to be reflected back. Since the speed of

electromagnetic radiation is close to 3×10^{10} centimeters per second, one-way measurements of distance accurate to one centimeter require a timing accuracy of 30×10^{-12} seconds and a clock that is stable to one part in 10^8. These are very strong constraints, but with modern timing technology, we can achieve them.

Satellite altimeters typically use radar pulses for measurement, but it is also possible to use light pulses from lasers. The radar altimeters in use to date have operated at a wavelength of about 2.2 centimeters. In order to improve the signal-to-noise ratio, the altimeter makes a determination of height every few tenths of a second while transmitting thousands of pulses per second. As many as a thousand pulses are averaged together for this purpose.

In principle, the operation is simple: when the height of the satellite above the surface is subtracted from the height of the satellite's orbit, the difference is the measurement of the topography of the surface (see Figure 10). But various sources of error must be considered. Uncertainties in the measurement of height result primarily from the effects of water vapor in the atmosphere and of free electrons in the ionosphere. As I mentioned at the beginning of this chapter, the presence of matter causes electromagnetic radiation to have a slower effective speed. Both water vapor in the lower atmosphere and free electrons in the ionosphere have this effect. The typical amount of water vapor in the atmosphere causes the radar pulses to slow so that height is overestimated by roughly half a meter. Free electrons cause an overestimate ranging from 2 to 20 centimeters.

The effects of water vapor can be assessed by directly measuring the amount of water vapor in the path of the radar pulse. This is done with a radiometer, which is tuned to the frequencies emitted by water in the spectral region of about 22.3 gigahertz. The radiometer data show how much water vapor there is in the path of the radar pulse so that the proper corrections can be applied. The effects of free electrons in the ionosphere can be accounted for by using two frequencies for the radar pulses. Because the ionosphere affects the two frequencies differently, the two measurements can be used to calculate both the height of the satellite and the electron content of the ionosphere.

Another major source of uncertainty in measuring topography is the determination of the orbit. For data on topography to be useful, the accuracy of the orbit determination must be as good as or better than the topographic signal to be measured. At the ocean surface, for ex-

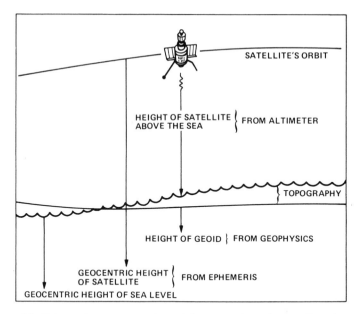

Figure 10. Schematic representation of the operation of a satellite altimeter. The height of the satellite is measured by the altimeter and subtracted from the known orbit location. The result provides a measurement of the surface topography. Accuracies of a few centimeters can be achieved with this technique.

ample, because the variation in height due to waves and currents is on the order of a few centimeters to meters, the orbit must be determined to an accuracy of at least a few centimeters.

But to achieve high accuracy, we must also understand the other forces at work. In order of relative importance, the uncertainties in the orbit can result from our lack of knowledge of the variations in the Earth's gravity field, from drag caused by the residual atmosphere at the satellite, from radiation pressure from sunlight, from perturbations caused by outgassing from the satellite, from the effects of ocean tides, and from the gravitational effects of the moon and the sun. Since we do not know enough about these forces to estimate their effects with sufficient accuracy, the only good way to reduce uncertainty is to track the satellite with great precision and then to use that information to provide an accurate orbit (TOPEX Science Working Group, 1981).

The TOPEX/POSEIDON precision altimeter mission (discussed in

detail in Chapter 4) will use a water vapor radiometer and a two-frequency altimeter to reduce uncertainties in water vapor and free electrons. To minimize atmospheric drag, the orbit chosen is higher than that of the usual polar-orbiter, in this case about 1,300 kilometers. In addition, the satellite has a compact design, so that the ratio of area to mass is as low as possible.

A further example of a nonimaging radar instrument is the scatterometer. The scatterometer is a radar sensor that illuminates the surface of the Earth at a selected angle of incidence and then measures the radiation that is scattered back. The principle was first discovered with the use of radar on ships, where it was regarded as a nuisance because it created noise or ''clutter'' on the radar screen that tended to obscure the signal of other ships. Scatterometers have been particularly useful in measuring wind at the sea surface by taking advantage of the fact that the scattered radar is strongly dependent on the small waves at the surface that are related to the surface wind. The scattered radar can thus be related to the surface wind, although the relationship is not a simple one, nor is it yet completely understood.

In order to measure wind direction as well as wind speed, scatterometers observe the sea in different directions using long antennas oriented at fixed angles relative to the ground. Each antenna produces a narrow beam in the required direction. A minimum of three antennas is required to reduce directional ambiguities to an acceptable level.

Imaging by radar expands the scope of remote sensing. The altimeter yields only single-point measurements, and many of these must be compiled in order to achieve a full description of the surface. By using imaging techniques, however, much more information can be collected in a given amount of time. Radar is particularly good for imaging because it is not greatly affected by atmospheric composition or clouds and because it can penetrate below the surface to show some subsurface properties.

But there is an important difference between imaging in the optical part of the spectrum and imaging at microwave or radio wavelengths, mainly due to the difference in wavelength. The resolution of a telescope aperture or antenna is proportional to the product of the wavelength and the height of the satellite, and inversely proportional to the size of the antenna or aperture. At the height of a typical satellite (approximately 800 kilometers) and at the short optical wavelengths, which are on the order of microns, resolutions of a few tens of meters

with an aperture size of only a few centimeters are possible (for example, the Thematic Mapper on Landsat). But at the longer microwave wavelengths of a few centimeters, even a 10-meter antenna only leads to a resolution of a kilometer or so (Elachi, 1987; Stewart, 1985; Stimson, 1982). To improve this resolution to the order of meters would require an antenna that is several kilometers long; such a structure would be very difficult to deploy in orbit.

It is possible to avoid having such large antennas in space by using an ingenious invention called synthetic aperture radar, which takes advantage of the motion of the antenna as the spacecraft travels in its orbit. The concept was first—and is still—used in instruments carried by aircraft. Each time a pulse of radiation is transmitted, the radar instrument occupies a position a little farther along on the flight path. As the sensor moves, successive echoes are recorded. If both the phase and the amplitude of the echoes are recorded, the information can be combined into a coherent image. The target stays in the beam for a significant period of time and is observed by the radar from numerous locations along the satellite path. The resolution of the image is thus the same as if the antenna were essentially as long as the distance the satellite moved while it was collecting the image. Since the larger the antenna, the better the resolution, this approach gains resolution of orders of magnitude more. For example, the synthetic aperture radar carried on Seasat had a true size of 10 meters and operated at a wavelength of 24 centimeters (or a frequency of 1.3 gigahertz) and a height of 850 kilometers. In a real aperture mode, the resolution would be about 20 kilometers. In the synthetic mode, the resolution is 25 meters, which corresponds to a synthetic antenna size of more than 8 kilometers, eight hundred times the actual size of the antenna (Stimson, 1982).

▪ SATELLITES AND THEIR POWER SOURCES

Some satellites act as passive reflectors in space, but most require power to operate. Thus, a major feature of satellites is their power system. This power is typically generated by solar cells, since the satellites spend much of their time in sunlight. Figure 11 illustrates the Nimbus-7 satellite, with its antennas and telescopes, to show how satellites look in flight. As Figure 11 shows, one of the largest and most

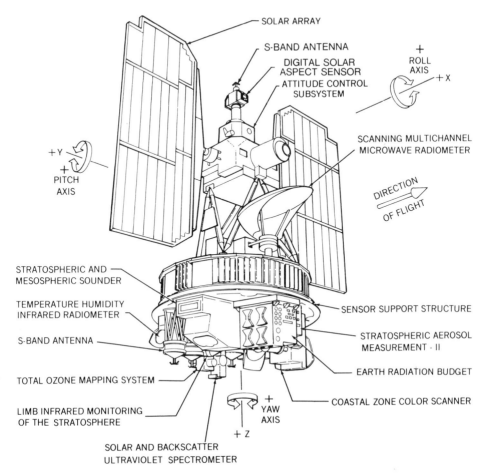

SOLAR ARRAY

S-BAND ANTENNA

DIGITAL SOLAR
ASPECT SENSOR

ATTITUDE CONTROL
SUBSYSTEM

+
ROLL
AXIS
+X

+Y

+
PITCH
AXIS

SCANNING MULTICHANNEL
MICROWAVE RADIOMETER

DIRECTION
OF FLIGHT

STRATOSPHERIC AND
MESOSPHERIC SOUNDER

TEMPERATURE HUMIDITY
INFRARED RADIOMETER

S-BAND ANTENNA

TOTAL OZONE MAPPING SYSTEM

LIMB INFRARED MONITORING
OF THE STRATOSPHERE

SOLAR AND BACKSCATTER
ULTRAVIOLET SPECTROMETER

SENSOR SUPPORT STRUCTURE

STRATOSPHERIC AEROSOL
MEASUREMENT - II

EARTH RADIATION BUDGET

COASTAL ZONE COLOR SCANNER

+
YAW
AXIS

+ Z

Figure 11. Schematic representation of NASA's Nimbus-7 satellite, which was the last of an Earth-observing series testing new concepts of measurement. Antennas, instruments, and solar cells are indicated. The spacecraft is three meters tall and four meters wide with the solar panels extended.

visible parts of most remote-sensing satellites is the set of solar power cells that collect the energy necessary for the satellite to operate. In the case of Seasat and Nimbus-7, the panels are arranged so that they can move continuously in order to expose a maximum surface area to sunlight. On the spin-stabilized cylindrical geostationary satellites (see Chapter 3), the solar cells are mounted all around the outer surface.

A second source of power is nuclear fission. Nuclear reactors in

space can provide a compact energy source that generates much more electricity than the large arrays of solar cells typically used. Nuclear power is also required for spacecraft that travel to the outer planets, where sunlight is too weak for solar cells. As Johnson (1989) points out, in 1989, nearly sixty objects carrying more than 1.5 tons of radioactive materials, primarily U235, were in space around Earth. The vast majority of these represent debris from the Soviet Radar Ocean Reconnaissance (RORSAT) program. In the past twenty years, thirty-three RORSATS have been launched. Space reactors are generally viewed with some caution because of the risk of release of nuclear materials to the atmosphere in a launch explosion or during burnout in the atmosphere. The first public controversy over space reactors occurred in 1978, when part of northern Canada was contaminated by radioactive debris from a failed Soviet Kosmos 954. The nuclear-powered Soviet satellites Kosmos 1402 and Kosmos 1900 also malfunctioned and fell back to Earth in 1983 and 1988, respectively.

■ DATA TRANSMISSION AND GROUND STATIONS

To be useful, data from satellites must be captured by ground stations for distribution. In the case of NOAA polar-orbiting meteorological satellites (see Figure 5), global data are tape-recorded on board and later played back on command as the satellite passes over a ground station. NOAA operates ground stations at two locations: Gilmore Creek, near Fairbanks, Alaska, and Wallops Island, Virginia. The French Meteorological Space Center also receives data at Lannion, France. When data are received at the ground stations, they are recorded and retransmitted through a commercial communications satellite to NOAA's facilities in Suitland, Maryland, for central processing (McElroy, 1985). Polar satellite data are also distributed internationally through the Global Telecommunications System (see Chapter 6). There are thirteen receiving stations for direct readout of geostationary satellite data in the United States, and many other commercial users have near real-time access through a ground network. Nearly twelve hundred stations around the world copy these data directly, and at least five hundred additional stations receive the data relayed through the European Meteosat.

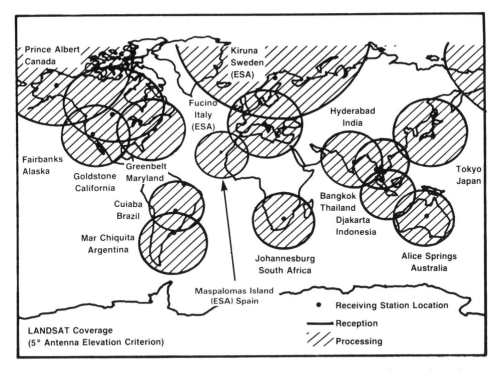

Figure 12. Location of receiving stations for the Landsat series of satellites and areal coverage at each station.

Data from the land-sensing programs such as the U.S. Landsat or the French SPOT are available for purchase. The Landsat data come through EOSAT, a joint venture formed by Hughes Aircraft and the General Electric Company. It was created as a vehicle to commercialize Landsat and distribute data to users. The NOAA "Landsat Memorandum of Understanding" requires that data received by a station be available to users around the world on a public, nondiscriminatory basis. Stations pay EOSAT an annual system access fee of $600,000 and nominal fees for each data product sold to users. Direct readout services for foreign ground station operators are available on a public, nondiscriminatory basis under consistent terms and conditions. The location of these stations and satellite coverage are shown in Figure 12. Users are free to purchase Landsat data archived at any station regardless of location. The SPOT data are distributed commercially by

SPOTIMAGE, a multinational company. Issues of data collection and dissemination are discussed further in Chapter 6.

A satellite data collection ground station that has proved very useful over the history of the space program is the one at Maspalomas, in the Canary Islands. The station was built in 1965 for data collection and tracking in the Apollo moon landing program. At the end of the Apollo project in the early 1970s, the station was abandoned. But in 1979, under an agreement between the European Space Agency and the Spanish government, the station was reactivated for receiving and processing data from the Nimbus-7 and Seasat satellites. At present, the station carries out satellite tracking and data reception from a wide variety of Earth-sensing satellites, including the NOAA-10 and NOAA-11 polar orbiting satellites, Landsat-5, SPOT-1, and MOS-1.

In order to provide communication and data links with satellites worldwide, NASA has established a Tracking and Data Relay Satellite System (TDRSS) (Long, 1987). The system is designed to transmit data from satellites to ground stations, and to monitor the progress of manned space vehicles and track newly launched satellites as they move to their assigned orbits. The TDRS satellites are also being used for real-time relays of experiments on space shuttles. The first such spacecraft (TDRS-A) was launched in 1983 into a geostationary orbit at 41 degrees west longitude over the Atlantic Ocean. The second planned satellite (TDRS-B) was lost in the explosion of the space shuttle Challenger in 1986. A third satellite (TDRS-C) was placed in geostationary orbit over the Pacific Ocean at 171 degrees west in 1988, and a replacement for TDRS-A, TDRS-D, was successfully launched to 41 degrees west longitude in 1989. TDRS-A is being kept in space at 79 degrees west as a spare. The TDRS satellites link all users to a single centrally located facility at White Sands, New Mexico. With these three data relay spacecraft, NASA will effectively be able to replace many of its extensive ground-based Earth stations. The USSR is also operating a satellite data relay network with geostationary satellites.

■ A BRIEF CHRONOLOGY OF REMOTE SENSING

Remote sensing goes back at least to the mid-nineteenth century when early cameras were first sent aloft in balloons. At the beginning of the twentieth century, a passenger in an airplane piloted by Wilbur Wright

made the first photographs from an airplane over Centocelli, Italy (Elachi, 1987), but it was not until 1946 that the first photographs were taken from V-2 rockets. In 1957 the Soviet satellite Sputnik opened the space age.

Satellites are a source of national pride and identification, an important factor in the development of national space programs. The Japanese name all their satellites after flowers popular in Japan: a broadcasting satellite was named *Yuri* (lily), test satellites *Kiku* (chrysanthemum), meteorological satellites *Himawari* (sunflower), communications satellites *Sakura* (cherry blossom), a geodetic satellite *Ajisai* (hydrangea), and the marine observation satellite *Momo* (peach blossom). Canada has used both French and Eskimo names (Alouette and Anik) for satellites. On their first satellite the Chinese included a music box that played a digitally synthesized version of the tune, "East is Red."

The following is a list of the major events in the development of remote sensing (information from Elachi, 1987; Research and Coordination Bureau, 1987; Committee on Earth Sciences, 1988; Curran, 1985; NOAA and NASA, 1987).

1957: First artificial satellite launched by the USSR.

1958: First U.S. Explorer mission discovered Van Allen belts. China began developing a sounding rocket.

1960: The United States launched the first generation of polar-orbiting meteorological satellites, the Television and Infrared Observation Satellite (TIROS-1), which provided the first systematic cloud cover photography and observations of Earth with broadband visible and infrared imagery.

1961: A manned Mercury satellite successfully took the first photographs of the Earth's surface from space. The United States initiated a series of reconnaissance satellites.

1962: The USSR launched the first in a series of photographic reconnaissance satellites. Canada put its research satellite Alouette I in orbit, and the United Kingdom launched its first satellite, Ariel-1, for the study of the ionosphere and the sun.

1963: The United States put into operation the first Automatic Picture Transmission (APT) for direct TV readout.

1964: NASA initiated the Nimbus series of experimental satellites. These were primarily experimental platforms to test instrument

concepts and to make measurements on a global basis. Italy launched its first satellite, San Marco, for studies of the ionosphere.

1965: France launched its first satellite, A-1. The USSR began Meteor, a polar-orbiting meteorological satellite program. The first complete view of the world's weather was taken by the U.S. TIROS-9, the first TIROS to be in sun-synchronous orbit.

1966: A new era in meteorological observations opened with the launch of the first geostationary spacecraft, Applications Technology Satellite-1 (ATS-1) by NASA. The ATS carried the spin-scan radiometer, which provided the first continuous observations of cloud and severe weather tracking from a stationary platform. Three ATS satellites were flown in the next ten years.

1967: The first full-disk image of the Earth was produced by the U.S. ATS-3 satellite. The United States also put into orbit the first infrared sounder for global temperature soundings.

1968: The United States launched its first Geodetic Earth Orbiting Satellite (GEOS).

1969: The first West German satellite, GRS-A Azur, was launched to study solar-terrestrial relations. The U.S. Nimbus-3 provided the first global vertical temperature profiles of the atmosphere.

1970: The decade began with Nimbus-4, which provided the first global ozone profiles. Japan launched its first satellite, OHSUMI, and China its first science exploration satellite, SKW-1.

1971: China launched a second science exploration satellite, SJ-1, which replaced the telemetry music box with a cosmic ray detector, X-ray detector, magnetometer, and other instruments. SJ-1 operated until June 1979.

1972: The United States launched the first Earth Resources Technology Satellite (ERTS), which provided the first multispectral map of the surface of the Earth. (In 1975, this satellite was renamed Landsat, the first in an ongoing series that now totals five.) Canada became the first nation to have its own commercial satellite communications system with the launch of Anik-1.

1973: The first active microwave sensor, operating as an altimeter, scatterometer, and radiometer, was flown on NASA's Skylab.

1974: The United States launched the Synchronous Meteorological Satellite (SMS-A), the first geostationary meteorological satellite, which was the forerunner of the Geostationary Operational Envi-

ronmental Satellite (GOES) system. Astronauts aboard Skylab used multicamera systems to provide Earth images in several spectral bands. The USSR launched its first geostationary communications satellite. NASA's Nimbus-5 carried the first Electronically Scanned Microwave Radiometer.

1975: Nimbus-6 provided the first atmospheric limb scanner and the first global Earth radiation budget measurements. Japan launched its first ionosphere sounding satellite, UME (Japan-1). An improved altimeter was flown on NASA's GEOS-3 satellite. France launched the geodetic satellite Starlette.

1976: The United States launched the first satellite in its Defense Meteorological Satellite Program (DMSP). NASA launched the Laser Positioning satellite Lageos-I.

1977: In preparation for the Global Weather Experiment in 1979, Japan obtained an operating geostationary meteorological satellite with the successful launch of Himawari, built by the United States. The European Space Agency launched its first geostationary meteorological satellite, Meteosat-1. This year also saw the Large Area Crop Inventory Experiment (LACIE), the first of the U.S. large-scale agricultural studies by satellite, and the first microwave sounder with all-weather sounding capability. The USSR began a land remote-sensing program with its Meteor-Piroda spacecraft.

1978: A "vintage" year for remote sensing. NASA launched two satellites using new microwave techniques that have had a major impact on subsequent systems: Seasat, a satellite devoted to measurements of the oceans, which provided the first global measurements of winds at the ocean surface, sea surface topography, surface and internal waves, and bathymetry in shallow regions; and Nimbus-7, the last of the Nimbus series, which provided a number of firsts, including global ocean color measurements and daily mapping of ozone concentration. (At this writing, the Nimbus-7 is still flying, although many of the instruments are not operating.) NASA also launched the Heat Capacity Mapping Mission with a scanning visible and infrared radiometer for geological and vegetation mapping. The United States initiated TIROS-N, an operational polar-orbiting environmental satellite system. The U.S. Solar Maximum Mission began to provide the first continuous measurements of the radiation from the sun.

1979: The European Space Agency launched its first satellite using the Ariane launch vehicle. The USSR began its oceanographic remote-sensing program.

1980: India launched its first satellite, Rohini.

1981: China launched SJ-2, a satellite intended for space physics exploration. This year also saw the first study by NASA of the Earth's aurora from space and the beginning of the U.S. Space Shuttle program, which would provide many opportunities for orbiting cameras and imaging instruments over the next five years. The first Shuttle Imaging Radar (SIR-A) was flown on the Space Shuttle. The satellites Dynamic Explorer 1 and 2 measured the impact of solar radiation on the atmosphere, auroral displays, and climate and weather.

1982: The Indian National Satellite System (INSAT-1a), a geostationary meteorological and communications satellite, was launched. The U.S. Thematic Mapper instrument on Landsat provided the first high-resolution multiwavelength images of Earth.

1984: The United States launched the Earth Radiation Budget Satellite (ERBS). The second Shuttle Imaging Radar (SIR-B) and the Large Format Camera, which provided spectacular imagery of many parts of the Earth, were flown on the Space Shuttle.

1985: The U.S. Navy launched the altimeter satellite, GEOSAT. Landsat-5 was deployed.

1986: France successfully launched the Satellite Pour l'Observation de la Terre (SPOT) satellite. This was the first in a series of satellites for the commercial production of images of the Earth. In the United States, the EOSAT company began operating the Landsat system on a commercial basis.

1987: The Japanese Space Agency launched the Marine Observation Satellite (MOS-1).

1988: China launched its first meteorological satellite, Wind-Cloud-1 (FY-1), into a sun-synchronous orbit with the CZ-4 Long March rocket. The Indian Remote Sensing satellite IRS-1A was launched with a Soviet rocket. ESA launched the first in a series of European operational geostationary meteorological satellites MOP-1 (Meteosat Operational Programme-1).

1989: The United States flew a Solar Backscatter Ultraviolet Experiment on the Space Shuttle. Japan launched GMS-4.

3

THE PRESENT CONSTELLATION OF SPACE-BASED SYSTEMS

To understand the Earth well enough to predict its future state, we need global measurements of key Earth processes that have a resolution high enough to reveal regional environmental trends. Satellite-borne instruments give us such a capability. Today, a constellation of satellites circles the Earth, providing measurements of the atmosphere, land, and ocean, testing new kinds of instruments, and developing more refined measurements. Figure 13 illustrates the operational satellites now in orbit.

Existing satellite-borne instruments have given us dramatic new views of the Earth. The global picture of land vegetation patterns and ocean color (which indicate biological productivity) in Plate II was produced at NASA's Goddard Space Flight Center with data from both NOAA and NASA satellite measurements. The land vegetation data are from the Advanced Very High Resolution Radiometer on the NOAA-7 polar-orbiting satellite for the period April 1982 to March 1985. The ocean color data are from the Coastal Zone Color Scanner instrument on NASA's Nimbus-7 satellite for the period January 1979 to June 1980. Although the periods during which these measurements were made do not overlap, the general patterns they reveal are believed to indicate the distribution of vegetation on the Earth's surface. Desert and fertile areas on the continents are immediately evident, with Africa providing a particularly vivid example. Ocean productivity is clearly most active near the coasts, but there is also a significant amount along the equator in the Pacific Ocean and high productivity in the Greenland Sea, between Greenland and Norway.

Satellite data have also been used to determine the global distribu-

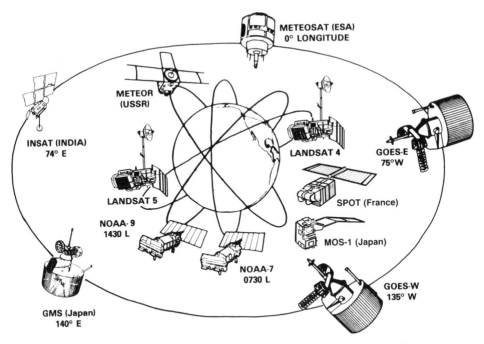

Figure 13. The current civil operational environmental satellite system, which includes satellites from five different countries and the European Space Agency. The diagram is not to scale, since the geostationary satellites are approximately 36,000 km from Earth, and the polar-orbiting satellites circle the Earth at a height of about 800 km.

tion of temperature (see Plate III) and to chart seasonal changes in surface temperature over the United States (see Figures 14 and 15). Here, the data are from the high-resolution infrared sounder (HIRS) and the microwave sounding unit (MSU) on the NOAA polar-orbiting satellites. The seasonal difference between the measurements made in January and those made in July illustrates the high heat capacity of the ocean, which takes months to change significantly in temperature.

Satellite measurements also provide a detailed view of the changing environment. Plate IV shows a regional image of the outflow at the Mississippi Delta, compiled from data recorded by the Landsat-4 Thematic Mapper instrument, in which sediment transport by the Mississippi River into the Gulf of Mexico is evident.

In the remaining sections of this chapter, I will survey current satellite systems and what we can learn about the Earth from satellite-

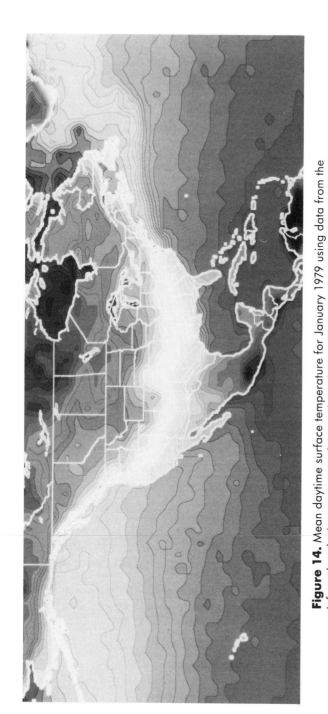

Figure 14. Mean daytime surface temperature for January 1979 using data from the infrared and microwave sounders on the NOAA polar-orbiting satellite. Compare to Figure 15, the July 1979 surface temperature for the same region. Note the strong seasonal changes of temperature over land and the relatively small changes in the ocean.

Figure 15. Mean daytime surface temperature for July 1979 using data from the infrared and microwave sounders on the NOAA polar-orbiting satellite. Compare to Figure 14, the January 1979 surface temperature for the same region.

gathered data. For convenience, I will group these satellite systems according to their areas of observation: the sun and its interaction with the Earth, the atmosphere, the oceans, the land surface, the cryosphere (sea ice, snow cover, and ice sheets), and geodesy and satellite navigation.

■ THE SUN AND ITS INTERACTION WITH THE EARTH

The Earth is bathed in radiation and in particles that emanate from the sun. Visible solar radiation is given off by the photosphere, the relatively cool surface layer of the sun. Above the photosphere and the warmer chromosphere is the very hot corona, whose occasional eruptions explode into a solar wind of particles that impinge on the Earth (Krimigis, 1988; Lanzerotti, 1987). These particles also affect satellites by creating a "hostile" operating medium.

Changes in the sun's output of radiation and particles (solar variability) occur over periods as short as one second, the time required for shock formation, and as long as the eleven-year sunspot cycle, the twenty-two-year magnetic polarity cycle, and the ongoing longer-term decrease in total radiation output that is based in the internal nuclear machinery of the sun itself. Many efforts have been made to connect various changes in the sun to climate changes on Earth, and it is clear that there are many physical connections between the upper atmosphere and solar output. Since even a small change in solar radiation could have a significant impact—according to some estimates, a 1 percent change in solar output could have as great an effect on net radiation as doubling the concentration of carbon dioxide in the atmosphere—in monitoring global change we must measure the changing solar energy that arrives at Earth to a very high degree of accuracy. And since as much as 40 percent of the sun's radiation is either absorbed by the atmosphere or reflected back into space by clouds, and the amount of reflection varies greatly with time, these measurements must be made from space rather than from the Earth's surface.

Although direct measurement of the sun's radiation is recent, it is already clear that solar radiation is variable. The eleven-year sunspot cycle and other longer-term variations have been confirmed by historical records. The rate of carbon-14 production, for example, which is

related to changing conditions in the extended solar wind of particles and radiation from the sun, can be studied using dated tree rings.

Solar output has been measured from rockets, satellites, and the U.S. Space Shuttle. Sounding rocket measurements began in 1976. In the same year, as part of the Earth Radiation Budget Experiment, the Nimbus series of satellites also began making measurements. The Solar Maximum Mission, launched in 1980, provided baseline measurements near the peak of the most recent eleven-year solar cycle. The data from this mission and from Nimbus-7 are consistent with the solar activity cycle (Willson and Hudson, 1988). Since solar output and climate change are linked, it will be necessary to continue gathering such measurements for as long as possible. A Solar-Terrestrial Energy Program (STEP) has been proposed for the first half of the 1990s to provide the initial coordination (Scientific Committee on Solar-Terrestrial Physics, 1988).

▪ THE ATMOSPHERE AND ITS CONSTITUENTS

Radiation from the sun interacts directly with gases in the atmosphere, with clouds, and with the Earth's surface. Clouds are particularly important because they reflect a large part of the incoming solar radiation. On the average, about 70 percent of the radiation incident on Earth is absorbed and about 30 percent is reflected. Accurate satellite measurements have shown that clouds account for about one-half of this reflection; without clouds, the absorbed amount would rise to about 85 percent (Ramanathan et al., 1989). Clouds also trap the radiation emitted from the Earth. Because it is net radiation that affects climate, to understand climate change we need to know the balance between these two large and competing effects, reflection and trapping. Model studies have found that changing cloud cover can have a much greater effect on climate than observed trends in solar radiation or changing amounts of atmospheric carbon dioxide. A change in cloud cover of just a few percentage points could have the same effect on the atmosphere as the doubling of carbon dioxide levels.

Clouds can be detected by the amount of light they reflect and the amount of radiation they emit. In order to monitor global changes in clouds, the International Satellite Cloud Climatology Program of the World Climate Research Program is archiving the information on

clouds that is being collected from operational geostationary and polar-orbiting meteorological satellites (Schiffer, 1989). It is also possible to determine cloud height by using temperature and sounding data; maps of global cloud cover and altitude are now regularly produced.

The Earth Radiation Budget Experiment (ERBE) currently in progress builds on an earlier program that was based on Nimbus-7 measurements. It was started in 1984 to provide long-term observations of the total amount of heat and light emitted from the sun, reflected solar radiation, and radiation emitted from the Earth and it component parts. These data are a key aspect of climate studies.

The ERBE program combines observations from NASA's Earth Radiation Budget Satellite (ERBS) with measurements from the operational NOAA-9 and NOAA-10 satellites. The ERBS is in a low (56 degrees) inclination non-sun-synchronous orbit, while the NOAA satellites are in sun-synchronous polar orbits with high (near-polar) inclination. This multisatellite configuration provides good coverage of the Earth. The ERBS satellite also carries a seven-channel radiometer covering the visible and infrared spectrum to monitor stratospheric aerosols, ozone, nitrates, and water vapor. The ERBE observing period is projected to extend at least through 1990. Recent analysis of ERBE data (Ramanathan et al., 1989) shows that, at least during 1985 and averaged over the globe, the cooling effect of clouds exceeded the warming effect of trapped radiation. The net cooling measured was about four times as large as the expected warming from a doubling of the atmospheric concentration of carbon dioxide. Thus, even small changes in the average amount of cloudiness could have a major impact on climate.

Large volumes of dust and sulfur compounds injected into the stratosphere from volcanic eruptions play a role similar to clouds in the lower troposphere. These particles have a net cooling effect on the Earth's radiation balance that can temporarily obscure other climatic effects, such as warming produced by trace gases. Major volcanic eruptions can be associated with climate fluctuations. Perhaps the best historical example is the eruption of Mount Tambora in Indonesia in the spring of 1815 (Stommel and Stommel, 1983), which sent enormous quantities of dust into the upper atmosphere, obscuring sunlight more extensively than any other volcano since 1600. This dust cloud circled the Earth for several years and appears to have been responsible for the famous "year without a summer" in 1816. Recent model calcula-

tions suggest that the Mount Tambora eruption could have lowered temperatures worldwide by as much as 1 degree Celsius during that year.

More recent examples of large eruptions include Mount Saint Helens in Washington state in 1980 and El Chichón in Mexico in 1982, whose volcanic dust and acid droplets reduced the amount of sunlight reaching the Earth by 5 percent in areas under the dust clouds. Satellite measurements have proved very valuable in monitoring the effects of these eruptions. The amount of light absorption in the stratosphere was measured globally during 1980 by the Stratospheric Aerosol and Gas Experiment (SAGE). Information was collected on the global extent of the effects of the Mount Saint Helens eruption and the gradual movement of the ejected material toward the southern hemisphere. The SAGE measurements continue on the Earth Radiation Budget Experiment satellites.

Human-induced increases in some trace gases, such as the chlorofluorocarbons (CFCs) used in refrigeration, have been implicated in the sudden and large springtime decrease in ozone over the Antarctic, and in a lesser but significant decrease in ozone over the rest of the world during the entire year. Ozone, a three-atom molecule of oxygen, constitutes less than one part per million of the gases in the atmosphere, yet it absorbs most of the ultraviolet rays from the sun, preventing them from reaching the Earth. Solar radiation can cause skin cancer, cataracts, and immune deficiencies and can harm crops and aquatic ecosystems (Stolarski, 1988; Stolarski et al., 1986). If the ozone level in the stratosphere decreases, the ultraviolet radiation at the surface will increase.

Although the Nimbus-7 satellite carried an instrument for monitoring ozone, it was a ground-based measurement in the Antarctic by the British Antarctic Survey that first detected the springtime lowering of ozone, beginning in about 1976 (Farman et al., 1985). Farman and his colleagues found that the ozone had decreased by more than 40 percent between 1977 and 1984. (Ironically as it turns out, the Nimbus-7 satellite instrument had been preprogrammed to reject as errors the very low levels of ozone being observed by the ground-based station.) Since 1984, NASA scientists have found that Nimbus-7 measurements confirm ground-based measurements and that the extent of the ozone hole is much larger than previously suspected. Recent satellite and aircraft studies in the Arctic have confirmed that the same chemistry responsi-

ble for ozone changes in the Antarctic also occurs in the northern polar regions (Kerr, 1989).

To predict weather and climate change, it is necessary to know the distribution of temperature and water vapor in the atmosphere. The Television and Infrared Observation Satellite (TIROS) and similar early weather satellites provided only pictures of clouds. In the almost thirty years since, weather-sensing systems have shown a continuous record of improvement. Today, the operational weather satellites that provide regular data for weather forecasting and severe storm warnings include both polar-orbiting and geostationary satellites. Each polar-orbiting satellite views the whole globe twice a day, while each geostationary satellite repeatedly observes the full disk of Earth throughout the day. Satellite observations measure conditions at the surface, in the intervening atmosphere, and in space around the spacecraft. The observations are made with high-precision sensors operating in many spectral intervals (Yates, Cotter, and Ohring, 1985). (For a review of the operations of meteorological satellites, see Smith et al., 1986; McElroy, 1985; Rao et al., 1989.)

The U.S. polar-orbiting satellite system consists of two Advanced TIROS-N spacecraft flying in sun-synchronous orbit at an altitude of 850 kilometers, which cross the equator at 0730 and 1400 local time. Their primary instruments are a radiometer and a sounder. The Advanced Very High Resolution Radiometer (AVHRR) is a five-channel scanning radiometer that produces images in the visible, near-infrared, and infrared spectral bands. The TIROS Operational Vertical Sounder (TOVS) produces profiles of temperature and water vapor for both the lower and upper atmosphere using suitable infrared and microwave spectral bands. In addition to the sounder and radiometer, the Advanced TIROS-N satellites also carry instruments for measuring solar irradiance, ozone profiles, and Earth radiation. A space environment monitor provides data on solar emissions of protons, electrons, and alpha particles.

The spacecraft also have sensing systems for search and rescue that can locate ships and aircraft in distress. The latter service is provided in cooperation with the Soviet, French, and Canadian governments. An ARGOS data collection and location system is carried as part of a project jointly supported by the United States and France.

A second U.S. polar-orbiting operational environmental satellite program, the Defense Meteorological Satellite Program (DMSP), is

operated for the Department of Defense (DOD) by the U.S. Air Force. A detailed comparison of the two programs, one designed for civil, the other for defense purposes, is provided in one of the series of Envirosat-2000 reports that cover the full range of U.S. meteorological satellite activities (Heacock, 1985). The mission of the DMSP program is to provide global visible and infrared cloud data and any other specialized meteorological, oceanographic, and solar data that are required to support the worldwide operations of the Department of Defense. The DMSP program requires imagery for use in tactical operations, while the NOAA polar-orbiters gather vertical temperature and moisture profiles for incorporation into the world's twice-daily synoptic forecast models. Data are supplied to both the Air Force and the Navy.

The instruments carried aboard the current series of DMSP satellites operate in the visible, infrared, and microwave parts of the spectrum. The Operational Line Scanner (OLS) provides data on global cloud cover and temperature and on the aurora. It observes three channels or bands in the visible and infrared compared to the five channels of the AVHRR on the NOAA satellites but with higher spatial resolution. Moreover, the OLS is the only operational imager with constant spatial resolution across the entire 3,000-kilometer swath width. This allows fast computer processing for strategic applications. The OLS also operates at very low light levels for nighttime and aurora measurements.

DMSP satellites also carry microwave instruments for measuring temperature profiles in the atmosphere, precipitation, soil moisture, wind speed over the ocean, sea ice, and clouds and liquid water in the atmosphere. A space environment sensor suite includes instruments for measuring electrons and protons, space plasmas, and magnetic field fluctuations. X-ray and gamma-ray detectors are also included. Figure 16 shows both the NOAA Polar-orbiting Operational Environmental Satellite and the Defense Meteorological Satellites with their instruments.

China launched its first polar-orbiting meteorological satellite, Wind-Cloud-1 (FY-1), in September 1988 (Cheng, 1988). Its major payload is a scanning radiometer with five observation bands in the visible and infrared. The satellite, a technical demonstration project with a design life of one year, has an orbit altitude of 900 kilometers, with an inclination of 99 degrees and a period of 103 minutes. A ground-based receiv-

ing system for cloud images consists of ground stations at Beijing, Guangzhou, and Urumchi, and a data processing center in Beijing. The system is also capable of receiving data from U.S. NOAA weather satellites.

The USSR has developed its own operational polar-orbiting meteorological satellites (for the most recent review of the Soviet space program, see Johnson, 1988). Since 1969, two to three Meteor satellites have been in orbit, sending information to receiving stations in Moscow, Novosibirsk, and Khabarovsk. Meteor-2 provides information on cloudiness and ice and snow cover over the Earth in visible and infrared spectral bands, temperature fields and cloudtop heights, water surface temperatures, and radiation. At the end of 1987, three Meteor polar-orbiters were operational. Eventually, a Meteor-3 is expected to replace the Meteor-2 constellation. It will consist of three satellites in orbital planes 120 degrees apart (Johnson, 1988).

Today, five geostationary satellites orbit the Earth, two operated by the United States, one by the European Space Agency, one by Japan, and one by India. The current U.S. system consists of two Geostationary Operational Environmental Satellites (GOES). As of February 1989, only one of these is working because of the failure of an internal lamp, and a replacement is not scheduled until 1991. In the meantime, the one functioning satellite is moved back and forth over the Pacific and Atlantic oceans during the year to provide the best coverage of storms and weather patterns. In addition, the European Space Agency is planning to move a spare Meteosat over the Atlantic to help fill the gap. The GOES system provides operational weather data, including cloud cover, temperature and water vapor profiles, real-time storm monitoring, severe storm warnings, and sea surface temperature measurements. The complement of instruments includes a visible and infrared imager, an infrared sounder, a space environment monitor, a data collection system, and a system for receiving and transmitting search and rescue signals (Schwalb, Cotter, and Hussey, 1985).

Figure 17 shows a schematic representation of the U.S. GOES satellite. Since geostationary satellites are much farther from the Earth than polar-orbiting satellites, the pointing accuracy of the instruments must be much greater. As a result, platform stability is a paramount requirement. To achieve this stability, most of the current geostationary satellites have a cylindrical shape and spin about an axis that is perpendicu-

POES

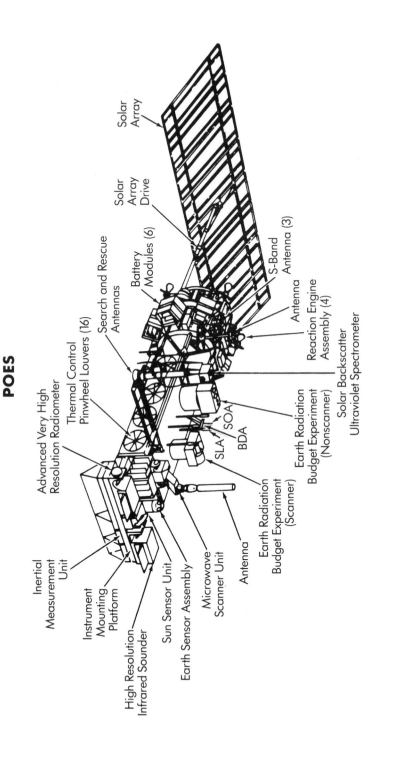

Inertial Measurement Unit

Advanced Very High Resolution Radiometer

Thermal Control Pinwheel Louvers (16)

Search and Rescue Antennas

Solar Array Drive

Battery Modules (6)

Solar Array

Instrument Mounting Platform

S-Band Antenna (3)

High Resolution Infrared Sounder

Sun Sensor Unit

Earth Sensor Assembly

Microwave Scanner Unit

Antenna

Earth Radiation Budget Experiment (Scanner)

SLA

SOA

BDA

Antenna

Reaction Engine Assembly (4)

Earth Radiation Budget Experiment (Nonscanner)

Solar Backscatter Ultraviolet Spectrometer

DMSP

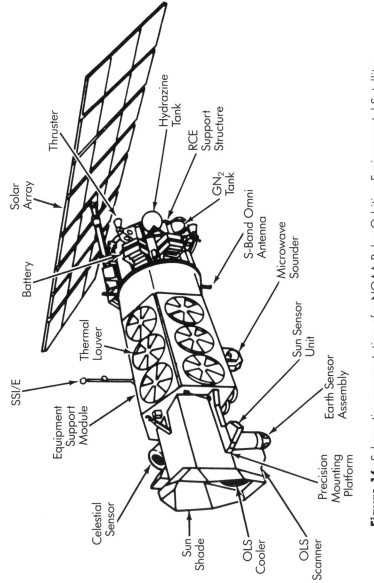

Figure 16. Schematic representation of a NOAA Polar-Orbiting Environmental Satellite (POES) and a U.S. Defense Meteorological Satellite Program (DMSP) polar-orbiting satellite. For scale, note that the longest dimension of the NOAA POES is somewhat over 7 meters.

Figure 17. Schematic representation of the U.S. NOAA Geostationary Satellite (GOES), showing the instruments, antennas, and solar panels around the outside. For scale, note that the height of the satellite is 4.4 meters and its diameter is 2.1 meters.

lar to the orbit plane. The spinning arrangement also requires less fuel to keep the satellite pointing in one direction. The outer surface of the satellite is covered with solar cells.

The spin of the satellite can be used to help the instruments provide images of the disk of Earth in view. This is the principle behind the "spin-scan" camera invented by Dr. Verner Suomi of the University of Wisconsin, which has been a primary reason for the success of the geostationary satellites for weather observations. The satellite spins at a rate of about a hundred revolutions per minute. With each swath of the satellite's turning (in the east-west direction), the camera is tilted down (in the north-south direction) one step out of twenty-four hundred, so that the whole disk of the Earth in view can be scanned and photographed in twenty-four hundred revolutions, or about twenty-four minutes.

Since the Earth is only a small part of the view of the satellite as it rotates, the instruments point to space much of the time. To compensate, the antennas are spun electronically in the opposite direction, so that they always point toward Earth. The newer geostationary satellites do not spin but are stabilized in a three-axis configuration, so that the telescopes can always point toward Earth, thus providing a stronger signal. This is the configuration used by the current Indian geostationary satellite (see Chapter 4). A rotating "reaction wheel" inside these newer satellites provides directional stability. Such reaction wheels are also used for stability in polar-orbiting satellites.

Because geostationary satellite instruments can obtain full images in a period of twenty minutes, meteorologists can view pictures in sequence and create the time sequences of weather developments that are seen in television broadcasts. These films are available to weather forecasters and have made possible a radical improvement in the prediction of regional and local weather (Smith et al., 1986). Figures 18 and 19 show pictures from the two U.S. GOES satellites.

The European Space Agency (ESA) geostationary satellite program became fully operational in 1988. Organized in 1975, ESA currently has thirteen member states: Austria, Belgium, Denmark, France, the Federal Republic of Germany, Ireland, Italy, the Netherlands, Norway, Spain, Sweden, Switzerland, and the United Kingdom. The primary activity of ESA's Earth Observations Program has been the development of an operational meteorological capability, which is now

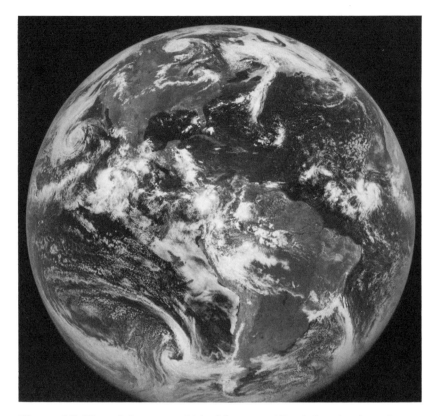

Figure 18. View of the eastern United States and South America from the easternmost U.S. Geostationary Operational Environmental Satellite taken on July 31, 1980.

operated by the European Meteorological Satellite Organization (Eumetsat), established in 1983. The current geostationary satellite, MOP-1, the first in a series in the Meteosat Operational Program (MOP), was launched in 1988 and provides operational weather data, cloud cover, radiation, and temperature measurements, and a data collection system for buoys, balloons, and other platforms. It is in orbit above the Greenwich meridian (Morgan, 1981). The major instrument carried on MOP-1 is a three-channel visible and infrared radiometer with a ground resolution at nadir of 2.5 kilometers and 5.0 kilometers, respectively. Figure 20 shows a picture from the European geostationary satellite.

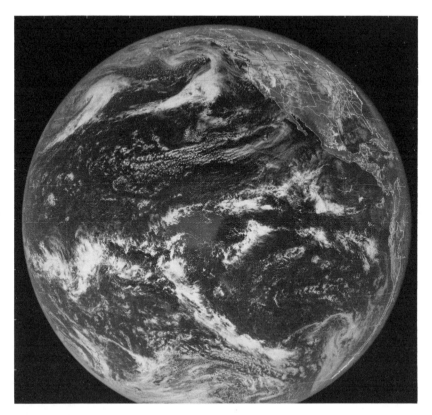

Figure 19. View of the Pacific Ocean and western United States from the westernmost U.S. Geostationary Operational Environmental Satellite taken on March 15, 1984.

Japan launched its first Geostationary Meteorological Satellite, the U.S.-built GMS-1, in 1977 (Research Coordination Bureau, 1988). The fourth in the series, which is now being built in Japan, was launched in 1989. Its orbit places it directly over Japan at 140 degrees east longitude. Satellite programs in Japan are under the aegis of the National Space Development Agency of Japan (NASDA), which is part of the Science and Technology Agency. The plans for NASDA are formulated by the Space Activities Commission, which reports directly to the prime minister's office. Remote sensing is an important element in the Japanese space program. Japanese meteorological measurements have focused on the Pacific Ocean, an area where other kinds of mea-

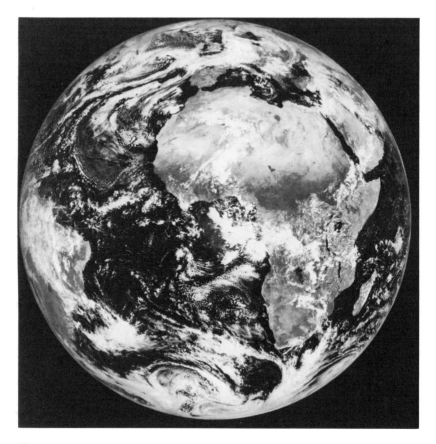

Figure 20. View from the Greenwich meridian recorded by the instruments aboard the European geostationary meteorological satellite Meteosat on March 15, 1989.

surements are sparse. Images of clouds and temperature data are used for daily weather forecasts and typhoon warnings. The weather data are also fed into the World Meteorological Organization's Global Tele-communications System to improve weather forecasts in eighteen countries in the Asian and west Pacific region as well as globally. Figure 21 shows a picture from the Japanese geostationary satellite.

The fifth geostationary satellite in the series is operated by India, which serves as a case study of how a developing country can exploit advanced technology to meet fundamental needs. The first generation

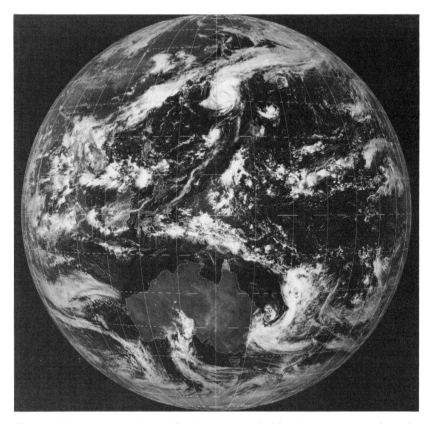

Figure 21. View over the Pacific Ocean recorded by the instruments aboard the Japanese meteorological satellite GMS-3 on September 15, 1988.

Indian National Satellite System (INSAT-1b) represents India's first step toward implementing operational space systems for identified national requirements (Government of India, 1988). INSAT-1b is a multiagency, multipurpose operational satellite system for meteorological observation and data relay, direct satellite television broadcasting, and domestic telecommunications. Since the first launch in 1983, the system has operated successfully.

INSAT-1b is a U.S.-built geostationary satellite located above 74 degrees east longitude. Its field of view thus includes the Indian subcontinent and the Indian Ocean. The satellite instruments provide information on day and night cloud cover, Earth and cloud radiance, and

temperature measurements. It has a Very High Resolution Radiometer operating in two channels in the visible and the infrared with resolutions of 2.75 and 11 kilometers, respectively. The VHRR image-derived winds are regularly put on the Global Telecommunications System, but the rest of the data have been available to India and neighboring countries only. INSAT-1b satellites are built by the Ford Aerospace Corporation under contract with the Indian Department of Space, and they have been launched by both United States and European Space Agency rockets. In the early 1990s these spacecraft will gradually be replaced by indigenously developed second-generation spacecraft, which will eventually be launched from India. Figure 22 shows a picture from the Indian geostationary satellite.

Although the USSR has launched many geostationary satellites for various purposes, notably communications and navigation, to date it has not launched a geostationary meteorological satellite. This apparent lack of urgency appears to be the result of the inability of satellite instruments in such an equatorial orbit to monitor either the Earth at high latitudes or the polar regions that directly affect much of Soviet territory. (It is obvious from Figure 22 that a satellite in geostationary orbit does not provide good coverage of the USSR.) The Soviets recognize the importance of such measurements for global weather and climate prediction, however, and have filed for telecommunications transmission and receiver frequencies in the geostationary belt. They are expected to launch such a satellite network in the next few years.

▪ THE OCEANS

The idea that the oceans could be observed from space was first proposed and developed in the mid-1960s (Ewing, 1965; Gower, 1981). Today, sea surface temperature, ocean currents, surface winds, wave heights and distribution, surface topography, and ocean color for sediment and plankton concentration can all be measured from space. (For a review of the subject, see Fu, Liu, and Abbott, 1989; Allan, 1983; Stewart, 1985; Robinson, 1985; and Maul, 1985.)

To a large extent, today's satellite measurements of the ocean derive from NASA's 1978 Seasat mission (Born, Dunne, and Lame, 1979; Bernstein, 1982; Stewart, 1985), and from NASA's Nimbus-7 mission, also launched in 1978 and as of 1989, still operating with some of its

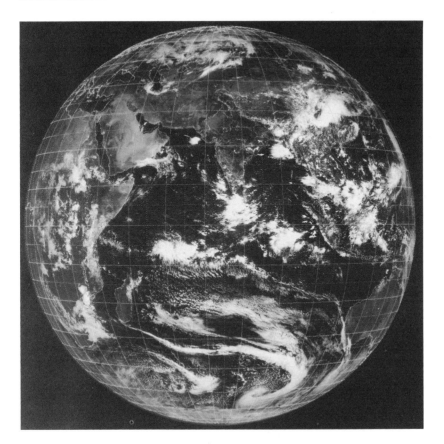

Figure 22. View over the Indian Ocean recorded by the instruments aboard the Indian geostationary meteorological satellite INSAT-1b on September 13, 1988.

instruments (Fleig and Cicerone, 1984). Seasat was designed to demonstrate the feasibility of new radar techniques for global monitoring of oceanographic phenomena. Unfortunately, the satellite failed just three months into the mission because of a short in the electrical power subsystem, but despite its early demise, all the instruments worked, providing a suite of data that is still being evaluated. Seasat carried an altimeter, a scatterometer, a scanning multichannel microwave radiometer, a synthetic aperture radar, and a visible and infrared radiometer.

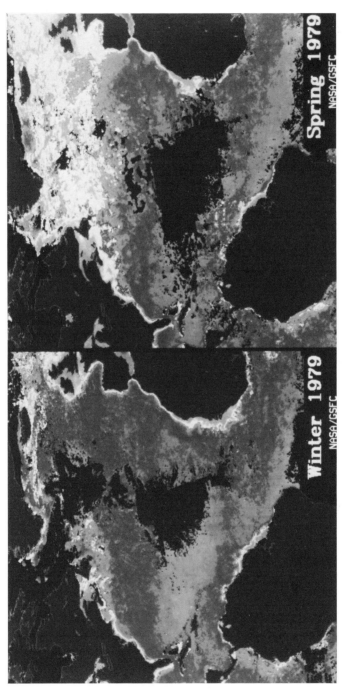

Figure 23. Seasonal changes in plankton growth as measured by the Coastal Zone Color Scanner on NASA's Nimbus-7 satellite. Note the strong "bloom" in the spring. Produced at Goddard Space Flight Center.

The instruments carried by the Seasat mission demonstrated that properties such as ocean surface temperature, wind, and currents could be measured to useful accuracy and then mapped globally on an all-weather basis with microwave instrumentation. At the same time, the rapid flow of information from the satellite emphasized the need for an "end-to-end" data system that would handle the data all the way from the satellite instruments to the final user community.

Nimbus-7 carried the first sensor for measuring ocean color, the Coastal Zone Color Scanner (CZCS) (Gordon et al., 1980), which was designed to establish the feasibility of determining chlorophyll concentrations from space. But it did much more. The sensor operated successfully until the summer of 1986, providing a long-term global dataset that has barely been exploited. Using in situ measurements, scientists have been able to develop a mathematical relationship between pigments and plankton chlorophyll, and validation experiments are continuing to extend the accuracy and utility of the relationship. CZCS data have also been found to be useful in defining ocean fronts, current patterns, and coastal sediment transport.

The global ocean color data shown in Plate II were derived from processing of CZCS data on the larger scale, providing a new dimension in the description and understanding of biological processes in the ocean (Esaias et al., 1986). Figure 23 shows the "spring bloom" of the plankton in the Atlantic Ocean as measured by the CZCS. Data like these are especially important in designing new scientific programs to study the role of the biogeochemical cycles of those elements that are important to life on Earth. One such program is the Joint Global Ocean Flux Study, which has carried out field studies of the spring bloom.

CZCS imagery has also been used around the world for studies of relatively small-scale features. These are of great interest to biological and chemical oceanographers and yet are most difficult to map from research vessels, since they tend to change rapidly. Larger features, such as plumes and eddies, can also be seen. CZCS and AVHRR imagery provided the first synoptic view of Gulf Stream eddies and showed how they are formed, how long they last, and where they go during their lifetime (Brown and Evans, 1982; Brown et al., 1985).

Several kinds of satellites currently make ocean measurements, and many more are in the planning stages (see Chapter 4). NOAA's operational weather satellites provide regular ocean measurements, primarily of sea surface temperature (Yates et al., 1986), which are available

in real time and are compiled weekly on a 50- to 100-kilometer grid with an accuracy of close to 1 degree Celsius. The main source of uncertainty in the data is the effect of water vapor in the atmosphere, but the multiple infrared channels on the new AVHRR have allowed significant improvements (Bernstein and Chelton, 1985). Other uncertainties can be introduced by volcanic eruptions: the dust veil from the April 1982 eruption of El Chichón in Mexico had a temporary but very marked effect on the ability of NOAA satellites to monitor sea surface temperatures.

The Navy first identified a need for geodesy data in the early 1960s, when submarine commanders realized that more accurate navigation would improve performance. The later development of cruise missiles intensified the need for better gravity field information. It became clear that a combination of ship and satellite altimeter surveys could provide the necessary improvements in the database. Previous missions, such as Seasat, had shown that the altimeter is a versatile and powerful tool for remote sensing of the ocean. After the loss of Seasat in 1978, the U.S. Navy conceived the Geodesy Satellite (GEOSAT) mission (Johns Hopkins APL Technical Digest, 1987) to determine the Earth's gravity field and to detect mesoscale ocean fronts and eddies, surface ocean currents, surface wind speed, significant wave height, and the edge of the sea ice. The altimeter flying on GEOSAT is an improved version of the one that flew on Seasat.

The GEOSAT satellite was launched in March 1985 into an 800-kilometer altitude, 108-degree inclination orbit, which slowly precessed to provide global coverage with a track spacing of 4 kilometers. The initial eighteen-month mission was aimed at collecting a closely spaced, precise measurement of the ocean surface topography and hence, the Earth's geoid over the ocean, for military use, and the resulting data were classified. In October 1986 the spacecraft was maneuvered into a seventeen-day exact repeat orbit (similar to the Seasat orbit) that had been optimized for collecting oceanographic data. In this orbit, the equatorial ground-track separation is 164 kilometers, and at higher latitudes, for example over the Gulf Stream, the orbit separation is 110 kilometers. The exact repeat orbit allows calculation of changes in surface topography between successive measurements. In this way, changes in the ocean can be observed directly.

A potentially important use of the GEOSAT altimeter data is for monitoring sea level in the Pacific Ocean to detect equatorial waves

that tend to precede the onset of the El Niño effect. Cheney et al. (1987) have shown that the data from GEOSAT compare favorably with island tide gauge data in the equatorial Pacific. The El Niño late in 1986, although not strong, was the first such event observed by a satellite altimeter.

These results not only verify the accuracy of the altimetric measurements, they also pave the way for systematic mapping of sea level change for the entire tropical Pacific. The satellite data are particularly valuable because they supply information from areas where there are no islands with sea level stations. They are providing a basinwide coverage and resolution not achievable before and represent an important new way of observing the ocean. Figure 24 shows global maps of sea surface variability from GEOSAT and Seasat. GEOSAT operated successfully through the end of 1989, when the tape recorder began to fail. The U.S. Navy plans to replace it with a second such altimeter satellite for 1990 whose orbit will be 180 degrees out of phase with GEOSAT. In the future, the data from this set of altimeter satellites will be valuable both in direct mapping of ocean processes and in helping the oceanographic community to improve its use and understanding of the data from later altimeter missions such as ERS-1 and TOPEX/POSEIDON (see Chapter 4).

Complementing the ocean measurements from operational weather satellites and GEOSAT are those from Japan's first Earth observation spacecraft, the Marine Observation Satellite-1 (MOS-1) (National Space Development Agency of Japan, 1982). MOS-1 is an experimental mission intended to serve as the forerunner of an operational program that will begin in the 1990s. Five missions are planned, the first two of which, MOS-1 and MOS-1b, have already been approved. The overall emphasis of the program is on ocean observation and the development of basic technology for global Earth observation.

MOS-1 was launched in February 1987 into a polar orbit of altitude 909 kilometers and inclination 99.1 degrees. Its equatorial crossing time (descending node) is nominally 1030. The repeat cycle is seventeen days. It has three sensors: a four-channel visible and thermal infrared radiometer (VTIR) for land and ocean color measurements; a four-channel (two visible, two near-infrared) multispectral electronic self-scanning radiometer (MESSR) for information on clouds and sea surface temperature; and a microwave scanning radiometer (MSR) for information on sea ice, snowfall, and water vapor content at the ocean

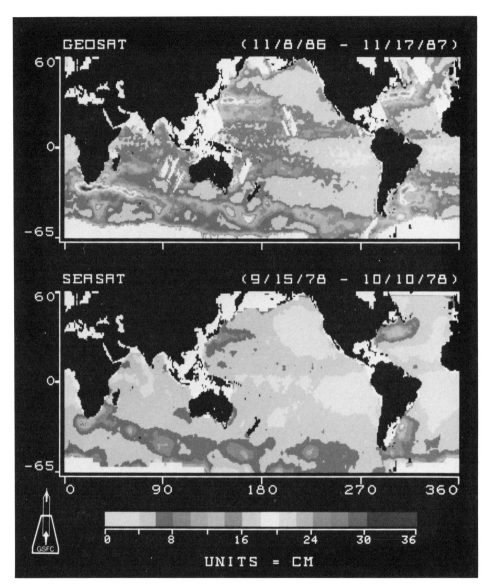

Figure 24. Global measurements of the variability of the sea surface as measured by the U.S. Navy's GEOSAT and NASA's Seasat satellite altimeters. Note the strong variability in the region of the Gulf Stream off the United States and the Kuroshio off Japan.

surface and in the atmosphere. MOS-1, which has a design lifetime of about two years, will be followed in early 1990 by MOS-1b. Subsequent missions will provide data simultaneously with the proposed Japanese Earth Resources Satellite, JERS-1 (see Chapter 4). MOS-1 data are of interest globally but require local receiving stations outside the tracking area of the Japanese Earth Observation Center receiving station, since there are no tape recorders aboard.

The European Space Agency sees the data from MOS-1 as a way to broaden its space-derived ocean and land database and to provide continuity in data from Nimbus-7 (ESA, 1987). Although the MOS-1 data are not of the same quality as the Landsat data, their availability from early 1988 onward will help to fill any gaps in Landsat coverage and to ensure continuity for ongoing research and application projects. The use of simultaneously acquired VTIR data will also permit monitoring applications over large areas, especially in western Africa and the western Mediterranean, for studies of desertification and oceanographic applications. A "Memorandum of Understanding" has been signed between the European Space Agency and the National Space Development Agency of Japan defining the terms and conditions of European access to MOS-1 data.

The USSR has also launched a series of oceanographic satellites, the KOSMOS series. Their first side-looking radar instrument began operation in 1983 (Johnson, 1988). The radar operates at a wavelength of 3 centimeters with a resolution of 1.5 to 2 kilometers. This satellite also carries a low-resolution visible scanner and a microwave radiometer. KOSMOS-1766 currently operates with a side-looking radar that monitors the polar ice packs for ship routing in these regions. A new information system receives and processes data from oceanographic satellites at a center near Moscow and then transmits ice forecasts directly to ships at sea via the EKRAN geostationary communications satellites.

■ THE LAND SURFACE

The longest series of satellite measurements of the land surface began in 1972 with the U.S. Earth Resources Technology Satellite (ERTS), which was renamed Landsat-1 (Earth Observation Satellite Company, 1987). The whole system or set of satellites became operational after

the launch of Landsat-4 in 1982. Landsat-4 and Landsat-5 are still in operation, and Landsat-6 is being built for launch in 1991. The Landsat system consists of a series of sun-synchronous, polar-orbiting satellites at an altitude of 705 kilometers and with an (approximately) sixteen-day repeat cycle. The data collected are used in land use inventory, geological and mineralogical exploration, crop and forestry assessment, and cartography.

The complement of instruments carried by Landsat-4 and Landsat-5 includes a Multispectral Scanner (MSS) with four channels in the visible and near-infrared, and a higher resolution instrument, the Thematic Mapper (TM), with seven channels, including the thermal infrared. Figure 25 shows Landsat-4 with its instruments. The spatial resolutions of the MSS and TM are 80 meters and 30 meters, respectively. The orbit configuration ensures that illumination conditions are approximately similar on adjacent tracks, which are seen one day apart. The swath width is 185 kilometers, and each swath is divided up

Figure 25. Schematic representation of the Landsat satellite with its instruments, antennas, and solar array panel.

into 185-kilometer segments, called scenes. Currently under discussion for possible inclusion on Landsat-6 is an enhanced Thematic Mapper with twelve channels and a resolution of 15 meters in the visible part of the spectrum.

Some Landsat data are broadcast directly to receiving stations below the satellite; other data are stored in recorders on board the satellite for later broadcast to stations around the world. As of 1989, Landsat data were being captured and distributed from thirteen such stations, each of which is responsible for generating and distributing a range of image products, often including both photographs and computer-compatible tapes. The gradual buildup of a worldwide network of receiving stations offers several advantages: a large proportion of the Earth's surface can now be observed in real time and images of the surface can be obtained during all seasons of the year.

In 1986, France launched its new Satellite Pour l'Observation de la Terre (SPOT), the first in a series of land-sensing satellites that complement the Landsat instrumentation (Courtois and Weill, 1985). Although Landsat has more spectral bands, and they extend farther into the infrared, SPOT has superior spatial resolution (McElroy, 1987). The satellite (see Figure 26) is in a sun-synchronous orbit, with an equator

Figure 26. Schematic drawing of the French SPOT satellite.

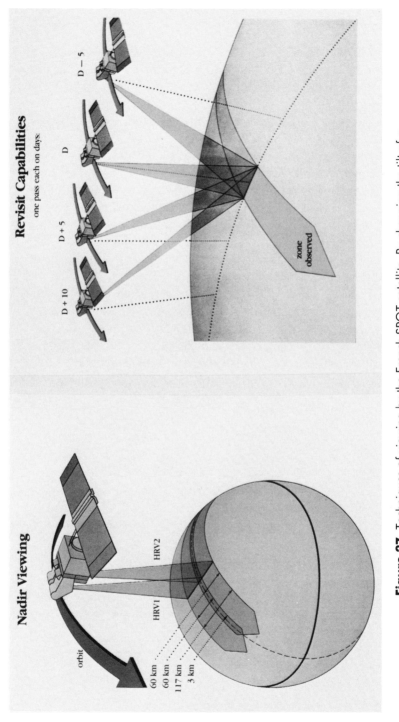

Figure 27. Techniques of viewing by the French SPOT satellite. By changing the tilt of a mirror, the satellite can revisit a given area.

crossing time of about 1030. The pattern repeats every twenty-six days (Cervelle, 1989).

A special feature of SPOT is its off-nadir viewing capability. The instrument mirrors can be pointed 27 degrees from the vertical to the east or west of the (approximately) north-south satellite direction to look at different sides of the track. SPOT can thus revisit an area at least twice a week, depending on latitude. Figure 27 shows how this works. For example, over the twenty-six-day period separating two successive passes over a given point, SPOT can observe the point seven times if it is at the equator and eleven times at 45 degrees latitude. The off-nadir viewing capability greatly increases data collection flexibility, especially by finding those times when cloud cover is at a minimum. Off-nadir viewing also allows SPOT to produce stereoscopic pairs of images by recording the same area during different passes at different angles. The resulting three-dimensional image is valuable for mapping and interpreting images.

SPOT's two high-resolution instruments, with three spectral bands in the visible, record color images with a resolution of 20 meters and black-and-white images with a resolution of 10 meters. The swath width of each instrument is 60 meters, with a total of 117 kilometers. The data are collected by several ground stations around the world and either distributed from these stations or sent to SPOT Image in France or SPOT Image Corporation in the United States, which distribute various data products. Full scenes are 60 by 60 kilometers and are available as photographs or as computer-compatible tapes.

The USSR currently performs land remote sensing from both short-term photographic reconnaissance satellites and from the Soviet Space Station MIR (Johnson, 1988). But the Soviets also have a class of long-lived remote-sensing satellites in the KOSMOS series, which began by gathering photographic data that was returned in capsules but now produces data in a digital format like that of the U.S. Landsat program. The satellite Meteor 1-30, in orbit since June 1980, returns data in a digital format in a variety of visible and near-infrared spectral bands with a resolution varying from 30 to 1,000 meters. A new satellite, KOSMOS-1869, was launched in 1987 and carries a television system, microwave instrumentation, and other instruments. KOSMOS-1870 was also launched in 1987 in a high inclination orbit, apparently to provide greater ocean coverage and to extend remote-sensing opportunities into the far northern Soviet territories. The Soviets reported that

Figure 28. Schematic representation of the USSR Meteor-Piroda satellite launched in 1980. These satellites provide photography comparable in resolution to the U.S. Landsat satellites (Johnson, 1987).

the on-board radar installation was "intended for the remote sensing of the earth and the world ocean regardless of weather conditions and the time of the day or night" (Johnson, 1988). Figure 28 is a schematic representation of a Soviet Meteor-Piroda satellite, believed to resemble the KOSMOS series.

The data provided by these land-sensing satellites are available by purchase only, and these costs can impede their use by scientific researchers and by developing countries (see Chapter 6).

■ THE CRYOSPHERE

Water in its frozen form—sea ice, snow cover, and ice sheets—plays a special role in the Earth's climate system. Sea ice in the polar regions and snow cover at all latitudes show large seasonal and interannual changes in extent. The resulting variability in reflected solar radiation affects the overall radiation balance of the Earth and hence the climate. The major ice sheets, located over Greenland and the Antarctic, contain most of the world's fresh water. Changes in the volume of these ice sheets through melting and creation of icebergs or changes in snow

accumulation could affect both sea level and climate. Core samples taken from these ice sheets provide a historical record of past climate and atmospheric composition. Since greenhouse warming is predicted to be higher in polar regions, changes in the cryosphere could be an early warning of such effects.

The cryosphere is thus a vital element in the climate system. Early in situ studies in the remote and hostile polar regions by individual explorers and scientists gave an initial but incomplete view of cryospheric processes at work. It quickly became evident that larger-scale programs would be required. A major international cooperative scientific program, the first International Polar Year (IPY) was conducted in 1882–83 and the second IPY fifty years later, in 1932–33. Because of rapid advances in technology, a third was organized in 1957–58 to address global geophysics and renamed the International Geophysical Year (IGY) to reflect its broader focus (Chapman, 1959). An important aspect in planning the IGY was the possible use of satellites for measurements in remote polar regions. The satellites launched in the late 1950s and early 1960s focused primarily on the upper atmosphere, but today satellites are being used routinely to monitor the cryosphere at all latitudes, both for operations in ice-infested regions (Zwally et al., 1983; Parkinson et al., 1987) and for studying the role of the cryosphere in climate (Untersteiner, 1989). Figure 29 shows variations in arctic sea ice from winter to summer as measured by the microwave imager on the Nimbus-5 satellite. Figure 30 shows the topography of the Greenland ice sheet as measured by the Seasat altimeter. If this topography could be monitored regularly, with adequate precision, we could determine whether in fact the ice sheet is growing or melting. Changes in the ice sheet are directly related to the amount of water in the ocean, and thus would provide clues about whether global sea level was rising or falling. Snow cover and river and sea ice are regularly monitored from space by operational meteorological satellites (Yates et al., 1986) and by the special Sensor Microwave Imager on the U.S. Defense Meteorological Satellite Program satellite.

■ GEODESY AND SATELLITE NAVIGATION

Satellites offer a powerful means for gathering information about locations on Earth and for measuring the Earth's shape and gravity field

Figure 29. Variations in Arctic sea ice as measured by the Scanning Multichannel Microwave Radiometer on the Nimbus-7 satellite during 1979.

Figure 30. Topography of the Greenland Ice Sheet as measured by the altimeter used on NASA's Seasat satellite in 1978.

(geodesy) to a high degree of accuracy. A constellation of satellites, one or more of which is always in view, allows all-weather navigation on land and sea. The United States' Global Positioning System (GPS), which will have twenty-one NAVSTAR satellites in orbit by 1993, provides location accuracy of better than 100 meters on a routine basis; accuracies of the order of 1 meter can be obtained by tracking the difference in position of two receivers. As of 1987 there were seven such satellites in orbit, providing all-weather navigation for aircraft and ships about 50 percent of any given day. The satellites can also be used for geodesy. The USSR has a constellation of twenty-four navigation satellites in orbit in its Global Navigation Satellite System (Glonass). Satellites for both systems use nearly circular orbits with an orbital period of twelve hours and are placed in three different orbital planes separated by 120 degrees (University NAVSTAR Consortium, 1987).

Clearly, there would be economies of scale in some cooperation between these systems. To this end, Morsviazsputnik, the Soviet satellite communications organization, and Inmarsat, the International Maritime Satellite Organization, signed an agreement in 1989 under which the USSR will provide technical consulting services to Inmarsat that could aid development of an international system. Inmarsat is interested in providing a service that would augment the GPS and Glonass systems with a geostationary system to monitor the integrity of the satellite signals. The system would be designed to increase the reliability and dependability of GPS and Glonass for international users (Aviation Week and Space Technology, 1989).

In addition, the USSR has offered the use of Glonass to international civil aviation and maritime operators, and released detailed technical information on the satellite configuration and signal structure. This information will make possible the design of a dual system that can use signals from both the GPS and Glonass. The availability of both systems will allow increased and redundant coverage and will also assuage the concerns expressed by some nations about depending on a satellite navigation system operated solely by the U.S. military. In addition, the new Soviet position will undoubtedly lead to healthy competition, which will encourage the development of improved, high-accuracy systems and enlarge the prospects for joint tracking and surveying campaigns (Davidson, 1988; University NAVSTAR Consortium, 1988).

These global navigation systems offer an unparalleled opportunity to

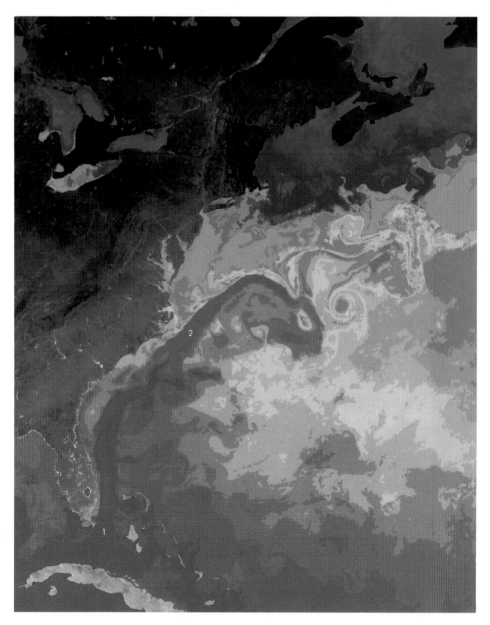

Plate I. Image of the surface temperature of the western Atlantic Ocean compiled from data from the NOAA Advanced Very High Resolution Radiometer on the polar-orbiting NOAA weather satellite. The Gulf Stream appears red (warm) at Florida and then moves into colder waters to the north, spinning off eddies.

Plate II. A global view of ocean biological productivity and land vegetation from a radiometer on board the NOAA-7 polar-orbiting satellite and an ocean color scanner on board NASA's Nimbus-7 satellite. The ocean data are from the period January 1979 to June 1980; the land data are from the period April 1982 to March 1985. See text for details. Produced at NASA's Goddard Space Flight Center.

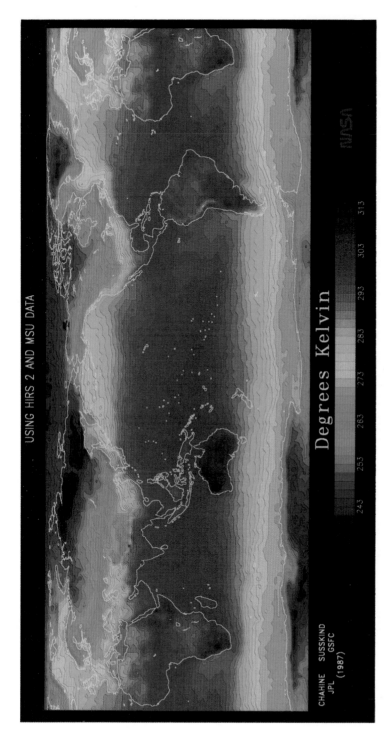

Plate III. Global surface temperature for December 1978 using data from the infrared and microwave sounders on the NOAA polar-orbiting satellite. Note the warm tropics, cooler poles, and heat transport effects of ocean currents, especially in the Eastern South Pacific and Atlantic Ocean. Produced at NASA's Goddard Space Flight Center in conjunction with the NASA's Jet Propulsion Laboratory.

Plate IV. A view of the outflow of the Mississippi River into the Gulf of Mexico put together with data from the Landsat Thematic Mapper. Sediment transport into the Gulf can be seen.

measure the shape and motion of the Earth's crust. Already, continental drift has been directly measured by the GPS system. These data can also be used to monitor seismic hazards everywhere on the globe, for example, in central and southeast Asia, where approximately 400 million people live in cities with populations greater than two million that are within striking distance of a magnitude 7 earthquake. Urbanization, population growth, and a lack of preparedness aggravate seismic risk in all countries. Space geodesy provides a unique approach to estimating the earthquake recurrence cycle in those countries where the existing geodesy is not yet precise enough (University NAVSTAR Consortium, 1988).

Public interest was stirred in 1986 by a news release about a new satellite-based measurement of the height of the Himalayan peak K2, which suggested that it might be higher than Mount Everest. An Italian team using improved equipment visited both mountains in 1987 and established that their heights, according to combined GPS and vertical triangulation measurements, were close to published measurements, with Everest remaining higher. In fact, the new data showed that the height of Everest appeared to be 30 meters higher than the published height. As a result, further measurements are planned. In 1989, the Italian Army's Geographic Institute reported that satellite measurements of Mont Blanc, Europe's highest peak, showed that it is 3.2 meters (10.6 feet) lower than reported on world maps. These small refinements reflect the high accuracy these measurements can achieve.

Unfortunately, global navigation satellites can interfere with other important scientific measurements. Radio astronomers use the radiation emitted by the hydrogen atom and hydrogen radicals like hydroxyl as a means to explore interstellar space, while the search for extraterrestrial intelligence involves a major survey of the sky over a broad range of wavelengths. Obviously, any artificial signal can interfere with these studies: Soviet Glonass satellites, for example, broadcast on frequencies around 1,600 megahertz, the same frequency as the radiation emitted by the hydroxyl radical, thus interfering with radio telescope measurement of hydroxyl. Since the ultimate goal is to have navigation satellites always visible, it appears that continuous interference is likely. The NAVSTAR satellites in the U.S. GPS system will transmit on three frequencies, one of which will obscure radio emissions from hydrogen in very distant galaxies. In order to avoid this problem, the

United States plans to construct the broadcasting equipment with transmitters that operate for only one-fifth of a second, synchronized with Universal Greenwich Mean Time. With this knowledge, radio astronomers will be able to filter out the artificial signals received during the specified time periods (Henbest, 1988).

To measure the movements of continents and of crustal deformation related to earthquakes very precisely, laser ranging using a satellite with retroreflectors can be used. One of those currently flying is the *Laser Geodynamics Satellite,* Lageos. Lageos is a very dense uranium sphere; it is only 60 centimeters in diameter but weighs 411 kilograms. Launched in 1976 into a very stable, precisely known circular orbit with an inclination of 110 degrees, it flies at a distance of 6,000 kilometers from Earth with a period of rotation of about four hours. The satellite is completely passive, its only function being to reflect laser pulses to provide precise positioning on Earth. Lageos has reflectors for both visible and infrared laser beams, but the infrared reflectors have not yet been used. Because of its distance from the Earth, it is not subject to atmospheric drag. Moreover, since it has been tracked for a long time, its orbit is by far the best known of any satellite: orbital position can be predicted to within a meter a full year into the future, and radial distance can be determined to within ten centimeters. Because of the progressive degradation of its reflectors, however, the satellite is expected to be replaced in 1991 by Lageos-II, a joint U.S.-Italian venture discussed in Chapter 4 (NASA Office of Space Science and Applications, 1988).

A similar satellite is the Japanese Experimental Geodetic Satellite (EGS), also named Ajisai (hydrangea), launched in 1986. It too is a passive satellite and was designed to improve the accuracy of geodetic surveys using conventional triangulation networks. The satellite is spherical, with two types of reflectors: visible mirrors and corner cube reflectors to reflect both the rays of the sun and laser beams from the Earth. The two reflectors will allow the satellite to serve as the apex of a triangulation network, facilitating higher accuracy in subsequent measurements. The French space agency, Centre National d'Etudes Spatiales (CNES), launched a laser-ranging Starlette satellite in 1976 and is currently building another of the same class for launch in 1990 to enhance studies of the Earth's gravitational field and ocean tides (Committee on Earth Sciences, 1988).

■ SURVEILLANCE AND RECONNAISSANCE

The success of remote-sensing satellites in delivering detailed information to a location far from an observed site makes them an ideal element in a covert intelligence program (Klass, 1971; Karas, 1983; Burrows, 1986; Jasani and Sakata, 1987; Krepon, 1989). From the very beginning of the space age, the intelligence and military communities have used remote sensing for surveillance of civilian activities as well as for mapping military bases, emplacements, and battlefields. Although the amount of money spent on military remote-sensing programs is classified information, it is generally known that the present yearly level of expenditures is greater than the total for the civil space program. Today, those countries that can launch satellites use the information gathered for strategic intelligence as well as for scientific and commercial purposes. Commercially available data from Landsat, SPOT, and Soviet satellites are regularly used in this dual way. In those countries with space capabilities, numerous connections exist between commercial and military applications. In France a future photoreconnaissance satellite called Helios will draw upon the technology and operational experience of the SPOT program (Krepon, 1989).

The importance of such surveillance is generally recognized. Burrows (1986) reports that in 1967, Lyndon Johnson told a group of local government officials and educators in Nashville that "if nothing else had come out of the space program except the knowledge we've gained from space photography, it would be worth ten times what the whole program has cost. Because tonight we know how many missiles the enemy has." According to Johnson (1988), there is a growing consensus that space-based reconnaissance has had a stabilizing influence in military affairs, because surprise aggression cannot occur.

Today, arms control is a major concern. As Burrows (1986) points out, without new technology such as satellite reconnaissance, it will be impossible for the United States and the USSR to be convinced that treaty compliance is being maintained. Yet the sensors used to monitor compliance with arms control agreements are exactly the same as those that gather targeting information for nuclear forces. Doyle (1987) notes the general agreement on both sides that as a stabilizing factor, satellite reconnaissance has been crucial in SALT treaty negotiations. To carry this idea further, the French delegation proposed that the

United Nations consider establishing an international satellite monitoring agency to maintain international confidence and security. Krepon (1989) discusses this concept, which has not yet been accepted, at some length.

In spite of the ubiquitous nature of these classified surveillance programs, their aims are narrow and their data generally unavailable to the scientific and commercial user community. Since much of this information is classified, these systems are not included in this book. An exception is the atmospheric and oceanic data collected by military satellites for weather and ocean forecasting. Good examples are the U.S. Defense Meteorological Satellite Program (DMSP), which is part of the ongoing operational weather satellite program, and the U.S. Navy GEOSAT program. Except in times of national emergency, the DMSP weather data have generally been made available; once GEOSAT was put into a repeat orbit, these data were also generally made available.

4

FILLING THE GAPS IN THE 1990s

Today's operational satellites and research missions have shown the feasibility of measuring many critical Earth processes even as they have yielded tantalizing data about the Earth. Satellite observations are now used routinely for detecting clouds, storms, and other weather hazards, and for monitoring sea ice for marine transport and land surface changes for agriculture.

Yet, despite the many satellites now flying and the quantity of data coming in, our knowledge of how the Earth works remains limited. At the same time, satellite observations have raised a number of new scientific questions that cut across traditional disciplinary boundaries within Earth science. What is the connection between the tropical ocean and the mid-latitude atmosphere, and between the manmade input of chemicals to the atmosphere and the ozone layer? What is the ocean/land/atmosphere response to increasing concentrations of carbon dioxide and other such gases and the processes associated with acid rain?

To document global environmental change adequately and to understand the Earth's coupled systems, we must have more systematic, long-term global measurements, and we need to learn how to fit these data together into models. The technology is largely available. But as NASA's Science and Mission Requirements Working Group for the Earth Observing System (1984) has noted, for a variety of reasons the actual deployment of these new state-of-the-art instrument technologies has not kept pace with their development, although several promise to break new ground in our understanding of the physical, chemical, and biological processes that control global change. We have

also learned that many instruments originally designed for a single purpose have proved to be valuable for other purposes: meteorological sensors such as the Advanced Very High Resolution Radiometer, for example, have also proved useful in oceanographic, ecological, and ice measurements.

By the mid- to late 1990s, as the Mission to Planet Earth evolves (see Chapter 5), we anticipate the establishment of a global Earth-observing system that will incorporate this new technology in both satellite and ground-based instrument networks. Although we are moving toward such a system, we are currently in transition between the sparse network of operational meteorological and land-observing satellites and the dense network we require. The new systems, based on early technology demonstrations such as Nimbus and Seasat, will give us better and more accurate measurements of important processes.

A full measurement capability will require both operational monitoring and research missions. The operational meteorological satellite system, with five geostationary satellites operated by four different space agencies, and the polar meteorological satellite programs operated by the United States and the USSR will continue. The U.S. Defense Meteorological Satellite Program series will also continue, as will the French SPOT program and the U.S. Landsat program. The European Space Agency's roster of planned programs is impressive; they are described in the report, *Looking Down, Looking Forward* (European Space Agency, 1985). The USSR will also carry forward its ongoing operational program.

But in spite of this formidable list of meteorological and land-sensing programs, there are a number of important gaps. We do not have the ability to monitor atmospheric radiation or atmospheric chemistry. We have no operational sensors able to monitor ocean currents, surface winds, or ocean color, no high-resolution capability either in the spectral domain or in spatial scales for measurements on land and sea, and no good techniques for monitoring the global hydrological cycle and precipitation. Moreover, if some existing systems, such as Landsat, are not continued, then these gaps will only become wider. In short, the data we are collecting today are reasonably adequate for dynamical weather prediction for periods of a few days, but they are insufficient for characterizing the atmosphere for periods extending from months to decades. An example: the visible and infrared radiometers used to depict the cloud cover of the Earth are not adequately calibrated in

flight. To remedy this situation, the World Climate Research Program undertook a major project, the International Satellite Cloud Climatology Project, to extract useful quantitative cloud cover information from operational, geostationary, and polar-orbiting weather satellite data (Morel, 1989). Global cloud information for each three-hour time interval over the period of the project is being developed.

To develop the necessary knowledge base about the environment and to provide needed measurements for the World Climate Research Program, the International Geosphere-Biosphere Program, and other similar scientific efforts, an ever-broadening group of countries is planning new satellite remote-sensing missions for the coming decade. Amid awakening global interest, Brazil, China, and India have joined ranks with Canada, the European nations, Japan, the United States, and the USSR to measure Earth's processes from space. Starting in late 1990 with the European Space Agency's ERS-1 satellite, a series of international research missions will attempt to fill many of the gaps I have noted. These missions will provide much of the data necessary to document global change through the mid-1990s, when we expect a global Earth-observing system to be in place (see Chapter 5).

In the following pages, I will review some of the still unresolved questions about solar forcing, the atmosphere and its constituents, the oceans, the land surface, the cryosphere (sea ice, snow and ice cover), and geodesy and the solid Earth and describe the satellite missions that have been proposed to help answer them.

■ THE ATMOSPHERE AND SOLAR FORCING

Although meteorological satellites and ground-based measurements provide global coverage and long-term data on the atmosphere, we have yet to find answers to a number of questions: Is radiation from the sun changing, and if so, how will this affect our weather? Can the accuracy of weather forecasts be improved and the useful forecast period extended? How are the chemical, radiative, and dynamic processes of the atmosphere coupled? What causes ozone variations? Clearly, new satellite measurements are necessary if we are to understand the global distribution of wind, temperature, moisture, and surface temperature on an all-weather basis; to observe with high frequency and spatial resolution the mesoscale features of wind,

temperature, humidity, cloud properties, and precipitation; and to observe the global distribution of atmospheric constituents such as aerosols, water vapor, and trace gases. We also need to understand how incoming radiation affects the atmosphere—how much is absorbed and how much is reflected.

For the 1990s, a Solar-Terrestrial Energy Program (STEP) has been proposed as part of an international effort to study the energy transfer mechanisms between the sun and the Earth (Scientific Committee on Solar-Terrestrial Physics, 1988). This program, which will include spacecraft in different locations in space within a few Earth radii, will measure, among other things, the solar wind, plasma dynamics, and the physics of aurorae. (For further discussion, see Parks et al., 1988; Akasofu and Kamide, 1987.)

The main United States effort in future atmospheric and radiation studies will be the Upper Atmosphere Research Satellite (UARS), which will gather data about the Earth's upper atmosphere, or stratosphere, to further our understanding of processes ranging from the chemistry and dynamics of the ozone layer to the effects of trace gases on climate change. The UARS satellite carries ten instruments that variously look up at the sun, monitor conditions at the spacecraft itself, and look toward the Earth (NASA, 1987, 1989a). Data from UARS instruments will be used to study energy input and loss, global photochemistry, the dynamics of the upper atmosphere, and the coupling between the upper and lower atmosphere. UARS is scheduled for a U.S. Space Shuttle launch in 1991. Investigators from the United States, Canada, and the United Kingdom will be involved.

The ten instruments carried on UARS will provide simultaneous measurements of solar radiation (from the far ultraviolet to the far infrared), of electrons, protons, X rays, and the magnetic field, and of radiative emission. The UARS measurements of the nitrogen, hydrogen, and chlorine families will be important to the prediction of the effects of atmospheric pollutants such as halocarbons and nitrous oxides from fertilizers on the upper atmosphere and will enlarge our understanding of the nitrogen and chlorine cycles. It will make observations of short-lived participants in chemical reactions such as ozone destruction and measure diurnal variations in atmospheric constituents. It will also measure stratospheric motions on a global scale, along with seasonal, and other, variations. The number of on-board instruments dictates a large spacecraft. Figure 31 compares UARS with Nimbus-7.

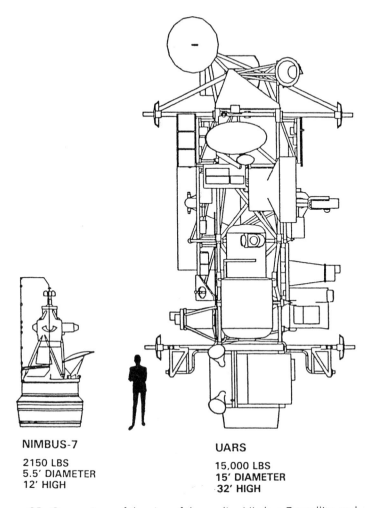

NIMBUS-7

2150 LBS
5.5' DIAMETER
12' HIGH

UARS

15,000 LBS
15' DIAMETER
32' HIGH

Figure 31. Comparison of the size of the earlier Nimbus-7 satellite and NASA's Upper Atmosphere Research Satellite (UARS). Note that UARS is almost 10 meters high.

UARS's particular combination of orbit and instrument design will provide nearly global coverage. The satellite is designed to have a lifetime of three years in order to span two Northern Hemisphere winters—the location and season with the largest natural variations in the stratosphere and upper atmosphere. The satellite will fly at an altitude of 600 kilometers in a non-sun-synchronous orbit with an inclination of 57 degrees. The orbit plane will precess through all local solar

times in about thirty-four days, thus allowing resolution of diurnal atmospheric effects in a period that is short in relation to seasonal effects. The limb-viewing instruments will provide high resolution in the vertical, 2.5 to 3 kilometers, with a latitudinal resolution of 500 kilometers and a longitudinal range that varies from 1,000 kilometers to a zonal mean. When combined with the 57-degree inclination of the orbit, the limb-viewing instruments will allow UARS to make measurements to 80 degrees latitude, thus covering better than 98 percent of the Earth's surface.

In the lower atmosphere, or troposphere, we need to understand the global hydrological cycle—clouds and rainfall, and their interaction with the ocean. The cycle of fresh water to and from the oceans, lakes, and rivers—and the energy associated with it—is one of the most poorly understood parts of the Earth system. Precipitation is measured routinely, but only at widely scatttered points on the Earth's surface and not at all over oceans. We particularly need information about precipitation and evaporation in the tropics, where such atmosphere-ocean interaction is intense. A new scientific program, the Global Energy and Water Cycle Experiment (GEWEX), has been proposed to begin in the mid-1990s as part of the World Climate Research Program. A major aim of GEWEX will be to determine ocean and atmosphere energy fluxes using satellite measurements. Two relevant missions have also been proposed: a joint U.S.-Japanese effort, the Tropical Rainfall Measuring Mission (TRMM) (NASA, 1989b), and the French Bilan d'Energie du Système Tropical (BEST) (CNES, 1988).

According to current plans, TRMM will be the first in a series of Earth Probes, missions that are smaller than the very large Earth Observing System (Simpson, 1988; Theon and Fugano, 1988). TRMM measurements will determine precipitation rates in the tropics, a crucial element in water circulation and atmospheric dynamics. The mission itself will serve to test the feasibility of using active and passive microwave data together with visible and infrared imagery to derive useful estimates of rainfall amounts and distribution. The TRMM program seeks a three-year dataset of monthly averaged rainfall to an accuracy of better than 20 percent for that part of the Earth between 35 degrees north latitude and 35 degrees south latitude. The data can also be used to understand how changes in atmospheric winds are affected by heat released into the atmosphere.

The TRMM satellite will be launched into an orbit with an inclination

Figure 32. The tropical orbit of the Tropical Rainfall Measuring Mission (TRMM), showing one-day coverage (16 orbits).

of approximately 35 degrees and an altitude of 325 kilometers (see Figure 32). Its planned three-year mission life will just overlap the final period of the Tropical Oceans and Global Atmosphere (TOGA) program of the World Climate Research Program. The 325-kilometer altitude, lower than that of the usual meteorological polar-orbiters (which is typically about 800 kilometers), allows the resolution of sensors to match the size of tropical rain cells more closely than they would from the higher altitudes. The low inclination also allows a more focused, denser (for example, diurnal) sampling in the tropics, where most rainfall occurs.

The TRMM instrumentation includes a 14-gigahertz radar to measure rain column height within a 200-meter area with a spatial resolution of four kilometers over a 150-kilometer swath, a 19-gigahertz passive microwave radiometer with a spatial resolution of 7 kilometers in a 600-kilometer swath, a visible/infrared scanner (AVHRR), which at this altitude would have a 0.5-kilometer resolution inside a 1,000-kilometer swath, and a conically scanning microwave imager similar to the one now flying on the U.S. Defense Meteorological Satellite Program (DMSP) satellite (see Chapter 3). Figure 33 shows the satellite and its instruments in its proposed mode of operation.

The BEST mission planned by the French space agency CNES is intended to obtain the total energy budget of the tropical atmosphere by measuring the climatological means of the relevant terms of the energetic and hydrologic processes: rainfall rate, evaporation and evapotranspiration fluxes, and latent and sensible heat fluxes. The

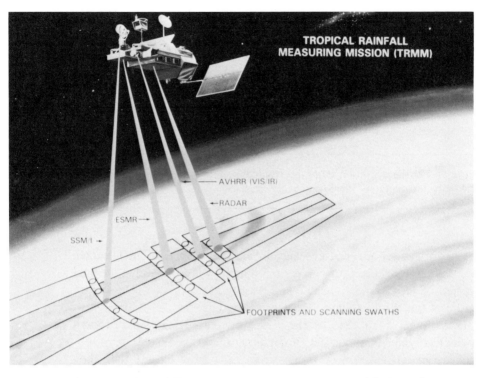

Figure 33. The Tropical Rainfall Measuring Mission: Instruments and flight configuration.

BEST mission will require a spacecraft in a 30-degree inclination orbit. The instrumentation will use passive and active microwave techniques for measuring rainfall rates and high resolution profiling of meteorological variables such as water vapor pressure, temperature, and winds. The instruments to be used are a precipitation radar, a scanning multichannel microwave radiometer, and a pulsed carbon dioxide laser profiler. The precipitation radar will have a large antenna (10 meters in diameter) for high spatial resolution (see Figure 34). The accumulated data, averaged on a monthly scale and over grid areas of the order of 200 kilometers, will be used for climate studies, for validating general atmospheric circulation models, and for studying tropical rain systems. BEST is currently under study at CNES with a possible launch in the mid- to late 1990s.

As far as operational weather measurements are concerned, the

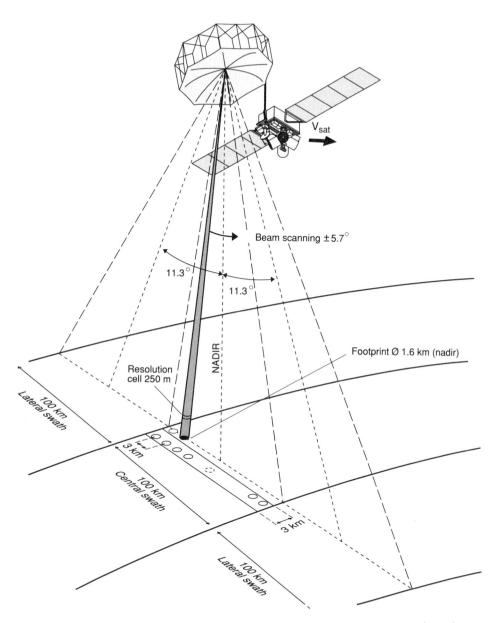

Beam scanning ±5.7°

11.3°

11.3°

V_{sat}

NADIR

Footprint Ø 1.6 km (nadir)

Resolution
cell 250 m

100 km
Lateral swath

3 km

100 km
Central swath

3 km

100 km
Lateral swath

Figure 34. The French BEST mission plans, showing instruments, antennas, and swath widths at the Earth's surface.

European Space Agency will continue its Meteosat Operational Program (MOP) with MOP-2 in 1990 and MOP-3 in 1991. Japan will continue its operational system with Geostationary Meteorological Satellite-5 (GMS-5) in 1993. Along with the development and successful launch of FY-1, its first meteorological satellite, China also has a geostationary meteorological satellite, FY-2, in the preliminary design phase. India plans to continue its geostationary satellite program with the launch of its Indian National Satellite System-IIa in 1990.

The USSR had originally planned to supply a geostationary meteorological satellite for the Global Atmospheric Research Program in the late 1970s, but because of technical difficulties, it was unable to provide a "spin-stabilized" spacecraft. The USSR apparently now plans to launch a series of Geostationary Operational Meteorological Satellites (GOMS) in the early 1990s. The GOMS will be positioned at 76, 166, and 346 degrees east, to provide coverage of the major part of Soviet territory. It is expected that the GOMS instrumentation will be similar to that aboard U.S. Geostationary Operational Environmental Satellites (GOES). The USSR also plans to continue the polar-orbiting Meteor series, which, starting in 1988, will measure ozone levels. In addition, the Soviets are jointly developing a four-channel scanning radiometer (ScaRab) with France for a flight in late 1990 (Johnson, 1988).

■ THE OCEAN

The large-scale movement of water in the ocean, also called the "general circulation," influences many other processes that affect human life. It affects climate by transporting heat from the equatorial regions toward the poles. The ocean also absorbs carbon dioxide from the atmosphere, thus delaying potential warming, but how fast this occurs and how the ocean and atmosphere interact in this process depend on surface currents, upwelling, and the deep circulation of the ocean. Fisheries rely on the nutrients that are carried by ocean movement. Large ships, such as oil tankers, either use or avoid currents to make efficient passage. The management of pollution of all kinds, ranging from radioactive waste to garbage disposal, depends on a knowledge of ocean currents. And the ocean is both a hiding place and a hunting ground for submarines.

Satellite and in situ measurements have given us an initial view of the global circulation and its driving force, wind stress; of the chlorophyll distribution that is related to biological productivity; and of the distribution of eddies in the ocean. But in many cases our measurements are not precise enough, nor do we have any long-term time series. What is the global distribution of heat, water, and momentum exchange between the oceans and the atmosphere? What are the processes that control sea ice and its interaction with the ocean? How are physical and biological processes in the ocean related? New satellite measurements are required to provide data on ocean circulation, sea surface temperature, wind stress, mesoscale eddies, chlorophyll distribution, wave properties, and fluxes across the surface.

As the Seasat mission (see Chapter 2) showed, it is possible to measure surface winds, waves, sea ice, and ocean surface topography. The shape of the surface reveals the highs and lows of ocean pressure, which can then be used to infer the motion of the ocean—just as a weather map illustrates atmospheric winds based on highs and lows in atmospheric pressure. The ongoing U.S. Navy GEOSAT satellite program is providing such ocean measurements.

Another satellite dedicated to ocean measurements is the European Space Agency's European Remote Sensing Satellite (ERS-1), which is scheduled for launch on a three-year mission in early 1991 (ESA, 1985, 1988). ERS-1 is expected to serve as the forerunner to a series of European remote-sensing satellites to be launched in the mid-1990s. The ERS-1 program focuses on ocean-related phenomena but will include microwave imaging over land on an experimental basis.

The ERS-1 payload will include an array of six instruments. A passive infrared radiometer, the Along Track Scanning Radiometer, will make measurements in three frequencies to determine sea surface temperature, cloud top temperature, cloud amount, land and ice surface radiances, and sea state from reflected sunlight. It will also be able to take measurements of an area of the sea from two different directions—from immediately above and at approximately 60 degrees incidence—which will allow an accurate atmospheric correction of the radiometer data. Combined with the radiometer is a nadir-pointing microwave sounder, which will be used to determine the total atmospheric water vapor content, the liquid water content and rain areas, and land and ice surface emissivity.

The ERS-1 will also employ two active radar systems. The first, a

13.5-gigahertz radar altimeter, will measure wave height, surface topography, and wind speed over the ocean. Over ice it can determine ice sheet surface topography and sea-ice boundaries. The second, the Active Microwave Instrument (AMI), which operates at 6.3 gigahertz, is really three devices in one. In the *image* mode, the AMI is a synthetic aperture radar for high resolution (30 meters), wide-swath (80 kilometers) imaging over ocean, coastal zones, and land. In the *wind* mode, the instrument is a scatterometer, measuring the change in the radar reflectivity of the sea surface caused by surface wind perturbation over a wide 400-kilometer swath. In the *wave* mode, the instrument operates with reduced power and a lower data rate to measure the change in the radar reflectivity of the sea surface due to ocean surface waves over small areas (5 kilometers by 5 kilometers).

To allow accurate determination of the satellite's height by laser ranging stations, ERS-1 carries a laser retroreflector. The data it gathers will be used to calibrate the radar altimeter and to improve the determination of the radial component of the satellite orbit. A Precision Range and Range Rate Equipment (PRARE) system will also provide precise range positioning information. Figure 35 shows ERS-1 and its instruments.

The satellite will be launched by an Ariane-4 rocket from the Kourou Space Centre in French Guyana into a near-polar circular sun-synchronous orbit of nominal 777-kilometer altitude. This initial orbit has been selected to give a repetition of the ground track every three days. The orbit will be deliberately varied during the lifetime of the satellite in order to optimize the measurements of the different instruments on board.

About a year after the ERS-1 launch in 1991, current plans call for a second ocean-measuring satellite, the TOPEX/POSEIDON mission, a joint effort of NASA and the French space agency, CNES. (TOPEX stands for Topography Experiment, and Poseidon is the god of the sea in Greek mythology.) The mission is a single-purpose operation. Each element has been specifically designed to contribute to a precise measurement of ocean surface topography (TOPEX Science Working Group, 1981; Stewart, Fu, and Lefebvre, 1986). The goal of the TOPEX/POSEIDON mission is to provide data on ocean topography for the study of mean and variable currents and ocean tides. It is intended to lay the foundation for a continuing program of long-term observations of the oceanic circulation and its changes.

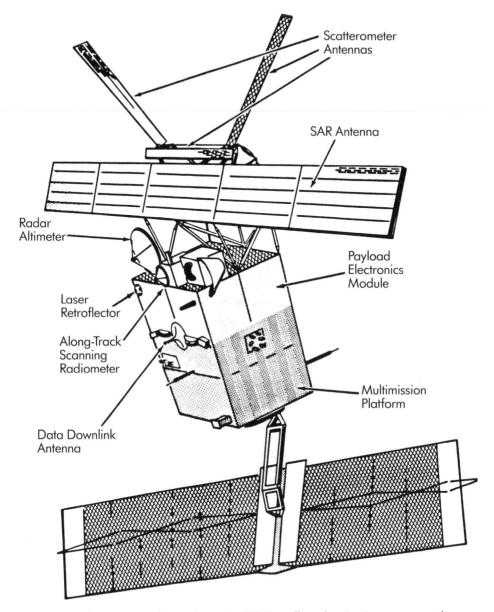

Figure 35. The European Space Agency's ERS-1 satellite, showing instruments and antennas.

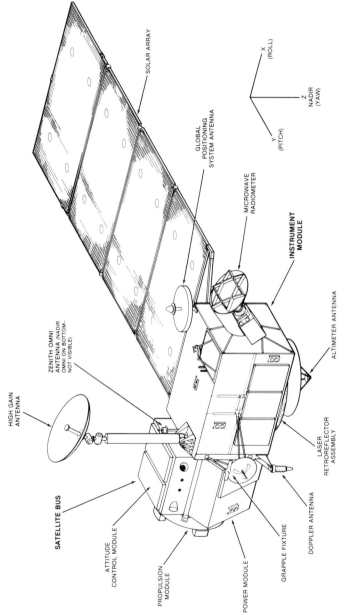

Figure 36. The joint U.S./French TOPEX/POSEIDON precision altimeter satellite and its instruments.

SOLAR ARRAY

GLOBAL
POSITIONING
SYSTEM ANTENNA

MICROWAVE
RADIOMETER

**INSTRUMENT
MODULE**

ALTIMETER ANTENNA

X
(ROLL)

Z
NADIR
(YAW)

Y
(PITCH)

ZENITH OMNI
ANTENNA (NADIR
OMNI ON BOTTOM–
NOT VISIBLE)

HIGH GAIN
ANTENNA

SATELLITE BUS

ATTITUDE
CONTROL MODULE

PROPULSION
MODULE

POWER MODULE

GRAPPLE FIXTURE

DOPPLER ANTENNA

LASER
RETROREFLECTOR
ASSEMBLY

Since topographical changes as small as a few centimeters can be of interest in studies of the general circulation, the measuring elements and the satellite orbit must be very carefully designed. TOPEX/POSEIDON will carry a dual-frequency altimeter (13.6 and 5.3 gigahertz), a microwave radiometer operating at three frequencies (18, 21, and 37 gigahertz), and a French solid-state altimeter (13.65 gigahertz). The precision tracking equipment will include a laser retroflector array, a French Dual Doppler receiver, and a receiver for signals from the satellite-based Global Positioning System. All of these measurements taken together are expected to reduce the uncertainties in the orbit to less than a few centimeters. NASA will provide the satellite bus, an altimeter and a radiometer, orbit tracking, and data handling capabilities. CNES will provide an additional altimeter, precision tracking, and data handling, and will launch the satellite with an Ariane rocket. Each agency will make data available to a wide community of users. Figure 36 shows the satellite and its instruments.

The satellite design and orbit have been chosen to ensure the best coverage of ocean currents and altimeter measurements of the highest accuracy. Since an evenly spaced grid of measurements over the ocean is optimal, neither a purely polar orbit, with mainly north-south tracks, nor an orbit confined to tropical regions, with mainly east-west tracks, is suitable. The choice of an orbit with an inclination of 63.1 degrees provides crossing angles of 45 degrees of the ascending and descending orbits at 30 degrees latitude (see Figure 37). This nonpolar, non-sun-synchronous orbit is also designed to minimize the tides as a factor in the measurement. If the satellite were in a sun-synchronous orbit, the tides, and hence sea surface height changes produced by the sun, would appear as a constant signal, and the changes due to the tides could not be measured. If we know the tides accurately, however, the tidal signal can be subtracted from the total signal. According to current plans, TOPEX/POSEIDON will measure the tides accurately so that later satellites will be able to operate in sun-synchronous orbits and still provide accurate ocean current measurements.

The inclination of 63.1 degrees does not allow coverage of the highest polar regions, but it does give good coverage of most of the rest of the ocean. Better polar coverage will be supplied by other satellites, such as ERS-1, which is in polar orbit. TOPEX/POSEIDON data can be used to calibrate the less accurate ERS-1 data at lower latitudes to provide high accuracy data in polar regions. The TOPEX/POSEIDON

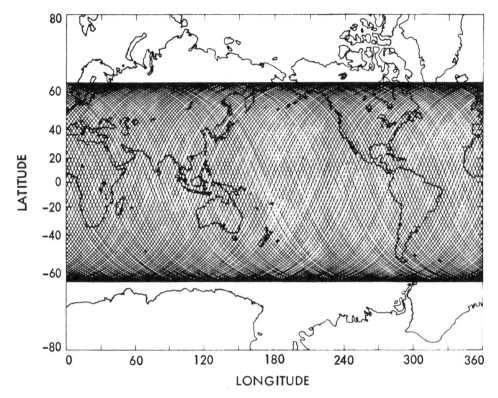

Figure 37. The ground track proposed for the TOPEX/POSEIDON mission at an altitude of 1,300 km and with an orbital inclination of 64 degrees. The number of tracks corresponds to a ten-day period of an exactly repeating ten-day cycle.

altitude will be 1,300 kilometers, higher than many similar satellites but chosen to reduce atmospheric drag. The repeat period is ten days, which ensures that ocean eddies with this time scale can be measured. The satellite is scheduled for launch in mid-1992 on a three-year prime mission, with a possible two-year extension.

Overall, the TOPEX/POSEIDON mission will determine the global field of variability in the sea surface from time periods of twenty days to the mission lifetime, a maximum of five years, and on spatial scales of 30 kilometers to the width of the ocean basins. When combined with shipborne observations and models of the ocean currents below the surface, the satellite data will permit estimates of the general circulation of the ocean over the mission's lifetime. TOPEX/POSEIDON is

thus a major component of the World Ocean Circulation Experiment (WOCE) planned for the early 1990s and aimed at understanding the role of the ocean in climate. Together, the satellite and field measurements from the WOCE will provide—for the first time—a global picture of the ocean circulation and its variability. With this information, oceanographers will be able to predict the general circulation, its changes, and its role in climate with greater assurance.

Two separate measurements are required to make full use of TOPEX/POSEIDON's precision altimetry data. The first is a gravity field measurement. To extract the mean pressure field from the sea surface, we must know the gravity field in order to determine a level surface. Sea surface height relative to this level surface produces the pressure differences that drive ocean currents. Although we understand certain aspects of the gravity field (such as the very long wavelength), little of the detailed, small-scale variability is known. To make such measurements a satellite gravity mission is required, and although there are no firm plans for such a mission, much discussion is currently taking place. The second measurement is surface wind stress. To achieve a full understanding of the ocean circulation, we must know not only the movement of the water but also the forces driving that movement. The wind is the main force, but radiation from the sun, precipitation, and evaporation are also important factors. The ERS-1 satellite will provide wind stress measurements at the beginning of the TOPEX/POSEIDON flight period, and a later follow-on to ERS-1 is possible.

The Seasat mission clearly demonstrated that spaceborne microwave scatterometers were capable of obtaining measurements of near-surface wind speed and direction over the global oceans. The need for long-term wind measurements, coupled with the availability of precision altimetry, propelled the development of the NASA Scatterometer (NSCAT) (Satellite Surface Stress Working Group, 1982). The NSCAT is an active radar system operating at a frequency of 13.995 gigahertz. The design calls for three antennas that will illuminate each side of the subsatellite track. Wind measurements will be obtained in two swaths, each 600 kilometers wide and separated by a gap of 350 kilometers. In a typical sun-synchronous orbit at an altitude of 830 kilometers and an inclination of 98 degrees, the instrument can collect wind speed and direction measurements over at least 90 percent of the ice-free global oceans once every two days with an accuracy of about two meters per

second. The absolute resolution is expected to be about 50 kilometers, and the relative location accuracy better than 10 kilometers. Like the altimeter, NSCAT makes less accurate wind measurements when liquid water is present in the atmosphere. Simultaneous measurements from a microwave radiometer are required to note when rainfall is degrading the scatterometer signal. NSCAT is now under construction for a scheduled flight on Japan's Advanced Earth Observing Satellite (ADEOS), which is expected to be put in orbit in 1995. This time schedule means that ADEOS will overlap with TOPEX/POSEIDON primarily during the extended mission, now planned for 1995–97, and with the follow-on satellite to the European Space Agency's ERS-1.

The missions and instruments discussed above have been aimed at measuring the physical parameters of the ocean: temperature, sea state, currents, and wind stress. But satellite instruments are just as indispensable for the measurement of biological processes in the ocean. We now know that ocean color can be a useful indicator of the state of biological populations and processes in the ocean. The Coastal Zone Color Scanner on Nimbus-7 provided a long-term dataset (1978–86) that has proved extraordinarily useful in understanding how these populations and processes are distributed and how they change. Ocean color measurements have given us the first global data on ocean productivity. These data have been a crucial factor in identifying the relation of biological processes to physical factors, and documenting upwelling caused by winds and changes in seasonal populations caused by monsoons. Ocean color can aid in identifying ocean currents, jets, and eddies for ship routing and offshore oil and gas exploration. But the Coastal Zone Color Scanner is no longer working, and plans are under way for a replacement.

The new instrument, called SeaWiFS (for Sea-viewing, Wide-Field-of-view Sensor), is being jointly developed in the United States by NASA, Hughes Aircraft, and the user community according to performance specifications identified by a Joint EOSAT/NASA SeaWiFS Working Group (1987). SeaWiFS observes radiation in eight bands in the visible spectrum and will focus on those regions of interest for the study of ocean color. Its spatial resolution will be 1 kilometer for local area coverage and 4 kilometers for global coverage. The sensor is designed for an equator crossing time near noon. Tape recorders will allow data to be collected for later transmission. Current plans call for

the SeaWiFS to be flown aboard a satellite launched by the new Pegasus launch vehicle in 1992.

Ocean measurements are also being carried out by Japan's Marine Observation Satellite (MOS-1), launched in 1987 (see Chapter 3). MOS-1, with a design lifetime of two years, is the first in an ongoing series. It will be followed in 1990 by MOS-1b, which has the same instrumentation and will focus on marine observations. At the same time, Japan's Earth Resources Satellite (often abbreviated JERS-1 to distinguish it from the European Space Agency's ERS-1) will be relaying more detailed land information.

The Advanced Earth Observing Satellite (ADEOS), to be launched in early 1995, will be Japan's fourth Earth-orbiting, remote-sensing satellite, following MOS-1, MOS-1b, and the planned JERS-1. It is viewed as an intermediate step toward the technically more sophisticated Polar Platform, Japan's contribution to NASA's Earth Observation System program in the late 1990s. The main objectives of ADEOS are to develop and operate advanced optical sensors, and to develop and use the high data rate Experimental Data Relay and Tracking Satellite (EDRTS). The core sensors on ADEOS will include a six-channel Ocean Color and Temperature Scanner (OCTS), which will have high radiometric resolution and a swath width of approximately 1,500 kilometers. A four-day orbit subcycle will allow observations of relatively rapid change in the ocean. The primary focus of OCTS will be observations of ocean color and temperature. An agreement between the United States and Japan allows the satellite to carry the NASA scatterometer for surface wind and sea state observations.

ADEOS will also carry an advanced visible and near-infrared radiometer, which will have high spatial resolution (eight to sixteen meters) for land images; a total ozone mapping spectrometer; an interferometric monitor for observation of carbon dioxide, methane, and other greenhouse gases; a spectrometer for observing the limb of the atmosphere at high latitudes; a polarimeter for measuring the polarization and directionality of radiation reflected from Earth, and a retro-reflector for lasers beamed from Earth. The latter instrument will allow measurement of the absorption of ozone, fluorocarbons, carbon dioxide, and other gases from Earth-based stations. These instruments are being developed by Japan in conjunction with France and the United States. ADEOS will fly in a sun-synchronous orbit at an altitude of 797

kilometers and an inclination of 98.6 degrees. The nodal period will be 100.92 minutes, and the repeat cycle forty-one days. The equator crossing time will be 1030. The ADEOS-EDRTS-Earth Observation Center will have a data link with a data transmission capability of approximately 120 million bits per second. This greater data acquisition capability, ten times larger than that of an ADEOS-EOC direct transmission link, will improve the frequency of global mapping and allow more timely observations.

Canada's RADARSAT, which will be described in more detail later, will also carry instruments for ocean measurements. Scheduled for launch in 1994, RADARSAT will carry a synthetic aperture radar whose primary use is for ice measurements, but which can also measure ocean winds and waves to help improve weather and sea state forecasting. In addition, the instrument will be able to detect ocean oil spills and make fishing, shipping, oil exploration, and offshore drilling safer and more efficient.

▪ THE LAND SURFACE

Using satellite measurements of the land surface, we are beginning to construct global maps of the Earth's vegetation and surface properties. But we do not yet have enough information on the global distribution of biomass and its variations, or on the global distribution and transport rates of tropospheric gases and aerosols, and the strengths of their sources and sinks, to answer fundamental questions. Why is the atmospheric methane concentration increasing? To what degree is the natural time variability of major chemical elements influenced by human activities? What is the global distribution of soil moisture? New global satellite measurements are required to address these questions and to provide data for determining the transport of sediments and nutrients from the land to the sea.

Such information is a key factor in future management of Earth's resources. For agriculture, we need to know the exact nature of the interaction between sunlight, plants, and soil. Can satellite estimates of precipitation, temperature, and solar radiation be made with sufficient accuracy for use in crop prediction models? For geology, we need to know which lithological, mineralogical, and structural geologic characteristics are favorable to the presence of mineral and hydrocarbon

resources. Can satellite systems be developed to identify and map the constituent mineralogy of soils and rocks?

The potential for measuring the amount of soil moisture from space has been demonstrated, but only over large, homogeneous, and lightly vegetated areas, and not to great depths. We still need to know the distribution of precipitation, evaporation, and runoff over the globe; how vegetation, soil, and topography interact with the components of the hydrologic cycle; and the distribution, capacities, and properties of major freshwater reservoirs and the transfer mechanisms between them. New satellite measurements are required to provide information on the amount of precipitation, evaporation, and water distribution on the surface of the globe and in the soil.

For land measurements, we look to the continuation of the existing U.S. Landsat series (the next would be Landsat-6) and the French SPOT series (in 1989, France approved the development of a fourth SPOT satellite to assure the continuation of imaging services into the next century). But other countries are also planning satellite Earth resource measurements. Japan's major land-observing satellite is the Earth Resources Satellite-1 (JERS-1) (NASDA, 1988), which will use newly developed optical sensors and a synthetic aperture radar to observe the land surface (see Figure 38). The data will be used to explore nonrenewable resources, to monitor land and coastal regions for agriculture, forestry, and fisheries, and to provide warning of natural disasters. Japan's Science and Technology Agency and the Ministry of International Trade and Industry are jointly coordinating JERS-1, and the latter is responsible for developing the satellite instrumentation.

JERS-1 will fly in a sun-synchronous orbit at an altitude of approximately 570 kilometers and an inclination of approximately 98 degrees. The repeat cycle is forty-four days, with a descending node time of 1030. There will be fifteen orbits per day. The satellite will carry a synthetic aperture radar operating at a frequency of 1.275 gigahertz with a swath width of about 75 kilometers and a resolution of 18 meters. The off-nadir pointing angle will be 35 degrees. A Visible and Near-Infrared Radiometer (VNIR) will have four spectral bands with a spatial resolution of 18 meters and a stereo viewing capability. A Short Wavelength Infrared Radiometer (SWIR) will also have four spectral bands, a resolution varying from 18 to 30 meters, and a swath width of 75 meters. The currently proposed launch date is early 1992; the design life of the satellite is two years.

Figure 38. Picture of Japan's planned Earth Resources Satellite-1 (JERS-1). Note the large synthetic aperture radar antenna.

JERS-1 will have a data recorder that stores data temporarily and then transmits the data when the satellite is over a ground station. The satellite will also be able to acquire data in real time when it is within radio range of a receiving station. In Japan, these data will be received at NASDA's Earth Observation Center near Tokyo. In the United States, a receiving station (the Alaska SAR Facility) has been established at the University of Alaska in Fairbanks, Alaska, for receiving, processing, and archiving synthetic aperture radar data from both JERS-1 and the European Space Agency's ERS-1, which will allow real-time collection of such data in regions of interest to users in the United States. Japan's ADEOS satellite will also provide useful information on land processes.

Canada's RADARSAT will carry a synthetic aperture radar (SAR) designed for ice measurements. The instrument is also capable of observing the Earth from several different angles to offer users a choice of image areas and resolutions. This stereoscopic SAR imagery will point out important geological differences and help identify potential mining sites. RADARSAT will also monitor and map renewable resources for the agricultural and forestry industries. Because it can acquire data through clouds and darkness, RADARSAT will be able to make regular observations of time-dependent phenomena, such as crop growth cycles. Since it is sensitive to water in soil and vegetation, it will be able to monitor plant conditions and, possibly, soil moisture. Because of the penetration of the radar signal, the SAR is particularly useful for geological mapping in regions with dense vegetation and thick cloud cover. RADARSAT data will be especially valuable to tropical countries, where jungle cover and persistent clouds make the collection of information by either ground-based observations or aerial photography very difficult.

The USSR has launched several radar satellites and plans to deploy others. Among them, the KOSMOS-1870 series, which initiated its measurements in 1987, has been supplied with both advanced radar and optical systems. Future satellites in this third series of Soviet spacecraft could possibly accommodate international remote-sensing instruments (Blanchard, 1988). China is actively developing Earth observation satellites that will use radio data transmission (Cheng, 1988), and among these, a satellite for resource surveying is a top priority. The subsystem technology is believed to be ready, and user demand is high.

Other countries are also beginning to enter this field. India has long been working on successive remote-sensing projects and is currently operating the sun-synchronous Indian Remote-Sensing satellite (IRS-1A). It was launched by a Soviet rocket in 1988 into an orbit with a twenty-two-day repeat and a height of 904 kilometers. It carries two instruments, each measuring in four spectral bands in the visible with resolutions of 72 and 36 meters, respectively (IRS Project Team, 1988; Indian Space Research Organisation, 1986). Brazil began its space program in 1966 with the installation of a station for receiving meteorological satellite images, and in 1973 began collecting Landsat data. In 1987, adaptations were made for receiving SPOT images. Current plans include a joint effort with China to develop an Earth observation mission with several spectral bands in the visible and with a resolution of 20 meters for launch in the mid-1990s (Instituto de Pesquisas Espaciais, 1989). Indonesia and the Netherlands are working together to complete the configuration of a Tropical Earth Resources Technology Satellite for flight in the early 1990s (Mayerchak, 1989).

▪ THE CRYOSPHERE

Understanding water in all its phases is essential if we are to understand variations in climate. Until now, only crude estimates of the spatial and temporal variations in the principal storage reservoirs of freshwater on Earth have been possible. If the Earth is indeed warming due to increased carbon dioxide, for example, we would expect to see melting of the Greenland and Antarctic ice sheet. Is this in fact occurring?

Satellite data have given us information on distribution and change in sea ice, and we have a fifteen-year record, with some gaps, of continental snow and ice cover. New satellite measurements are now needed to determine on a global scale the amount, extent, and movement of snow cover, sea ice, and glacial ice.

As I have noted, the European Space Agency's ERS-1, Japan's JERS-1, and various Soviet satellites will carry radars that will be of particular use in measuring ice and snow. Canada's RADARSAT satellite will use radar to obtain detailed images of the Earth even through darkness and clouds (Canadian Advisory Committee on Remote Sensing, 1985). Although its primary aim is to provide timely and reliable

information on ice and sea conditions in the Arctic and coastal regions, it will also supply information on moisture in the ground and on vegetation. A company called RADARSAT Limited has been formed to distribute and market data and images; however, Canada's partners in the project will have free access to the satellite data to image any part of their territory (Cockburn, 1989).

The major instrument aboard RADARSAT will be a synthetic aperture radar with a resolution of 15 to 30 meters and a swath width of 500 kilometers. The United States may contribute either an advanced very high resolution radiometer or a scatterometer. RADARSAT will fly at an altitude of almost 800 kilometers in a sun-synchronous orbit with an inclination of 99.48 degrees. It will have a three-day repeat cycle, but the repeat coverage in this polar orbit will be better the farther north the satellite goes. RADARSAT will cover most of Canada every seventy-two hours, for example, and the Arctic every twenty-four hours. Processed and interpreted data is expected to be available to users only a few hours after the satellite passes over a particular area.

RADARSAT will be important in supplying reliable information on sea-ice conditions and supplying it quickly. Because the data can be used to detect strengths and weaknesses in ice, they are valuable for plotting the easiest courses for ships and icebreakers. Improved weather and ice prediction will help to reduce navigational risks and increase the safety and effectiveness of resource exploration. The data will also be used to monitor ships and their tracks through the ice for daily surveillance of Arctic waters.

■ GEODESY AND THE SOLID EARTH

Space technology has already proved useful in measuring the slow drift of the continents (1 to 10 centimeters per year), but key questions remain unanswered. What are the forces that drive plate motion? What is the structure of the Earth's core, and how is the geomagnetic field generated by a core dynamo? New satellite measurements are needed to update and improve our understanding of the Earth's gravity and magnetic fields, to develop global maps of the crustal deformation of plate boundaries, and to determine the relative velocities of the major tectonic plates.

Satellite measurements of the Earth's gravity field tell us about its

internal structure and give us the information necessary for calculating level surfaces. They can reveal the pattern of underlying mantle convection and show how the smaller scales of mantle convection interact with the large-scale plate structure of the lithosphere. Satellites allow us to make measurements in regions inaccessible by normal means or instrumentation. They can, for example, uniquely determine the mass distribution under the Himalayas, Tibet, and neighboring areas of Asia where the collision of India with Eurasia is currently being accommodated by the elevation of the world's highest mountains and by the extrusion of China toward the Pacific Ocean. Collisions of this kind have been a major element in the evolution of the continents over the last four billion years, and satellite gravity data is essential for describing and understanding this complex process fully.

To date, the major positioning satellite used for determining information about the solid Earth has been the Laser Geodynamics Satellite, Lageos-I, discussed in Chapter 3. This single satellite has contributed more information about the solid Earth than all the other satellites of the past twenty-five years. In 1984, a cooperative agreement between NASA and the Italian space agency was signed for the development and launch of Lageos-II, which is expected to be launched in 1991 into a similar high-altitude orbit (5,900 kilometers), but with a lower inclination. Lageos-II will provide more accurate baseline lengths, improved knowledge of the Earth's gravity field on long space scales, and better tide models (Committee on Earth Sciences, 1988; NASA Office of Space Science and Applications, 1988).

Although the Earth's gravity field can be measured at the height of a satellite simply by watching the perturbations of the satellite orbit—the fact that the Earth is slightly pear-shaped was confirmed this way—these measurements, usually at heights of more than 500 kilometers, can reveal only the part of the gravity field with space scales greater than several hundred kilometers. To achieve a more detailed mapping of the gravity field, it is necessary to fly a special mission much closer to Earth.

The European Space Agency is currently planning such a mission for launch in the mid-1990s (ESA Directorate of Earth Observation and Microgravity, 1988). Called ARISTOTELES (Applications and Research Involving Space Techniques Observing The Earth fields from Low Earth orbit Spacecraft), the satellite would orbit the Earth at an altitude of about 200 kilometers for a period of six months to perform

its primary mission of mapping the gravity field. Thereafter, it would be raised to an altitude of about 700 kilometers for another three years, where it would serve as a geodetic satellite for precise positioning. The measuring system consists of four accelerometers, which measure the motions of freely suspended masses isolated from all outside effects except gravity. The accuracy of the measurement is expected to be equivalent to a few centimeters in the shape of the geoid at the Earth's surface, with a spatial resolution of 100 kilometers. ARISTOTELES will also carry an instrument to measure the Earth's magnetic field.

The United States is also considering a gravity and magnetic field measurement mission called the Geopotential Research Explorer Mission (GREM). GREM would include a satellite flying in a low-altitude orbit that would carry an instrument for magnetic field measurements and would rely on precise measurements of suspended and isolated masses to track changes in gravity. If approved, GREM would be part of the Earth probe series (see Chapter 5). Because of the clear overlap between GREM and ARISTOTELES, NASA and the European Space Agency have discussed a joint mission that would combine the two efforts (NASA Office of Space Science and Applications, 1988).

▪ GALILEO: THE EARTH ENCOUNTERS

NASA's Galileo mission to the planet Jupiter, launched in October 1989, will provide unique information about Earth as it travels to the outer solar system (Clarke and Fanale, 1989) for arrival at Jupiter in December 1995. As originally planned, the spacecraft was to be launched on a direct trajectory to Jupiter using the Space Shuttle and a Centaur rocket upper stage. Following the Challenger accident, however, the Centaur stage was cancelled for safety reasons and a smaller Upper Inertial Stage (IUS) was designated for the mission.

Since the IUS does not have the necessary energy to inject the Galileo spacecraft into a direct trajectory to Jupiter, the spacecraft will be routed to swing past Earth, Venus, and then Earth again to give it a series of planetary gravity assists to reach Jupiter. Galileo will fly by Earth in December 1990 and again in December 1992. Its instruments, designed to measure a full set of variables about Jupiter, will be used during these encounters to monitor the Earth.

The Galileo spacecraft will approach the Earth from the dark side

and view it from the light side as it departs. The viewing conditions and the fact that there are just two passes limit the nature and extent of the remote sensing that can be accomplished. Yet it will be possible to collect data on methane, chlorofluorocarbons, and other trace gases of importance to the greenhouse effect. The "airglow" or ultraviolet fluorescence caused by the interaction of the sun with the atmosphere has never been measured from a spacecraft while coming in from deep space. This observation will provide information on the abundances of atomic hydrogen and oxygen, and molecular nitrogen. Observations of the ozone hole at the South Pole will also be possible. Since the spacecraft will be a great distance from Earth, the magnetic field and charged particles as well as the neutral hydrogen "tail" blown away from Earth by the sun can be measured. Very accurate measurements of the mass of the Earth will also be possible by measuring the acceleration of the spacecraft as it comes in toward the Earth.

Finally, as the spacecraft approaches Earth from deep space, it will take a continuous series of pictures that will be made into a motion picture, including several eight-hour-long segments of the Earth rotating and of the moon orbiting past the Earth. At the farthest range, the Earth and moon will appear as thin crescents; at the closest approach, the Earth will fill the frame. At closest approach a continuous five-day sequence will be made of Earth; eight days later, a sixteen-hour sequence will show the moon orbiting past the Earth. The resulting film will give us a perspective on Earth and its place in the solar system that has never before been achieved.

5

MISSION TO PLANET EARTH

Now that we have a constellation of operational satellite systems to provide certain limited data on a routine basis and a series of new, short-term (three- to five-year) missions under way to help fill in the information gaps, we are ready to begin planning for the establishment of a comprehensive global observing system that will provide data on a continuing basis into the twenty-first century. In recognition of this next step, the Earth Systems Sciences Committee, sponsored by the NASA Advisory Committee but also making recommendations to NOAA and the National Science Foundation, proposed both a goal and a challenge for the future. The goal: to achieve a scientific understanding of the entire Earth system on a global scale by describing how its component parts and their interactions have evolved, how they function, and how they may be expected to continue to evolve on all time scales. The challenge: to develop the capability to predict those changes that will occur during the next decade and the next century, both naturally and in response to human activity (Earth Systems Sciences Committee, 1988). The committee recommended a program that included three main elements: global long-term measurements from satellites and ground-based systems to document the physical, chemical, and biological processes responsible for the evolution of Earth on all time scales; the use of that data in quantitative models of the Earth system to identify and simulate global trends and to make predictions; and the establishment of an information base for effective decision-making in responding to the consequences of global change.

The Earth System Sciences Committee recommendations built on the reports of two committees of the National Research Council, the

Committee on Science, Engineering, and Public Policy, and the Task Group on Earth Sciences. In its 1985 Research Briefings, the Research Briefing Panel on Remote Sensing of the Earth of the Committee on Science, Engineering, and Public Policy spoke to the issues:

> To advance our understanding of the causes and effects of global change, we need new observations of the Earth. These measurements must be global and synoptic, they must be long-term, and different processes such as atmospheric winds, ocean currents, and biological productivity must be measured simultaneously. We have learned that major advances in Earth Sciences have come from syntheses of new ideas drawn from such global, synoptic observations. The synthesis of plate tectonics from large-scale data is a major step in understanding how the Earth works; the understanding of the dynamics of large-scale circulation of the atmosphere that comes from global observations has permitted a significant increase in the accuracy of weather predictions. Now we must take the next steps.

The Panel emphasized that long-term continuity of measurements is crucial, pointing out that a twenty-year time series would cover two sunspot cycles, the period over which the temperature change due to the greenhouse effect is expected to be larger than natural climate fluctuations, the eruptions of five to ten volcanoes, the occurrence of two to five El Niños, and the period over which the major effects of deforestation will become clear. The Panel underscored the need for making physical, chemical, and biological observations all at the same time, since the physics, chemistry, and biology are all interrelated in the Earth system.

The Panel noted that we are today on the verge of establishing a global system of remote-sensing and Earth-based instruments for long-term, global, synoptic measurements of different processes on the Earth, and concluded that the data from the instruments and the concurrent development of numerical models that can run on supercomputers provide the potential for achieving significant advances in understanding global environmental change.

The Task Group on Earth Sciences of the National Research Council's Space Science Board (1988) underscored the need for global measurements and went on to propose a "Mission to Planet Earth" in a report that was part of a larger study on space science in the twenty-first century:

> The Earth is the only planet on which we can simultaneously make global satellite observations and deploy adequate instrumentation to

image the interior, including the mantle and core, in order to address fundamental questions . . . In this report the Task Group proposes a Mission to Planet Earth as an essential part of our country's program of space exploration. This proposal is not as paradoxical as it sounds, for it concerns the integrity and unity of the Earth as a planet, and it emphasizes the necessity for studying Earth as a whole. Only by a Mission to Planet Earth can we obtain a satisfactory degree of resolution of the changes in the earth environment over time, and therefore of history.

The Task Group went on to define an overall system that would include polar-orbiting, geostationary, and special orbit satellites, and a network of ground stations. In making this clarion call, the members of the Task Group joined their voices to those of others who had already recognized this need. The phrase "Mission to Planet Earth" appeared in the literature at least as early as the book, *Mission to Earth: Landsat Views the World* (Short, Lowman, and Freden, 1976), a compilation of early Landsat images, but more recently it has come to refer to a major initiative to study our planet simultaneously from space and from the ground (Ride, 1987; Rasool, 1987; Edelson, 1985).

Today, the "Mission to Planet Earth" encompasses an overall plan to use space-based technology to advance scientific knowledge of how the Earth works as a system, how the environment is shaped and changed, and how these changes affect and are influenced by humankind (see Figure 39). As conceived, the mission would establish and maintain a global observation system in space, which would perform multidisciplinary, long-term (at least fifteen years) measurements. It would include a comprehensive data system to allow quick and efficient access to large volumes of data at various levels of processing. The measurement technology and the data systems would provide the vital information needed to document global change so that we can understand and eventually predict it.

Thus, the elements of a mission to planet Earth are an essential part of such scientific programs as the World Climate Research Program and the International Geosphere-Biosphere Program. These two major international interdisciplinary programs, one focusing on the physical aspects of climate change, the other on the biological and chemical aspects, will be successful only if a Mission to Planet Earth in fact supplies the unique information about the Earth available through satellites. Figure 40 shows the various components of the mission, ranging from space platforms to global models.

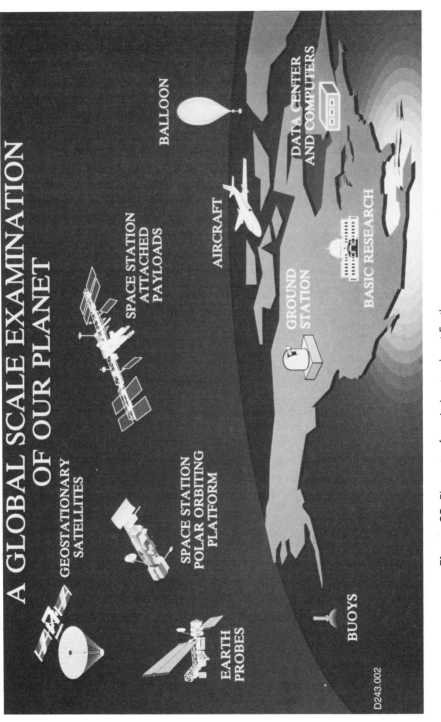

Figure 39. Elements of a mission to planet Earth.

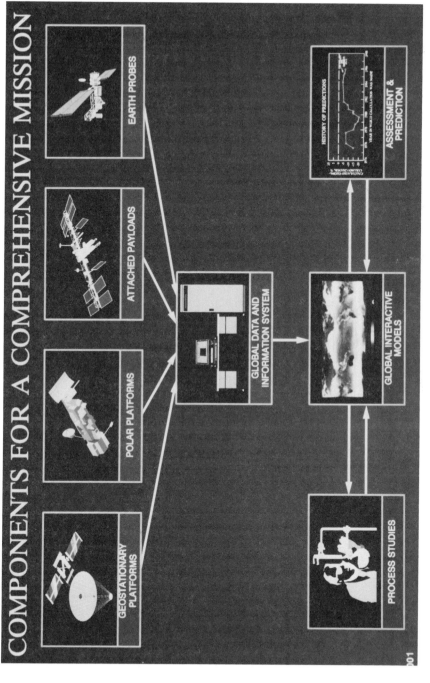

Figure 40. Specific components of a mission to planet Earth.

Mission to Planet Earth consists of three main space-based elements: polar platforms, Earth probes and other instruments in polar or nonpolar orbit, such as payloads attached to the Space Station, and geostationary platforms. I have already mentioned some possible Earth probe missions (see Chapter 4), which will begin in the mid-1990s. The Earth Observing System, which will fly on the polar platforms, is the centerpiece of the mission. It is an international effort involving the United States, Europe, and Japan. The launch of the first polar platform in this series is planned for the late 1990s. The geostationary platforms are planned for launch after the year 2000, and I will discuss them only briefly.

▪ THE EARTH OBSERVING SYSTEM

Together, the instrumentation, the polar platforms, and the data management system make up the Earth Observing System, or EOS (the acronym spells the name of the Greek goddess of the dawn). The idea of putting together a large system for simultaneous Earth measurements is not new, but it was given new impetus by the success of the remote-sensing missions discussed in earlier chapters and by NASA's interest in developing new technology in support of Earth observations. Originally, the polar platforms were linked to the development of the Space Station, since both were to be serviced in space to achieve long lifetimes. The serviceability concept for the platforms is not now part of the plan because the technology is not yet available. NASA concluded that several polar platforms in low Earth orbit supporting a set of highly capable advanced technology remote-sensing instruments held great promise. In 1981, NASA formed the Earth Observing System Science and Mission Requirements Working Group to develop the concept further. The information that follows is derived largely from the work of that group and its successor, the Earth Observing System Science Steering Committee.

The charter of the Earth Observing System Committee, made up of both NASA scientists and others from the major Earth science disciplines, was to define the low Earth polar orbit observations required to address the major Earth science questions. Although the EOS group focused on those instrument systems appropriate to low Earth polar orbit, it also noted that other measurement systems in nonpolar or

geostationary orbit should logically be included in the total mission to planet Earth concept. The EOS proposal builds on what is already available: the operational programs discussed in Chapter 3 and the Earth-observing missions discussed in Chapter 4. In its recommendations, the EOS group emphasized several basic aims: that existing data be preserved, that the current operational capability be sustained, and that currently planned research missions (for example, UARS, ERS-1, RADARSAT, TOPEX/POSEIDON, ADEOS, Lageos-II) and operational improvements be carried out. In particular, the EOS strategy to achieve a comprehensive dataset assumes the continuing availability of morning and afternoon atmospheric soundings and of morning surface images from operational and commercial satellites such as the ongoing NOAA, Landsat, and SPOT series.

Ultimately, EOS will cover the full range of the electromagnetic spectrum, from ultraviolet to microwave frequencies, using both active and passive remote-sensing techniques. Its data system will be designed to ensure that data can be extensively exploited in combination with information from land- and ocean-based instruments. The Earth Observing System instrumentation will provide information on a variety of Earth processes, from the radiative balance between the Earth and the sun to the motion of continental plates. The instruments will measure the global distribution of energy input to and energy output from the Earth; the structure, composition, and dynamics of the atmosphere from the ground to the upper atmosphere; global rates, amounts, and distribution of precipitation; the physical and biological structure, composition, and dynamics of the land surface, including terrestrial and inland water ecosystems; key components and processes of the Earth's biogeochemical cycles; ocean circulation, surface temperature, wind stress, sea state, and biological activity; the extent and age of sea ice, ice sheet elevation and roughness, the extent of glaciers and snow; and the motion of the Earth as a whole, including its rotation dynamics and the drift of the continental crust.

In developing the complement of EOS instruments, it became clear that all instruments need to be in orbit at the same time so that continuous observations of the Earth are possible. It was further recognized that studying a phenomenon using sensors with different operating principles or sensing parameters was likely to lead to greater insights into the phenomenon. The image from a high spatial and spectral resolution optical sensor, for example, could be compared in detail to the

same image obtained with a synthetic aperture radar for greater under-standing (McElroy, 1987).

In order to achieve accurate measurements from multiple sensors flying simultaneously, certain sets of instruments must be on the same platform. This allows rapidly changing atmospheric processes to be monitored simultaneously so that atmospheric corrections can be made to surface measurements. Optical instruments that provide images of the surface require corrections because of changes in atmospheric opti-cal properties, which can fluctuate within minutes; thus, tropospheric sounders, which can provide the necessary corrections, must be on the same platform as optical surface imagers so that both observe the same column of air below. Likewise, the chemical balance of trace species in the atmosphere can shift in seconds; since different species are mea-sured by different sensors, all such sensors must be on the same plat-form. And altimeter and laser ranging systems must fly together with global position system receivers to ensure precise location accuracy.

The weight of the minimum set of instruments that must fly together is greater than the launch capability of existing vehicles but less than the launch capability of those that will be available in the late 1990s. Rather than divide the sets of instruments into several packages, NASA has decided to put all the U.S. instruments for EOS on two polar platforms, EOS-A and EOS-B.

The EOS-A instruments will address scientific requirements for the study of the hydrologic cycle: evaporation, precipitation, and transport of water vapor; for monitoring the radiation budget and surface tem-perature; and for the study of clouds, biological activity and ecosys-tems, atmospheric circulation, and surface mineralogy. The EOS-B instruments will supply data for the study of stratospheric ozone, chemical species and winds, the global monitoring of tropospheric chemistry, ocean circulation and surface winds, earthquakes, and the growth and melting of glaciers. The European and Japanese polar plat-forms for EOS will provide measurements of atmospheric composi-tion, water vapor, aerosols, and clouds; mapping of mineral and vege-tation species for geology, agriculture, and forest resources; and measurements of sea surface temperature, color, and wind.

The design concept for the U.S. EOS platforms is not fixed at this time, but Figure 41 provides a schematic example. The platform is shown with its asymmetric solar panel configuration. It will be 16 me-ters long and 4 meters wide and will weigh 13,600 kilograms. Because

Figure 41. Schematic representation of NASA's polar-orbiting platform EOS-A. For scale, note that the platform itself, excluding the asymmetric solar panel, is 16 meters long.

of its large size and the multiplicity of instruments that will need to be accommodated simultaneously, many have voiced reservations about this configuration. Some have called for fewer instruments on more platforms, claiming that such a multisatellite system would minimize the chance of a massive, single-point failure either on launch or in space, would be easier to implement, and would cost less. To begin to address this issue, NASA has proposed that the schedule for the second polar platform, EOS-B, be flexible so that it could serve as an alternative in case of the failure of EOS-A. To be effective, this flexibility must be built into the overall funding support. Clearly, the choice of platform is an important one for the success of the program, and further discussions will be required to find the best solution, particularly for replacement of instruments that fail. But since the new measure-

ment capability is the key to providing the necessary data, I will focus here on the instruments rather than on the specific spacecraft configuration that might be used.

Research and Facility Instruments

In summary, current (1989) plans for the U.S. polar platforms include a total of twenty-eight instruments in two basic categories: research and facility. Several other instruments will be carried by the European and Japanese platforms and on the U.S. Space Station. The facility instruments will be advanced versions of those currently flying. The research instruments will extend Earth measurement technology. Since EOS is not yet an approved mission, the instrument complement is not yet confirmed. Here, I will provide a short summary of the facility instruments that have been proposed as of 1989 and then go into more detail about two new facility imaging instruments that demonstrate advances in technology. Further information about the EOS system is available in the ten-volume report of the NASA Earth Observing System Science Working Group (1984–87), in particular, volume 2, and in the report, *Earth Observing System: 1989 Reference Information* (Goddard Space Flight Center, 1989). Other useful information appears in McElroy and Schneider (1984, 1985), McElroy et al. (1985), and the European Space Agency report (1986).

The following list briefly describes the facility instruments currently planned for the polar platforms. Over twenty research instruments have also been proposed as possible additions to the total complement. They include instruments for accurate solar irradiance measurements, imaging of lightning, and wind and wave measurements; and instruments to measure the Earth's magnetic field or perform high-precision location tasks, among others.

> *Atmospheric Infrared Sounder (AIRS).* An infrared sounder for atmospheric temperature and trace chemical species measurements with an instantaneous field of view ranging from 15 to 50 kilometers and an ability to scan 49 degrees to either side of the ground track. It will have very high spectral resolution, with 115 spectral bands. Temperature measurements are expected to be accurate to better than 1 degree Celsius with a resolution of 1 kilometer in the vertical.

Altimeter (ALT). A dual frequency (5.3 gigahertz and 13.6 giga-hertz), TOPEX-class radar system for studying ocean and ice surface topography. The altitude precision will be at least 2 centi-meters.

Advanced Microwave Scanning Radiometer (AMSR). For measur-ing atmospheric water vapor, sea surface temperature, and sea surface wind. It includes a multifrequency (6.6 to 31.55 gigahertz), electronically scanned antenna with a temperature resolution of better than 1 degree Kelvin, and has a spatial resolution of 9 to 50 kilometers and a swath width of 1,200 kilometers.

Advanced Microwave Sounding Unit (AMSU). A radiometer for measuring atmospheric temperature and humidity profiles. It pro-vides temperature measurements with a resolution of 0.25 to 1.3 degrees Celsius from the surface to an altitude of 40 kilometers in fifteen spectral channels ranging from 23.8 to 89 gigahertz; water vapor profiles in five channels from 89 to 183 gigahertz; and an instantaneous field of view of 50 kilometers for temperature and 15 kilometers for water vapor, with coverage of 50 degrees on either side of the ground track.

Atmospheric Lidar (ATLID). A laser-based instrument for measur-ing cloud top height, atmospheric inversions, and aerosol layer distribution. It will operate in the 1.06- or 1.53-micrometer spec-tral range, with a vertical resolution of 100 to 500 meters and a horizontal resolution of 10 to 50 kilometers.

Geoscience Laser Ranging System (GLRS). A high-precision laser system for measuring tectonic plate motion and for topographic mapping of ice sheets, land, and cloud top surfaces. It has three major subsystems: a laser ranging/altimetry subsystem, an optical tracking system, and a navigation and altitude determination sub-system. The diameter of the spot ranges from 80 to 290 meters on the ground. The system uses retroreflecting cubes embedded in the surface target.

High-Resolution Imaging Spectrometer (HIRIS). An imaging spec-trometer providing detailed localized measurements of geological, biological, and physical processes with a resolution of 30 meters over a swath width of 30 kilometers. It has a programmable point-ing capability. The instrument covers the spectral ranges of 0.4 to 2.5 micrometers divided into almost 200 spectral bands and has an on-board spectral and radiometric calibrator.

High-Resolution Imaging Spectrometer (HRIS). An imaging spectrometer for land and coastal remote-sensing applications, including mapping of different types of geological structures and vegetation species, geology, agriculture, and forest resources. The spectral range is from 0.4 to 2.5 micrometers with a spectral resolution of better than 20 nanometers. There are 10 bands, selectable from 100. The swath width is 20 to 60 kilometers and the ground resolution 20 to 50 meters.

Intermediate and Thermal Infrared Radiometer (ITIR). A spectrometer providing a high-resolution thermal imaging capability complementary to the HIRIS for surface biology, mineralogy, soil properties, surface temperature, and geothermal resources. It covers a spectral range of 0.85 to 11.7 micrometers. Resolution is expected to be 15 meters in the near- and short-wavelength infrared region and 60 meters in the thermal infrared region.

Laser Atmospheric Wind Sounder (LAWS). A doppler lidar system for direct tropospheric wind measurements using a carbon dioxide laser transmitter. It has a vertical resolution of 1 kilometer and covers a horizontal area of 100 kilometers square, for a radial velocity measurement of 1 meter per second.

Medium-Resolution Imaging Spectrometer (MERIS). An imaging spectrometer primarily to monitor global ocean color in 9 spectral bands, which can be selected from a total of 60 in the spectral range of 0.4 to 1.04 micrometers. It has a spatial resolution of 500 meters, with a cross-track scan of 1,000 to 1,500 kilometers. It also has a 20-degree tilt capability that allows it to avoid sunglint.

Moderate-Resolution Imaging Spectrometer: Tilt (MODIS-T) and Nadir (MODIS-N). Imaging scanning spectrometers for measuring land vegetation and geology, ocean surface temperature and color, and atmospheric aerosols and clouds. MODIS-T has a 50-degree tilt capability and a spectral range of 0.4 to 1.04 micrometers in 64 bands. For MODIS-N, the field of view ranges from a square 250 kilometers on a side to 1 kilometer on a side; the swath width is 1,800 kilometers. The spectral range is 0.4 to 14.2 micrometers in 40 spectral bands.

The European polar platform will carry as facility instruments the medium-resolution imaging spectrometer (MERIS), the high-resolution imagery spectrometer (HRIS), the atmospheric lidar (ATLID), and in-

struments for measuring clouds and radiation. The Japanese platform will carry the intermediate thermal infrared radiometer (ITIR), the advanced microwave scanning radiometer (AMSR), and the laser atmospheric wind sounder (LAWS). Each will carry research instruments.

The U.S. polar platforms will also carry a communications package; a command, communications, and data handling system; a search and rescue system similar to the one carried on current NOAA satellites; and the Advanced Data Collection and Location System (ADCLS/ ARGOS-2), which is used for locating and transmitting data from drifting platforms, balloons, and automatic measurement stations in remote sites. The improved doppler-based system (ARGOS-2), which operates at a frequency of 401.650 megahertz, will provide a location accuracy of 1 kilometer and a platform speed determination of 30 centimeters per second. Because of power and weight limitations, a synthetic aperture radar has not been included in the initial plans, but it may be added later or flown on a separate platform.

Instruments by Measurement Category

It is not possible to construct a one-to-one correspondence between measurement parameter and instrument, since some instruments make multiple measurements. Moreover, in most cases, several different instruments are needed to satisfy the requirements within one measurement category. Table 1 shows how the instruments will be used to measure various parameters.

MODIS and HIRIS

The Moderate-Resolution Imaging Spectrometer (MODIS) and the High-Resolution Imaging Spectrometer (HIRIS) will focus on collecting data essential to understanding biogeochemical cycles, the hydrologic cycle, geological processes, and long-term climate. Because of their improved spatial, temporal, and spectral resolution, these instruments may well make it possible to recognize individual species or functional groups of organisms and the complex patterns typical of ecosystems on a global scale. This information is expected to provide new insights in ecological studies.

MODIS will cover a spectral range from visible to infrared with a resolution of about 1 kilometer and a swath width of 1,500 kilometers.

Table 1. EOS facility-class instruments by measurement category.

Upper atmosphere and radiation
 Earth radiative balance: AIRS, AMSU, MODIS-N, MODIS-T
Lower atmosphere, clouds, and precipitation
 Precipitation rate: AMSR
 Atmospheric temperature and water content: AIRS, ATLID, AMSU,
 AMSR, MERIS, MODIS-N, MODIS-T
 Cloud properties: AIRS, HIRIS, ITIR, ATLID, MERIS, MODIS-N,
 MODIS-T
 Aerosols: ATLID, LAWS, HIRIS, MERIS, MODIS-N, MODIS-T
 Tropospheric winds: LAWS
Surface temperature
 Oceans and land: AIRS, AMSU, AMSR, ITIR, MERIS, MODIS-N
Oceans, fresh water, sea ice
 Biological activity: MERIS, MODIS-N, MODIS-T
 Ocean circulation: ALT, MERIS, MODIS-N, MODIS-T
 Ocean waves: ALT
 Ocean surface winds: ALT, AMSR
 Sea ice extent and character: AIRS, AMSU, AMSR, HIRIS, MERIS,
 MODIS-N
Land surface, snow and ice, mapping fires and floods, geodynamics
 Land surface composition: HIRIS, HRIS, ITIR, MERIS, MODIS-N,
 MODIS-T
 Land surface biological activity: HIRIS, HRIS, MERIS, MODIS-N,
 MODIS-T, ITIR
 Surface topography: ATLID, GLRS
 Plate and glacier motion: GLRS
 Snow and ice extent and character: AIRS, AMSR, HIRIS, MERIS,
 MODIS-N

Since global coverage means that the resolution cannot be as fine as is necessary to monitor many important smaller-scale processes, MODIS will be complemented in the visible and near-infrared by HIRIS, with a resolution of 30 meters and a swath width of 30 kilometers. HIRIS can be thought of as a "zoom lens" for MODIS. The broader spectral range will be covered by other thermal and microwave imagers.

MODIS and HIRIS will use new high spectral resolution technology, which permits measurements in more spectral bands than was previously possible, to provide visible and infrared images. Increased spectral information will allow vastly improved data interpretation, including better discrimination of specific species and of such physiological parameters as the age and moisture content of the biological popula-

tions under observation. In order to take full advantage of the high-resolution information, the data systems must be able to cope with much higher rates than are currently used.

MODIS is designed to be able to observe in more than 100 spectral bands from the visible to the infrared (0.4 to 2.4 micrometers) with a spectral resolution of between 0.01 and 0.03 micrometers (10 and 30 nanometers). MODIS will also provide images, in the infrared spectral windows of the atmosphere, of 3 to 5 micrometers and 8 to 14 micrometers, with resolutions of 50 and 500 nanometers, respectively. The instrument will consist of two parts, one able to tilt its viewing axis to view fore and aft of the subsatellite point, the other viewing directly downward at all times. The tilt capability allows the instrument to avoid sunglint from the ocean surface and to study the reflectance of forest leaf canopies at different angles. MODIS will represent a substantial improvement over existing and planned Advanced Very High Resolution Radiometer (AVHRR) systems, which have only five spectral bands.

The MODIS design derives directly from the experience gained from the Coastal Zone Color Scanner on Nimbus-7 (see Chapter 2), the AVHRR, and the Thematic Mapper instrument. Thus, it has a resolution of 1 kilometer and a swath width of 1,500 kilometers, which will assure complete coverage at the equator at least every two days. This improved resolution will permit the detection of changes at the surface and of clouds that are now undetectable with the current, daily 4-kilometer resolution AVHRR data.

As noted above, the MODIS system consists of two instruments, MODIS-Tilt (MODIS-T) and MODIS-Nadir (MODIS-N). MODIS-T allows for viewing the surface at predetermined angles fore and aft of the subsatellite point or nadir. Current plans call for an imaging spectrometer with a 64 by 64-element silicon detector. The 1,500-kilometer swath is scanned in 9.5 seconds, the time required for the subsatellite point to advance 64 kilometers. The optical system separates the image into sixty-four spectral bands approximately 10 nanometers in width and covering the spectral range from 400 to 1,000 nanometers. Figure 42 shows the MODIS-T scan geometry.

MODIS-N is a more conventional imaging radiometer with a cross-track scan mirror and collecting optics, and a filter that divides incoming energy between two optical paths: one for the range of 0.4 to 1.0 micrometers, which has eighteen spectral channels; the other for the

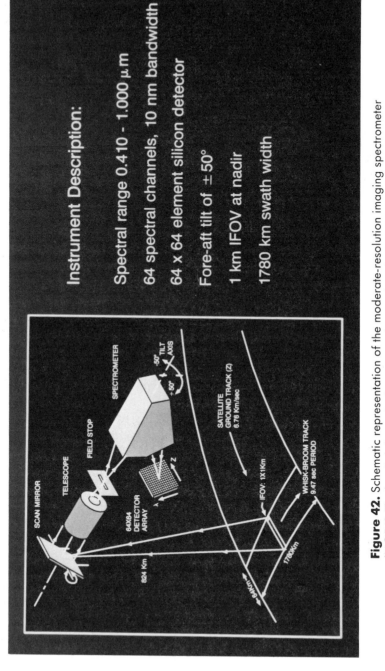

Figure 42. Schematic representation of the moderate-resolution imaging spectrometer (MODIS-T), showing the optical system and ground track scan geometry.

infrared range of 1 to 12 micrometers. Of particular interest for the study of soil moisture and evapotranspiration and for measuring ocean surface temperatures are the seven spectral bands in the 3.5 to 4.0 micrometer and 8.5 to 12.0 micrometer window regions. When taken together, the data rates from both instruments are high. With a careful selection of an optimal subset of all available spectral channels, the data transmission rate could be limited to about 8.8 megabits per second during daylight and 1.2 megabits per second at night. Because of this large amount of data and the need for rapid data delivery, specifically in support of field programs and oceanic expeditions, on-board processing will be used to provide information in a direct broadcast mode.

MODIS will not replace the operational satellite capability being planned for the same period. Rather, an operational NOAA payload will most likely be flying in an orbit similar to that of MODIS, providing thermal infrared coverage of the entire Earth four times per day. The AVHRR will continue to provide meteorological, land vegetation, and ocean surface temperature measurements to complement the information from MODIS.

In order to correct MODIS measurements for atmospheric absorption and/or contamination by temperature, humidity, and variations in clouds, simultaneous measurements that provide direct information on atmospheric properties in narrow spectral regions are essential. Narrow windows can be chosen to avoid absorption of water vapor, for example. In order to increase spectral resolution, spatial resolution can be decreased; that is, in order to get a large enough signal in the narrow spectral region, a larger surface area must be covered. Suppose, for example, that a MODIS channel at 8.55 micrometers has a width of 0.5 micrometers and a spatial resolution of 1 kilometer. The transmission of the atmosphere through this channel is about 78 percent. A high-resolution channel at 8.866 micrometers, with a width of .0075 micrometers, has a transmission of 95 percent, but a surface area at least 50 kilometers on a side must be viewed in order to get enough signal. Thus, it is essential to have an atmospheric temperature and humidity sounding capability alongside MODIS. This will be provided by the Atmospheric Infrared Sounder.

Our ability to monitor surface conditions will increase considerably when simultaneous and selective sampling of specific areas with both low resolution (500 meters) and high resolution (30 meters) becomes

possible. This is the conceptual basis for the integrated MODIS/HIRIS sensor configuration proposed for EOS. This multilevel sampling by remote sensing has long been advocated for range and forest management, and has been used in such applications as locust monitoring in the desert and crop forecasting. But there are difficulties in coordinating, obtaining, and registering contemporaneous coverage from different platforms. Simultaneous MODIS and HIRIS data from the same space platform would help to solve this registration problem. Moreover, simultaneous high-resolution data would also provide an important intermediate spatial and spectral link between ground measurements and the low-resolution data.

More detailed coverage—finer spatial resolution and more spectral resolution—is also needed on a local basis for land and inland water surfaces. To understand the signal from a sensor like MODIS, it is necessary to recognize that many processes contribute to the signal that comes from the 1 square kilometer of resolution; to understand fully how this averaging takes place, it would be valuable to have measurements at a resolution much smaller than 1 kilometer. In addition, some processes that are important at the global scale take place on scales that are much finer, often as small as tens of meters. Examples include oceanic upwelling and mixing along narrow fronts, forest clearing, desertification, and changes in snow and ice boundaries. It is also important to be able to develop accurate and detailed maps of features that change rapidly over the surface, such as surface geologic features, soil types, and continental rock units.

The High-Resolution Imaging Spectrometer (HIRIS) has been designed to meet the need for high-resolution data in the spectral range from visible to near-infrared. It will acquire simultaneous images in 192 spectral bands in the 0.4- to 2.5-micrometer range, with a spectral sampling interval of 0.10 micrometers. The spatial resolution will be 30 meters over a 30-kilometer swath. HIRIS can be pointed to focus on specific areas that require high-resolution study. It will also be capable of looking forward or backward along the satellite ground track to observe directional reflectance properties and variations in atmospheric attenuation with viewing angle. Cross-track pointing allows multiple viewing opportunities during one orbit revisit cycle, currently planned for sixteen days.

This very detailed spectral resolution will permit new kinds of studies of soils, suspended sediments and plankton, snow, and terrestrial

vegetation. Together with the data from MODIS, dynamic short-term changes that occur in soils will be measured. Detailed examination of suspended sediments and phytoplankton in coastal and inland waters, and globally, will be possible. The high spectral resolution of HIRIS allows a much better definition of snow characteristics from space. By providing detailed measurements of the reflectance characteristics of the snow pack and of impurities absorbed in the snow at different elevations, it will clarify our understanding of the radiation balance. Finally, HIRIS will permit the study of biochemical processes in vegetation canopies by continuously sampling selected systems for signs of stress or degradation.

The 30-meter resolution is designed to focus on important processes in ecosystems. The largest trees create openings of this size when they fall. Since trees have an important effect on the gas balance of the atmosphere—absorbing carbon dioxide and emitting oxygen, for example—it will be valuable to see these effects directly. Because HIRIS is designed to target specific areas with very high spectral and spatial resolution, it has a very high raw data acquisition rate, about 512 megabits per second, which will require a disciplined approach to data processing. Various data-compression schemes are under study.

Orbit

The observation requirements included in the EOS plans can all be met in the current design with a polar-orbiting satellite in sun-synchronous orbit. With two platforms, an ideal arrangement is to have one equator crossing time in the morning and one in the afternoon. The morning platform allows viewing of the land surface with an adequate level of solar illumination prior to the daily cloud buildup and provides an illumination angle that highlights geological features. Ocean observations in the visible, on the other hand, need good solar illumination, and hence a high solar inclination, which argues for a near-noon time for ocean instruments. Vegetation monitoring requires cloud-free skies, which calls for an early to mid-morning overpass. Studies of soil moisture through thermal properties would require an overpass time around 1330. The afternoon crossing time satisfies the operational need for timely delivery of the major evening forecast for the continental United States, .so the first U.S. platform will operate in the afternoon crossing mode. The European Space Agency platform will have a

morning crossing time. Another U.S. polar platform is being discussed for the afternoon time, and a Japanese platform that does not yet have its crossing time set will probably have a morning crossing time.

In addition to the equator crossing time, the other important element of the orbit is the altitude. The orbit must be higher than about 500 kilometers to avoid excessive drag from the atmosphere. The higher the orbit, the easier it is to achieve broad coverage. The lower the orbit, however, the less power is required for active radar instruments to sense the Earth, so a compromise is necessary. A second issue constraining the altitude is the possibility (not now planned, but under discussion) of servicing the polar platform from space. The fuel required to move platforms or servicing vehicles to and from operating altitudes and the orbits attainable by the U.S. Space Shuttle would limit the range of the polar platform to no more than 850 kilometers. In-flight servicing may become possible at a later time as the technology develops and becomes more cost-effective. In the meantime, the mission systems will be designed to allow for servicing should it become feasible.

The full complement of platforms envisioned for the Earth Observing System consists of six polar platforms and the Space Station, which will carry a number of attached payloads. The six platforms are the U.S. NASA Polar Platforms 1 and 2 (NPOP-1 and NPOP-2), a separate NOAA operational polar orbiter, two European Space Agency polar platforms (EPOP-1 and EPOP-2), and a Japanese polar platform. NPOP-1 and EPOP-1 are scheduled for launch in 1998. NASA's second platform, NPOP-2, and Japan's polar platform are expected to be launched in 1999, and the European Space Agency's second platform in the year 2000.

The platform orbits have been chosen to be complementary. The NASA polar platforms and the second ESA polar platform will each fly at an altitude of 705 kilometers, which is the same as the Landsat orbit. This provides a ground trace that repeats every sixteen days, with an approximate repeat pattern every two days. Instruments that can look out to 45 degrees from nadir will be able to obtain coverage every two days. The orbit has a slight eccentricity and a point of closest approach (perigee) near the North Pole to ensure a "frozen" sun-synchronous orbit (Casey, 1989) (see Chapter 2).

The NOAA polar orbiter, the first ESA polar platform, and the Japa-

nese polar platform will fly at an altitude of 824 kilometers. This allows wide-swath instruments to obtain global coverage every three days with 90 percent coverage every two days. Coverage for high-resolution, narrow-swath instruments can be expanded by using the same instruments on both the morning and afternoon platforms. The attached payloads will be operating in the Space Station orbit, which has an inclination of 28.5 degrees and an altitude of 400 kilometers.

Data and Information System

The overall goal of the Earth Observing System is to achieve a comprehensive data and information system that will provide the Earth science research community with reliable access to available Earth science data. To do this, EOS will develop an integrated data system to permit quick transfer of large volumes of data at various levels of processing, including geophysical parameters, model output, and algorithms (or transformation rules) used to process EOS data (Dutton, 1989).

The proposed data and information scheme provides efficient transfer of information. Among its provisions: Data from operational instruments may be made available to any user for any use by the governments participating in the program as part of their operational mission. Research data will be made available to users from the participating countries at a cost not to exceed that of reproduction and transmission. The principal investigators on the research teams will not be able to reserve a period of exclusive use, and users from other entities will be encouraged to seek agreements for cooperative activities to permit access to data on these terms. Enhanced data, research results, and algorithms specific to particular disciplines will be made available to other researchers on the same basis as the original data through the data-providing agency (Dutton, 1989).

To meet the science and applications needs, the EOS data and information system is being designed to operate in two modes. The first will allow investigators interested in interdisciplinary studies access to a wide variety of different kinds of data. A broad segment of the Earth science research community will be involved in the development and subsequent management of the system. But the system will also function in a more traditional sense as a data system for the EOS program

itself by managing data transmission, ground-based data distribution, and processing and storage of the data for the duration of the mission (NASA Earth Observing System Reports, vol. 2, 1987).

This will be a formidable task. The EOS data stream will comprise more than 90 percent of all the space science data in the 1990s. According to current estimates, it appears that the research and operational data systems must be capable of handling a peak data rate from space of over 600 million bits per second (Mbps) and an average of about 50 Mbps. In comparison, note that a single television channel broadcasts about 3 Mbps; the EOS data rate is comparable to 200 channels broadcasting at once. The current Geostationary Operational Environmental Satellites transmit at a data rate of somewhat over 2 Mbps of processed data and a total of somewhat over 4 Mbps of raw data. A typical day for Landsat would see the collection of 200 scenes from the Multispectral Scanner and 50 scenes from the Thematic Mapper. This represents about 128 gigabits of data per day, or 1.5 Mbps. The two NOAA polar-orbiting environmental satellites produce about 35 gigabits per day, or 0.4 Mbps. The sum of all of these is about 6 Mbps. It should be noted that of all these datasets, only the Thematic Mapper processing system has a substantial backlog, but this is the result of an undersized data system rather than of technological limitations.

The sum of the maximum amount of data from the two new polar platforms plus the continuing data from the geostationary weather satellites, roughly 606 Mbps, is somewhere between ten and a hundred times the current data stream. This is a large number, but it still will require only modest increases in data system performance over the next decade. Thus there is no reason to believe that the required data system is technically beyond reach. This is especially the case because much of the increase is produced by only a few high data rate instruments, in particular, the High Resolution Imaging Spectrometer, which in itself has a raw data acquisition rate of about 512 Mbps.

The design of the data system incorporates three important ideas: integration of research and operational data, access at several levels of processing (a nonhierarchical system), and inherent flexibility. The design is intended to preserve the existing operational space-to-ground communications while using the Tracking and Data Relay Satellite System (TDRSS). The nonhierarchical nature of the system helps users to access data in the system. Inherent flexibility allows various parts of the system to vary greatly in capability and to evolve without disrupt-

ing the whole. Using the existing system together with TDRSS allows mutual backup and makes it easier to increase both research and operational data streams.

A larger issue is that of finding the best and most efficient way in which the science and applications community can make use of the data stream. An important lesson learned over the past few years from various experimental or "pilot" data systems is that data systems cannot afford to try to provide every kind of data to every user. User sophistication is as necessary as data system sophistication. If the EOS data and information system is to work and be cost-effective, it must develop its capabilities in the context of a knowledgeable user community. This means that part of the EOS program must be devoted to educating the new users, and it puts the responsibility for coming to an agreement on the final structure of the system on both the program managers and the users.

■ EARTH PROBES AND ATTACHED PAYLOADS

In NASA's terms, Earth probes are moderate and low-cost missions ranging from several million dollars to the order of 100 million dollars, whose total costs do not exceed about 150 million dollars (in comparison, EOS's projected costs range from 15 to 30 billion dollars). Earth probes include instrument development, flight on inexpensive satellites, and attached payload development for the Space Station. This category has also been referred to as an Earth Explorer mission series (Committee on Earth Sciences, 1988). In Chapter 4, I discussed three possible missions now under consideration as Earth probes: the Tropical Rainfall Measurement Mission, the ARISTOTELES gravity mission, and the ocean color SeaWiFS program. The U.S. Navy's follow-on to its altimeter mission GEOSAT—planned to start in 1990—although not designated as an Earth probe, is in this general, low-cost category.

Two other Earth probe missions in the lower cost range are now under discussion. The first is the Total Ozone Mapping Spectrometer (TOMS) now on board the Nimbus-7 satellite. Flight of this instrument on a new satellite would provide continuous global coverage of changes in the ozone distribution, including monitoring of the seasonal ozone "holes" in the polar regions. NASA is negotiating the next flight of the instrument on the Soviet Meteor-3, with subsequent flights on a

U.S. satellite economically launched by a Scout rocket, and the Japanese ADEOS.

A second possible low-cost Earth probe would be a measurement of the Earth's magnetic field by U.S. and French instruments carried on a French satellite. This is the joint Magnetic Field Experiment/Magnolia program.

Studies are under way on various instruments that could be carried on the U.S. Space Station as "attached payloads." These include a rain-mapping radar, a lightning imager, a broadband radiometer, and a spectrometer for stratospheric aerosol and gas measurements.

▪ GEOSTATIONARY PLATFORMS

The geostationary platforms (GEO-EOS) of Mission to Planet Earth are the next step beyond the polar platforms. They are currently being studied for development in the mid-1990s, with the earliest possible launch at the beginning of the twenty-first century. These platforms would carry instruments to complement those on EOS polar platforms. They would enhance, and in certain cases replace, the existing set of five geostationary platforms that currently provide operational radiation, atmospheric, and land and ocean measurements, and data transmission and location services.

According to current discussions, the geostationary platforms would carry instruments with very large antennas in order to achieve high resolution in space and time. New types of instruments, such as scanning altimeters and scatterometers, and very high resolution microwave imagers and radiometers, are also being discussed. The spacecraft will most likely be three-axis stabilized like the latest GOES series (Jedlovec, Wilson, and Dodge, 1989) and will use the EOS Data and Information System to transmit and disseminate data.

As proposed, Mission to Planet Earth will consist of a satellite-based observing system, a network of Earth-based measurement programs, a coordinated data system that both archives and disseminates data, and large computers to assimilate the data and to model Earth processes.

The satellite-based observing system would consist of at least five geostationary satellites, the minimum necessary to cover the entire

Earth for continuous global measurements. It would have a set of from two to six polar-orbiting platforms to cover the full globe, including the polar areas, and to provide platforms for a variety of instruments that must be closer to the Earth. In addition, a series of special missions requiring other orbits would also be included. These could range from the Earth probes discussed above and short-duration Shuttle flights to one- to three-year missions in nonpolar orbits (such as TOPEX/ POSEIDON) and permanent constellations such as the Global Positioning System.

A complementary Earth-based observing system provides measurements of those quantities that cannot be determined from space, allowing increased resolution in regional studies and supplying calibration and verification of space observations. Examples include long-term sea level stations, biological monitoring stations for studies of terrestrial and oceanic ecosystems, seismic stations on Earth and at the sea floor, and GPS receivers and laser corner reflectors on the Earth surface for monitoring tectonic deformation. Wherever applicable, the data should be transmitted in real time and integrated with observations from space. The National Research Council Task Group on Earth Sciences of the Space Science Board proposed that this network would eventually evolve into a "Permanent Large Array of Terrestrial Observatories" (PLATO).

The data system is a crucial element. A central data authority is needed to identify data location, arrange for access to data, ensure that data are adequately stored and protected, and establish formats and other conventions for easy transfer. When the major new observing systems are in place, data rates will be very high, requiring much selective averaging and heavy use of new technology, possibly beyond videodiscs to new storage and retrieval technologies.

Supercomputers for assimilating the data and running models of the Earth system are the crucial and integrative element of the entire program. The data by and large tell us what the Earth is doing now, but models are required for understanding the processes that explain the behavior of the Earth system now and for making projections, and eventually, actual predictions of future change. We are dealing with a complex, turbulent global system of living and nonliving material on many scales, which involves a wide variety of substances and properties over a distance ranging from the core of the Earth to the outer atmosphere. Modeling the system requires the best datasets possible, the

fastest computers, and the most imaginative ideas. In turn, this modeling can provide a context and a direction for future observations, and a basis for making environmental policy. Thus, the planning for a global Earth Observing System is well in place.

But for EOS and Mission to Planet Earth to become a reality, long-term funding commitments, not yet in place, are required. As of late 1989, EOS was on schedule to be proposed as an approved NASA program in early 1990. NASA's Earth Science and Applications Division had reorganized to focus on EOS, and Goddard Space Flight Center had been assigned as the lead center for EOS project management. Although the U.S. government appears favorably disposed toward NASA's plans for this major new effort, its large cost means that much work will have to be done by both NASA and the outside Earth science and applications community to achieve the necessary funding commitment.

6

PREPARING FOR THE
TWENTY-FIRST CENTURY

The dream of a constellation of satellites that will provide a continuous stream of information about the state of the Earth and monitor its changes is almost a reality. As we saw in Chapter 5, there are no major technical barriers to constructing such a constellation: the satellites and the sensors can—and are—being built. Even the problem of how to cope with massive amounts of data is being addressed through new developments in computing and communication technology. Computers are also becoming powerful enough to run models of the processes that govern global change, and useful forecasts and predictions are being made. And many countries have developed the technology to participate in this effort. Now we need to turn the research and the technical developments that are rapidly taking place into a comprehensive operational system. By "operational" I mean a program to which a commitment is made for observing and disseminating data on a routine and continuing basis. The existing operational system is limited in scope, and even the Earth Observing System is proscribed by its fifteen-year lifetime. To develop the comprehensive, long-term system that is needed, the main issues that remain to be addressed are institutional, but as is often the case, these are the most difficult. National security, technology transfer, data dissemination, cost, and international coordination are all involved. In this chapter, I will show how all these factors work against a global operational system, and how we might overcome enough of them to make such a system work for the indefinite future.

The development of the existing meteorological satellite system has demonstrated that strong international cooperation leads to more

efficient planning and operation. Meteorological satellites can resolve features only on a scale of a kilometer, but the new land-sensing instruments on the Landsats, SPOT, and the Soviet KFA-1000 can resolve objects on a scale of tens of meters. Previously, only classified and military measurements achieved such resolution, but now the new high-resolution civil systems, since they can observe targets of intelligence and military interest, can threaten national security. The SPOT and Landsat satellites, for example, provided excellent pictures of the Chernobyl nuclear reactor explosion.

Even nonmilitary meteorological data are considered by some countries to be critical to national security. For several years, India refused to allow access to the cloud images from its newest geostationary satellite for reasons of national security. The irony of this situation is that the satellite was built and launched by the United States, which then found itself excluded from access to the data.

The parallel development of military- and civilian-based programs is another factor that affects costs and international coordination. In some cases, such as the U.S. Navy GEOSAT program, data have only been made available after military usefulness has ceased, or only certain data products have been released. More could be done to release other types of retrospective data that are valuable for scientific research and to transfer appropriate remote-sensing technology into the civilian sector for greater cost efficiency.

At the same time, the private commercial sector has become aware of the potential profit in selling remote-sensing data, either in raw form as it comes directly from the satellite, or in a value-added form suitable for many of the applications discussed in Chapter 3. Governments, particularly those of United States and France, have also become aware of this market and have begun to support the transfer of the potentially profit-making aspects of remote sensing to private entities. The government of the USSR, for example, has offered new high-resolution data at a cost designed to bring in new revenues (Blanchard, 1988).

The results to date have not been promising because the profits are not sufficient to support a fully commercial venture. In the United States, a private corporation, the Earth Observation Satellite Company (EOSAT), a joint venture of Hughes Aircraft Company and the General Electric Company, was founded to carry out Landsat activities. But the government and EOSAT have not been able to come to an agreement about the level of support needed for starting up a purely com-

mercial activity. The system came close to termination in March 1989. Fortunately, the government was able to put together a coalition of agencies to come up with the necessary funds for continuing the program for one more year, but new satellites in the series may be in jeopardy unless a permanent support policy is established (Marshall, 1989).

The French government supports its land-sensing system SPOT with a subsidy from public funds through the commercial company, SPOT Image; the worldwide sales revenues have been growing. SPOT Image has increased its income by offering value-added processing: In 1986, an image of a scene 60 kilometers on a side with radiometric and geometric corrections cost about 1,500 dollars for a digital tape and about 800 dollars for a photograph. The same image projected onto a specific cartographic projection cost about 2,500 dollars for a digital tape and 1,600 dollars for a photograph.

Eventual recovery of the real cost of satellite data is often necessary in developing a commercial venture, but it has an adverse effect on both noncommercial users, such as scientific researchers, and developing countries. Access to remote-sensing data by countries in the satellite flight path has generally been subject to an "open skies" policy: if the country wishes it, the data from that satellite have been made available and can be collected through a local ground station subject to negotiation of an access agreement with the satellite operator. But today, as countries try to recoup the costs of expensive systems, many satellites send data only to their own ground stations. The costs to other countries are increasing. In the world of the twenty-first century, a system that allows both developing and developed countries to have access to such environmental data is essential. The high cost of data to researchers can impede the flow of scientific research and leave valuable data unstudied. This has happened with much of the Landsat data. Thus cost, national security, international interests, and scientific and commercial interests are all intertwined. There is hope that these issues can be successfully addressed. But new mechanisms will have to be set up to make it work.

■ TOWARD NATIONAL AND INTERNATIONAL COORDINATION

The first step in addressing potential conflict is to bring the interested parties together, and to some extent, this has already happened. Today

there are more than two hundred national and international advisory and policy groups for civilian Earth observation activities alone.

In his overview of public international law concerning civilian remote sensing, Uhlir (1986) provides a comprehensive list of existing groups (see also Uhlir and Shaffer, 1985). A comprehensive review of all of these groups is not possible here, but I will attempt to summarize the role and composition of the major ones to give a sense of ongoing coordination activities. (For further information, see Uhlir, 1989; Hodgkins et al., 1985; NOAA and NASA, 1987; and the Office of Technology Assessment, 1985.)

National Coordination

The first stage in the process of developing new space programs is the development of a plan. In the United States, this means that the agencies involved with space programs work with other agencies, the Office of Management and Budget, and Congress, as well as the outside communities of scientists and engineers, commercial users, and the public. NASA, for example, has advisory committees at each level of the organization. NOAA, as the primary domestic user and disseminator of meteorological satellite data, also uses advisory committees, but traditionally to a lesser extent than NASA. NASA and NOAA also have joint working groups to address interagency subjects of common concern related to satellites.

The Office of Science and Technology Policy receives broad oversight on remote sensing and global change from its Committee on Earth Sciences (CES), which is part of the Federal Coordinating Council for Science, Engineering, and Technology (FCCSET). Within FCCSET/ CES is a subcommittee on Global Change, which is developing an interagency strategy with a strong emphasis on satellite measurements (Committee on Earth Sciences, 1989). An Interagency Working Group on Data Management for Global Change is addressing the problems associated with the enormous amounts of data that are expected. Another group, the Federal Committee for Meteorological Services and Supporting Research (FCMSSR), supports working groups on all aspects of operational environmental satellites and space environment forecasting.

Interaction with policymakers in Congress takes place through direct discussions, policy and budget negotiations, formal testimony, and in

Congressional liaison offices in the agencies. Congressional committees—the Committee on Science, Space, and Technology in the House of Representatives and the Committee on Commerce, Science, and Transportation in the Senate, for example—and their subcommittees, are concerned with issues of space policy.

The major link between government agencies like NASA and NOAA and the academic and private industry science and engineering community is the National Research Council (NRC). From the very beginning of the space program, the NRC has established committees and sponsored conferences on space activities. In the fall of 1957, it held a conference to discuss research projects on rockets and satellites for the International Geophysical Year. Newell (1979) has provided a history of that period and the interaction between the National Research Council and NASA. Today, the NRC supports several committees with an interest in remote-sensing activities, including, among others, the Committee on Earth Studies of the Space Studies Board (SSB), the Aeronautics and Space Engineering Board, the Polar Research Board, the Board on Atmospheric Science and Climate, the Ocean Studies Board, the Board on Earth Sciences, and the Committee on Global Change. The SSB Committee on Earth Sciences (now Studies) has produced a series of reports on the need for remote sensing from space, as have a number of other SSB committees (see the reference list for more details).

One of the most active of the specialized groups in the United States is the Geosat Committee (not connected with the U.S. Navy's GEOSAT mission discussed earlier), a nonprofit educational organization dedicated to the improvement of satellite and airborne remote-sensing technology and to developing applications for civilian data users worldwide. The Geosat Committee has been particularly effective in promoting the ongoing development of Landsat and the use of its data.

Various societies and professional groups are also active in the field. Among them are the American Bar Association Aerospace Law Committee and Satellite Technology Committee, and the International Institute of Space Law. The American Institute of Aeronautics and Astronautics has an Earth Observation Satellite Committee on Standards with subcommittees on data, telemetry, and sensors. The American Society for Photogrammetry and Remote Sensing publishes a technical journal on remote sensing.

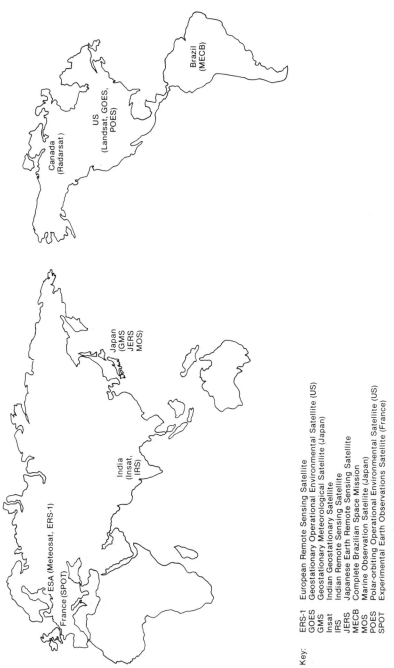

Figure 43. Global membership in the Committee on Earth Observations Satellites (CEOS).

Key:

ERS-1	European Remote Sensing Satellite
GOES	Geostationary Operational Environmental Satellite (US)
GMS	Geostationary Meteorological Satellite (Japan)
Insat	Indian Geostationary Satellite
IRS	Indian Remote Sensing Satellite
JERS	Japanese Earth Remote Sensing Satellite
MECB	Complete Brazilian Space Mission
MOS	Marine Observation Satellite (Japan)
POES	Polar-orbiting Operational Environmental Satellite (US)
SPOT	Experimental Earth Observations Satellite (France)

In the United Kingdom, the Remote Sensing Society publishes the *International Journal of Remote Sensing,* which covers all aspects of the subject and its applications. The French Society of Photogrammetry and Remote Sensing also publishes a regular bulletin, as does the German Society of Photogrammetry and Remote Sensing.

International Coordination

International coordination and cooperation among governments has been the norm in meteorology for more than one hundred years and in space-based measurements for more than fifteen years. The Coordination on Geostationary Meteorological Satellites, the first informal technical group to be established, first met in 1972. Today the group promotes international standardization and sharing of data products, sharing of common data transmission frequencies, and coordination of coverage zones to minimize overlap and maximize global coverage. Current members are the United States, the European Space Agency, Japan, India, and the USSR. In 1984, the Economic Summit established the International Polar-Orbiting Meteorological Satellite Group, which was charged to discuss issues relating to international contributions to the U.S. polar-orbiting satellite system and to later internationally developed polar-orbiting observation systems. Membership in the group is limited to those countries that participate in the Economic Summit and those countries that are current, or potential, contributors to the future polar-orbiting meteorological system.

Also in 1984, several coordination groups combined to form the Committee on Earth Observations Satellites to coordinate spaceborne observations of the ocean and the land for the international user community. Brazil, Canada, France, India, Japan, the United States, and the European Space Agency have been involved (see Figure 43). The Committee serves as a forum for the exchange of technical information. Membership in the group is open to international, national, or regional organizations responsible for operational or near-operational spaceborne programs.

The Council of Europe, the Commission of European Communities, and the European Space Agency sponsor the European Association of Remote Sensing Laboratories (EARSeL) with representatives from seventeen countries, including Canada. EARSeL has fifteen working groups cover most of the scientific and practical aspects of remote

sensing. The Paris office coordinates educational programs and workshops, and publishes a regular newsletter.

The United Nations has been involved in remote-sensing issues through its Committee on the Peaceful Uses of Outer Space (COPUOS), which has a Scientific and Technical Subcommittee and a Legal Subcommittee. Despite the fact that a Working Group on Remote Sensing of the COPUOS Legal Subcommittee has been working to produce an international agreement on remote-sensing principles ever since Argentina proposed the idea in 1970, the group has not yet been successful because of unresolved conflicts over data dissemination issues. Several other United Nations agencies and bodies also sponsor space-related programs. The Natural Resources Division of the Department of Technical Cooperation for Development operates an international remote-sensing center for the study of Earth resources. The United Nations Revolving Fund for Natural Resources Exploration supports airborne and remote-sensing image processing. The United Nations Economic Commission for Africa, with the African Remote Sensing Council, sponsors regional remote-sensing programs.

In addition, specialized agencies of the United Nations are committed to remote-sensing activities. The United Nations Educational, Scientific, and Cultural Organization (UNESCO) supports remote sensing through a number of programs. UNESCO's Intergovernmental Oceanographic Commission (IOC) coordinates activities and holds workshops on the use of remote sensing in the marine sciences. The Food and Agriculture Organization provides technical assistance to field projects using remote-sensing (Voute, 1986).

The World Meteorological Organization (WMO) coordinates the use of operational remote sensing for meteorology, ocean observations, and hydrology, and together with the International Council of Scientific Unions and the United Nations Environment Program (UNEP), cosponsors the World Climate Program. WMO and UNEP also cosponsor the Intergovernmental Panel on Climate Change, which is charged with developing recommendations for governmental action on global environmental issues. UNEP coordinates remote-sensing applications for environmental management and monitoring—in the Global Environmental Monitoring System (GEMS) program, for example. The World Health Organization (WHO) focuses on remote-sensing approaches to environmental monitoring, particularly of air and water

pollution that create health risks or affect the propagation of disease. For the United Nations Disaster Relief Co-ordinator Office (UNDRO), remote sensing provides vital assistance in forecasting natural disasters.

The primary nongovernmental international scientific group concerned with remote sensing is the International Council of Scientific Unions (ICSU). ICSU and the World Meteorological Organization co-sponsor the World Climate Research Program, which is part of the World Climate Program. Another ICSU program, the International Geosphere-Biosphere Program (IGBP), has identified satellite-based measurements as a key factor in measuring global environmental change. The ICSU Committee on Space Research (COSPAR) has two relevant Commissions, one on Space Studies of the Earth's Surface, Meteorology, and Climate, and one on Space Studies of the Upper Atmospheres of the Earth and Planets. Since 1987, an ad hoc COSPAR Group on Remote Sensing for Global Change has been providing the IGBP with periodic updates on remote-sensing issues (Rasool, 1987). COSPAR's Advisory Committee on Data Problems and Publications sets the standards for exchanging space-related data. The ICSU Inter-Union Commission on Frequency Allocations for Radio Astronomy and Space Science provides oversight on the frequency bands used in space for sensing and communication. Among its many activities, ICSU's Committee on Data (CODATA) sponsors a Multi-Satellite Thematic Mapping Project, which began in 1982 with studies of data from Landsat, Meteosat, SPOT, and the NOAA TIROS-N satellites for interpreting geological formations in Africa and China.

The World Bank encourages the use of remote sensing in many of the projects supported by its loans and by credits from the International Development Association. The bank also relies on a remote-sensing unit in its cartographic activities. The Interamerican Development Bank (IDB), a regional affiliate of the World Bank, is financing a remote-sensing unit in Colombia.

Internationally, a number of other regional remote-sensing groups have also been established. The Society of Latin American Specialists in Remote Sensing meets biannually to share research results and to formulate plans for data reception stations. The African Remote Sensing Council involves twenty-three countries in overseeing the activities of two regional centers supported by United States and African donors. The Asian Society for Remote Sensing works with the Asian

Regional Remote Sensing Center and a United Nations Regional Remote Sensing Program to further project activities in southeast Asia.

Among the international groups providing a forum for discussion of observations and the U.S. Space Station complex is the International Coordination Working Group (ICWG). The ICWG offers an opportunity for international dialogue among representatives of national space agencies so that the U.S. Space Station and the polar platforms can accommodate the required measurements. Membership is open to those countries planning to use the polar platforms for Earth observations. The Coordination Group of Space Station Partners is discussing payload and platform development. As planning moves forward for the proposed International Space Year (ISY), scheduled for 1992, a number of groups are considering remote-sensing issues, including the ISY Global Standards for Observing Systems Working Group and the Space Agency Forum for the ISY (SAFISY). SAFISY currently has twenty-five space agency members.

At least one of these groups is trying to coordinate related activities and encourage communication. The Coordination Subcommittee of the Space-based Observation Systems Committee on Standards was established at the American Institute of Aeronautics and Astronautics to act as an information clearinghouse for the activities of all civilian Earth observation advisory and policy groups, with special attention to establishing technical standards for remote-sensing technologies. The subcommittee will periodically collect and disseminate relevant information on the status and plans of these groups.

■ DATA TRANSMISSION AND DATA SHARING

Coordination is particularly important in the transmission and sharing of data. A limited number of radio frequencies are available for data transmission. In order to avoid interference in satellite radio transmissions, the International Telecommunications Union coordinates satellite telecommunications and broadcasting. Radio regulations are set to designate discrete frequency bands for specific users. Frequency allocations for remote-sensing satellites are established periodically by the World Administrative Radio Conferences and recorded by the International Frequency Registration Board.

The multiple use of radio frequencies has caused difficult problems.

In 1986, Motorola proposed a series of local area networks of personal computers linked by radio transmissions in the 1700 to 1710 megahertz frequency band. The plan called for radio links between millions of small personal computers, resulting in a system that would replace current cable networks. Unfortunately, this frequency band is the same one used by the polar-orbiting meteorological satellites to transmit high-resolution picture data. If there were only a few such satellite receivers, the interference could be minimized, but their numbers are growing rapidly, and increased radiation from the proposed network transmission could seriously interfere with reception of satellite data. As a result, government agencies and private companies objected to the Motorola proposal. The matter is still under consideration by the U.S. Federal Communications Commission.

A common agreement on data sharing has yet to be reached. The United States has strongly supported the concept of "open skies" and the official policy of public nondiscriminatory availability of data. As a Presidential Directive in 1978 stated, "the United States rejects any claims to the sovereignty over outer space or over celestial bodies and rejects any limitations on the fundamental right to acquire data from space" (White House Press Secretary, 1978). Most nations engaged in remote sensing from space have adopted the American open skies approach, but some favor restrictions on both the collection and dissemination of data (Ad Hoc Committee on Remote Sensing for Development, 1977), such as placing limits on the resolution of Earth observation sensors, requiring prior consent of a country for satellite observation, and allowing nations to have first rights to data taken over their territory. None of these restrictions has actually been established to any significant extent.

Data from the U.S., Soviet, European Space Agency, and Japanese meteorological satellites have traditionally been broadcast free of charge directly to ground stations and through the global telecommunications system (see Figure 44) to users. Anyone with a ground receiving station can tune in on the transmissions while the satellite is overhead. No attempt is made to recover the costs of operating or procuring the remote-sensing system. But India's INSAT broadcasts its data only to a central Indian receiving station. The USSR broadcasts remote-sensing data, other than meteorological data, only to countries that are parties to the Convention on the Transfer and Use of Data of the Remote Sensing of the Earth from Outer Space, a treaty

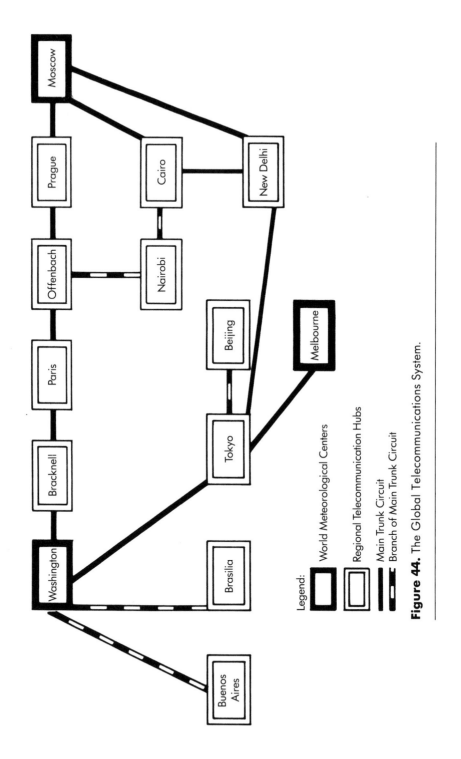

Figure 44. The Global Telecommunications System.

Legend:

World Meteorological Centers

Regional Telecommunication Hubs

Main Trunk Circuit

Branch of Main Trunk Circuit

signed in 1978 by Cuba, Czechoslovakia, the German Democratic Republic, Hungary, Mongolia, Poland, Romania, and the USSR. This is the only existing treaty that imposes a prior consent condition on the dissemination of remote-sensing data, but it has had little international effect because the signatories come exclusively from the Soviet bloc (Uhlir, 1986).

Up to now, meteorological data have been made available at minimum cost: hard copy (excluding computer tapes) is sold at a price that reflects only the cost of reproduction. For land surface data, the U.S. Landsat program includes the provision that data be made available on a public, nondiscriminatory basis as one of the principal requirements in granting licenses to operators. The only restriction has been the costs, which are charged to all users. The French SPOT operates in the same way.

In 1987 the USSR began to offer high-resolution photographs obtained from its KFA-1000 and other satellites to customers outside the Soviet bloc at competitive prices through Soyuzkarta. The European Space Agency also plans to charge customers for data from its ERS-1 satellite (beyond that available in real time for meteorological and oceanographic operations), but the specifics have not yet been decided beyond an access fee for direct reception of ERS-1 data. Some data will also be available for direct exchange. The main issue here is that many users, in both developed and developing countries, may not be able to afford the data they need for their research or applications work.

■ ORGANIZING FOR THE FUTURE

Satellite-based Earth-observing systems can make a fundamental contribution to understanding, describing, and monitoring the Earth. But despite broad international interest and activity, such programs, especially in the long-term operational mode, remain costly. It is essential that ways be found to make sure that future Earth-observing systems are as efficient as possible. It seems clear that over the long term it would be most efficient to procure a standard satellite and operating system worldwide. This means merging national governmental and commercial interests with new and innovative intergovernmental and private arrangements.

One way to do this is to look for ways that existing government and commercial observing systems could be combined at a net cost savings to government. McElroy (1987, 1989) has proposed that an international network of Earth-observing systems could become analogous to the successful INTELSAT and INMARSAT of the telecommunications world, with all countries benefiting from improved, more reliable, and less costly services. It is worth considering the pros and cons of this international partnership, which he calls "Envirosat."

The argument for a new kind of partnership is based on the following facts. The institutions that use remote sensing include international, national, and state agencies; commercial firms; academic institutions; and individuals. These users receive data from two sources: government-funded and -operated satellite systems and the private sector operations such as EOSAT and SPOT. Although the market for land data alone has proven to be insufficient to sustain a remote-sensing program, it appears that governments could provide a market based on their own needs for combined land, meteorological, and oceanographic remote-sensing services. Other users would add to the market. With a large enough market, a viable private sector operation could be established to provide data to all users.

In the United States such an approach is fully consistent with current administration space policy, which states that "expanding private investment in space by the market-driven commercial sector generates economic benefits for the nation and supports governmental space sectors with an increasing range of space goods and services" (White House Fact Sheet, 1988). The administration's space policy directive also states that governmental space sectors shall use commercially available goods and services to the fullest possible extent and shall avoid actions that may preclude or deter commercial space sector activities, except as required by national security or public safety.

In the U.S. civil space program, national and international government and private sector responsibilities are mixed. NASA satellites are built and operated by the private sector and often involve international contributions. NOAA satellites and sensors are built and largely operated through the private sector. Many of the instruments are provided by other countries (Canada, France, and the United Kingdom, for example). EOSAT is responsible for operating the Landsat system, for developing the next satellite in the series, and for marketing the products.

Thus, we have three systems that are essentially built and operated

by the private sector, but with a restriction that precludes economies of scale. NOAA is currently barred from providing space on its polar-orbiting satellites for EOSAT sensors. EOSAT is barred from flying NOAA sensors, and NASA does not plan to use EOSAT spacecraft to carry any of its sensors, although it is currently planning SeaWiFS, a joint activity with EOSAT on ocean color measurement (see Chapter 4). What is needed is closer coordination of all of these efforts. Without it, the government will continue to fund three systems at a higher than necessary cost.

According to McElroy, good opportunities for partnerships exist. One is to allow EOSAT to place its sensors on the NOAA polar orbiters and to provide for two data streams, one for commercial data and one for government data. Another is to charge EOSAT or a comparable private entity with the responsibility for the overall operation of the NOAA satellites and the provision of specified data to the government. In the latter case, the government would specify the conditions.

In the first of these examples, the government would improve the current situation by funding one less spacecraft per polar constellation (by maintaining two polar-orbiting satellites in operation rather than three). In the second case, benefits would be realized by economies of scale in tracking and data systems. A NASA-private sector partnership could also be put into place by changing the rules so that NASA could rely on the private sector to carry and operate its research sensors. It should be noted, however, that NOAA plans in the long run to operate just one polar-orbiting satellite (ESA plans to operate the other). Thus, the first example would probably not lead to cost savings. But the second and third examples could provide benefits. It is a fact that any arrangement to save costs on operational satellite programs would help NOAA to operate more effectively within its limited budget. One major problem faced by NOAA is that more than 40 percent of its total budget is allocated to satellite operations. At the present time, even the relatively small changes required in the normal course of operating the satellite programs can cause major financial disruptions for other programs unrelated to remote sensing. If costs could be reduced, this problem could be avoided.

Another solution is to put satellite operations into a separate budgetary category completely removed from NOAA. Then NOAA's other programs would not be jeopardized. The NOAA satellite operations could be moved to another agency (such as NASA), or taken entirely

out of the government sector. NOAA's mission requires the data that is collected from satellites, but it does not require that NOAA actually operate the satellites. A specific plan to do this would transfer the entire operational satellite arm of NOAA to EOSAT or a comparable private entity, which would operate the two U.S. polar-orbiting operational satellites. The polar-orbiting satellite with an equatorial crossing in the afternoon would carry a complement of NOAA operational meteorological instruments and any instruments requiring a high sun angle. The morning polar-orbiting satellite would carry the Landsat and other instruments that have traditionally used that orbit.

A merged data processing system would include both commercial and government data streams, which would take different paths after commercial processing. The private satellite operator would simply replace the satellite arm of NOAA as the source of government data, producing a system analogous to that in France, where the ARGOS data collection system is now operated by a private entity formed exclusively for this purpose. It should be noted, however, that this entity is staffed by personnel from the mother agency, CNES, set up with CNES capital, and under CNES control. For search and rescue, Canadian and French hardware are now carried on the NOAA satellites as part of an international system, and whether the satellite carrying the system is governmental or private appears to be irrelevant.

McElroy emphasizes that with this kind of arrangement, no substantial change in current data practices would be necessary. Moreover, the fear inspired by the "commercialization" of the weather service appears to have no real basis. Such an arrangement does not turn over the national weather service to a private company that may or may not have a long-term interest; it simply allows the government to contract for the data and services it needs at the best possible price. The government contracts only for what it requires under its own terms and conditions. It spends no funds that it would not otherwise spend and loses no control that it does not wish to give up. The danger is that the costs may not be controllable—if the private entity raises costs beyond that which the government feels is reasonable, it may be difficult to get the system back without a hiatus in data.

The proposed arrangement could allow for economies of scale in space systems, ground tracking, and data systems. It provides an assured market for the private company, and an expanded private sector role in space, while reducing government activities. Just as an early NASA contract underwrote the beginnings of the International Tele-

communications Satellite organization (INTELSAT), a government contract could underwrite a new commercial venture for remote sensing of the Earth. The difference is that telecommunication services are sold at a profit to commercial or government customers; remote-sensing data would be largely of interest to governments. The size of the market is a crucial and, to some extent, unknown factor.

How would this arrangement affect developing international remote-sensing interests? It is possible to envision a unified international polar-orbiting remote-sensing system, since relatively few satellites can meet the continuing needs of all nations. To achieve such a system, a full partnership among the United States, Japan, France, Canada, and the United Kingdom (the latter three because of their current participation in the NOAA polar orbiter program), and possibly the USSR would have to be encouraged.

In terms of geostationary satellites, although there are currently five in orbit (operated by the United States, the European Space Agency, Japan, and India), it makes little sense for each nation to design, develop, and operate its own. Why not jointly design a standard geostationary environmental satellite and operating system? The success of INTELSAT and the International Maritime Satellite Organization (INMARSAT) has shown that the procurement of a large number of identical satellites can reduce costs. France is using this multimission concept by designing a spacecraft for their SPOT-4 system (for launch in the mid-1990s) that will also be used for Helios, their military reconnaissance satellite under development for launch in 1993. The United States could follow suit by using the same system for civilian and military meteorological satellites. In a related area, still further efficiencies could be achieved in the global dissemination of satellite data products.

A private entity could benefit from handling the government-required services because it could merge that data stream with data from purely commercial sensors or from other sources to create new information products with marketable value. As new products became viable and the private entity became more profitable, the total cost of data to the government would be reduced. The operators of the French SPOT system have already recognized this opportunity and are planning to update and extend to the infrared the spectral band width of their high resolution visible sensors to make SPOT-4 more useful for monitoring vegetation throughout the world.

How would national security be affected? There are two major is-

sues: improving the quality, or spatial resolution, of the images and providing backup to military systems. The issue of resolution will always be with us, since the military and intelligence communities prefer to keep the highest resolution information classified. But this has not stopped the development of high resolution instrumentation either in the United States or abroad. The Landsat Thematic Mapper has a resolution of 30 meters, and SPOT a resolution of 10 meters. The USSR has recently released photographic data with a resolution as fine as 5 meters, but the extent of global coverage is not known. The development of technology will inevitably continue toward higher resolution, depending on market interest. If higher resolution data prove valuable in geological mapping and the search for resources, then instruments will be developed, either here or in other countries. In any case, stated U.S. policy encourages the development of commercial Earth-imaging systems that are competitive with or superior to foreign-operated civil or commercial systems.

In terms of providing backup to military satellites, the U.S. NOAA satellites currently serve this function for the Defense Meteorological Satellite Program (DMSP) operated by the U.S. Air Force. But whether operated by a private entity in the United States or as part of an international effort, the meteorological satellites would still provide civil data to the defense community through the same channels they use today, although there would be a loss of unilateral control over the spacecraft and the data stream. Whether this is acceptable depends on military policy as well as cost. Operational, long-term Earth observation from space is an international matter that might well be supported by a capable global industry. New cooperative arrangements could be advanced to expand capabilities and reduce costs. McElroy's proposal for action shows that there is a possible path to effective and efficient operations.

It was the management expert Peter Drucker who observed that long-range planning does not deal with future decisions but with the future of present decisions. This is nowhere truer than in remote sensing, with its long lead times for satellites and instrumentation. It has been said that science and engineering can "invent the future." Now is the time for the international space community to decide to set in place a fully operational satellite-based system to monitor global environmental change in the decades ahead.

REFERENCES

I found the following recent general reports especially useful.

Earth Systems Sciences Committee of the NASA Advisory Council. 1987. *Earth System Science: A Closer View*. Washington, D.C.: National Aeronautics and Space Administration.

ICSU/COSPAR Ad Hoc Group on Remote Sensing for Global Change of the Committee on Space Research of the International Council of Scientific Unions. 1987. "Potential of Remote Sensing for the Study of Global Change," ed. S. I. Rasool. *Advances in Space Research* 7:1–97.

NASA Earth Observing System Science Steering Committee. 1984–1987. *The Earth Observing System Reports*. 10 vols. Washington, D.C.: National Aeronautics and Space Administration.

NASA Space Applications Advisory Committee. 1987. *Linking Remote-Sensing Technology and Global Needs: A Strategic Vision*. Washington, D.C.: National Aeronautics and Space Administration.

NOAA and NASA. 1987. *Space-Based Sensing of the Earth: A Report to the Congress*. Washington, D.C.: U.S. Government Printing Office.

2. How Remote Sensing Works

Note: this list includes a number of recent textbooks that, although not cited directly in the text, provide useful discussions of remote sensing of the Earth.

Allan, T. D., ed. 1983. *Satellite Microwave Remote Sensing*. New York: John Wiley and Sons.

Barrett, E. C. 1982. *Introduction to Environmental Remote Sensing*. 2d ed. London and New York: Chapman and Hall.

Browning, K. A., B. J. Conway, J.-P. A. L. Muller, and D. J. Stanley. 1988. *Exploiting Remotely Sensed Images: Proceedings of a Royal Society Discussion Meeting*. London: The Royal Society.

Casey, D. 1989. "Frozen Orbits?" *The Earth Observer* 1 (2) (May, 1989). NASA/Jet Propulsion Laboratory newsletter.

Chapman, Sidney. 1959. *IGY: Year of Discovery*. Ann Arbor: University of Michigan Press.

Chen, H. S. 1985. *Space Remote Sensing Systems, An Introduction*. Orlando: Academic Press.

Clarke, A. C. 1984. *Ascent to Orbit: A Scientific Autobiography*. New York: John Wiley and Sons.

Committee on Earth Sciences, Space Sciences Board. 1988. *Strategy for Earth Explorers in Global Earth Sciences*. Washington, D.C.: National Academy Press.

Curran, P. J. 1985. *Principles of Remote Sensing*. New York: John Wiley and Sons.

Eden, M. J., and J. T. Parry, eds. 1986. *Remote Sensing and Tropical Land Management*. New York: John Wiley and Sons.

Elachi, C. 1982. "Radar Images of the Earth from Space." *Scientific American* 247:54–61.

―――― 1987. *Introduction to the Physics and Techniques of Remote Sensing*. New York: John Wiley and Sons.

EOS Science and Mission Requirements Working Group. 1984. *Earth Observing System Working Group Report*. Vol. 1. Washington, D.C.: National Aeronautics and Space Administration.

Feynman, R. 1985. *QED: The Strange Theory of Light and Matter*. Princeton: Princeton University Press.

Feynman, R., R. B. Leighton, and M. Sands. 1964. *The Electromagnetic Field*. Reading, Mass.: Addison-Wesley.

Hall, D. K., and J. Martinec. 1985. *Remote Sensing of Ice and Snow*. London and New York: Chapman and Hall.

Harris, R. 1987. *Satellite Remote Sensing: An Introduction*. London and New York: Routledge and Kegan Paul.

Holz, R. K. 1985. *The Surveillant Science: Remote Sensing of the Environment*. 2d ed. New York: John Wiley and Sons.

Hord, R. M. 1986. *Remote Sensing: Methods and Applications*. New York: John Wiley and Sons.

Houghton, J. T., F. W. Taylor, and C. D. Rodgers. 1984. *Remote Sounding of Atmospheres*. Cambridge: Cambridge University Press.

Johnson, N. L. 1988. *The Soviet Year in Space, 1987*. Colorado Springs: Teledyne Brown Engineering.

―――― 1989. "The Space Debris Menace." In *Space Technology International 1989*. London: Cornhill, pp. 275–77.

Kelley, K. W., ed. 1988. *The Home Planet: Images and Reflections of Earth from Space Explorers*. Reading, Mass.: Addison-Wesley; London: McDonald; Moscow: Mir.

King-Hele, D. G., D. M. C. Walker, J. A. Pilkington, A. N. Winterbottom, H. Hiller, and G. E. Perry. 1987. *The R.A.E. Table of Earth Satellites, 1957–1986.* 3d ed. London: Macmillan; New York: Stockton Press.

Koval, A., and L. Desinov. 1987. *Space Flights Serve Life on Earth.* Moscow: Progress.

Langley, R. B., R. W. King, and I. I. Shapiro. 1981. "Earth Rotation from Lunar Laser Ranging." *Journal of Geophysical Research* 86:11913–18.

Langley, R. B., R. W. King, I. I. Shapiro, R. D. Rosen, and D. A. Salstein. 1981. "Atmospheric Angular Momentum and the Length of Day: A Common Fluctuation with a Period near Fifty Days." *Nature* 294:730.

Lo, C. P. 1986. *Applied Remote Sensing.* New York: Longman Scientific and Technical Publishers.

Long, M. 1987. *World Satellite Almanac: The Comprehensive Guide to Satellite Transmission and Technology.* Indianapolis: Howard W. Sams.

Maul, G. A. 1985. *Introduction to Satellite Oceanography.* Dordrecht, The Netherlands: Martinus Nijhoff.

McElroy, J. H. 1985. *NOAA Satellite Programs Briefing.* Washington, D.C.: National Oceanic and Atmospheric Administration.

Mueller-Wille, C., and R. M. Smith. 1983. *Images of the World: An Atlas of Satellite Imagery and Maps.* Essex, United Kingdom: Collins-Longman. Originally published in German as *Diercke Weltraumbild-Atlas.* 1981. Braunschweig: Georg Westermann Verlag.

Newell, H. E. 1980. *Beyond the Atmosphere: Early Years of Space Science.* Washington, D.C.: National Aeronautics and Space Administration.

NOAA and NASA. 1987. *Space-Based Remote Sensing of the Earth: A Report to the Congress.* Washington, D.C.: U.S. Government Printing Office.

Research and Coordination Bureau, Science and Technology Agency. 1987. *Space in Japan.* Tokyo: Federation of Economic Organizations.

Robinson, I. S. 1985. *Satellite Oceanography: An Introduction for Oceanographers and Remote-Sensing Scientists.* New York: John Wiley and Sons.

Sabins, F. F. 1987. *Remote Sensing Principles and Interpretation.* 2d ed. New York: W. H. Freeman.

Stewart, R. H. 1985. *Methods of Satellite Oceanography.* Berkeley: University of California Press.

Stimson, G. W. 1982. *Introduction to Airborne Radar.* El Segundo, Calif.: Hughes Aircraft.

Szekielda, K.-H. 1988. *Satellite Monitoring of the Earth.* New York: John Wiley and Sons.

TOPEX Science Working Group. 1981. *Satellite Altimetric Measurements of the Ocean.* Pasadena, Calif.: Jet Propulsion Laboratory.

Trevett, J. W. 1986. *Imaging Radar for Resources Surveys.* New York: Chapman and Hall.

Tricker, R. A. R. 1967. *Paths of the Planets*. London: Mills and Boon; New York: Elsevier.

Tsang, L., J. A. Kong, and R. T. Shin. 1985. *Theory of Microwave Remote Sensing*. New York: John Wiley and Sons.

3. The Present Constellation of Space-Based Systems

Allan, T. D., ed. 1983. *Satellite Microwave Remote Sensing*. New York: John Wiley and Sons.

Aviation Week and Space Technology. 1989. "Soviet Satellite Agency to Provide Technical Aid to Inmarsat." *Aviation Week and Space Technology* 131:81.

Bernstein, R. L. 1982. "Seasat Special Issue 1: Geophysical Evaluation." *Journal of Geophysical Research* 87(C5).

Bernstein, R. L., and D. B. Chelton. 1985. "Large-scale Sea Surface Temperature Variability from Satellite and Shipboard Measurements." *Journal of Geophysical Research* 90:11619–30.

Born, G. H., J. A. Dunne, and D. B. Lame. 1979. "Seasat Mission Overview." *Science* 204:1405–6.

Brown, O. B., and R. H. Evans. 1982. "Visible and Infrared Satellite Remote Sensing: A Status Report." *Naval Research Reviews* 29:7–25.

Brown, O. B., R. H. Evans, J. W. Brown, H. R. Gordon, R. C. Smith, and K. S. Baker. 1985. "Phytoplankton Blooming off the U.S. East Coast: A Satellite Description." *Science* 229:163–67.

Burrows, W. E. 1986. *Deep Black: Space Espionage and National Security*. New York: Random House.

Cervelle, B. 1989. *SPOT: Des Yeux Braques sur la Terre*. Paris: Press du CNRS.

Chapman, S. 1959. *IGY: Year of Discovery*. Ann Arbor: University of Michigan Press.

Cheney, R. E., L. L. Miller, B. C. Douglas, and R. W. Agreen. 1987. "Monitoring Equatorial Pacific Sea Level with GEOSAT." *Johns Hopkins APL Technical Digest* 8:245–50.

Cheng, Y. 1988. *An Outline of China's Space Activities*. Washington, D.C.: Embassy of the People's Republic of China.

Committee on Earth Sciences, Space Sciences Board. 1988. *Strategy for Earth Explorers in Global Earth Sciences*. Washington, D.C.: National Academy Press.

Courtois, M., and G. Weill. 1985. "The SPOT Satellite System." In *Monitoring Earth's Ocean, Land and Atmosphere from Space—Sensors, Systems, and Applications*, ed. Abraham Schnapf. New York: American Institute of Aeronautics and Astronautics.

Davidson, J. 1989. "The Art of Pinpointing: The Role of Satellites and Inmarsat in Navigation." *Journal of the British Interplanetary Society* 42:285–89.

Doyle, F. J. 1987. "The Utility of Civil Remote-Sensing Satellites for Arms Control Monitoring." In *Satellites for Arms Control and Crisis Monitoring*, ed. B. Jasani and T. Sakata. Oxford: Oxford University Press.

Earth Observation Satellite Company. 1987. *Landsat*. Lanham, Md.: Earth Observation Satellite Company.

ESA. 1987. "European Dissemination of Marine Observation Satellite (*MOS-1*) Data." In *A Portrait of Images: The Earthnet Contribution*. Paris: European Space Agency.

Esaias, W. E., G. Feldman, C. R. McClain, and R. Evans. 1986. "Monthly Satellite-Derived Phytoplankton Pigment Distribution for the North Atlantic Ocean Basin." *EOS: Transactions of the American Geophysical Union* 67:835–37.

Ewing, G. C., ed. 1965. *Oceanography from Space*. Technical Report 65-10. Woods Hole, Mass.: Woods Hole Oceanographic Institution.

Farman, J. C., B. G. Gardiner, and J. D. Shanklin. 1985. "Large Losses of Total Ozone in Antarctica Reveal Seasonal ClOx/NOx Interaction." *Nature* 315:207.

Fleig, A. L., and R. J. Cicerone. 1984. *Nimbus-7 Special Issue: Scientific Results. Journal of Geophysical Research* 89 (D4).

Fu, L.-L., W. T. Liu, and M. R. Abbott. 1989. "Satellite Remote Sensing of the Ocean." In *The Sea*, vol. 9. New York: John Wiley and Sons.

Gower, J. F. R., ed. 1981. *Oceanography from Space*. New York: Plenum Press.

Gordon, H. R., D. K. Clark, J. L. Mueller, and W. A. Hovis. 1980. "Phytoplankton Pigments Derived from the Nimbus-7 CZCS: Initial Comparisons with Surface Measurements." *Science* 210:63–66.

Government of India, Department of Space. 1988. *1987–1988 Annual Report*. Bangalore: Indian Space Research Organization.

Heacock, E. L., ed. 1985. *Envirosat-2000 Report: Comparison of the Defense Meteorological Satellite Program (DMSP) and the NOAA Polar-orbiting Operational Environmental Satellite (POES) Program*. Washington, D.C.: National Oceanic and Atmospheric Administration.

Henbest, N. 1988. Untitled. *New Scientist* 120:28–29.

Houghton, J. T., A. H. Cook, and H. Charnock, eds. 1983. *The Study of the Ocean and the Land Surface from Satellites*. London: The Royal Society.

Italian Army Geographic Institute. 1989. *International Herald Tribune*, Jan. 19.

Jasani, B., and T. Sakata. 1987. *Satellites for Arms Control and Crisis Monitoring*. Oxford: Oxford University Press.

Johns Hopkins APL Technical Digest. 1987. "The Navy Geosat Mission." *Johns Hopkins APL Technical Digest* 8 (2). Laurel, Md.: Johns Hopkins University Applied Physics Laboratory.

Johnson, N. L. 1987. *Soviet Space Programs 1980–1985*. San Diego: American Astronautical Society.

—— 1988. *The Soviet Year in Space, 1987.* Colorado Springs: Teledyne Brown Engineering.

Karas, T. 1983. *The New High Ground.* New York: Simon and Schuster.

Kerr, R. A. 1989. "Arctic Ozone Is Poised for a Fall." *Science* 243:1007–8.

Klass, P. J. 1971. *Secret Sentries in Space.* New York: Random House.

Krimigis, S. M. 1988. "The Sun and the Sun-Earth Connection." *Journal of the British Interplanetary Society* 41:63–80.

Krepon, M. 1989. "Spying from Space." *Foreign Policy,* No. 75 (Summer 1989):92–108.

Lanzerotti, L. J. 1987. "Solar-Terrestrial Physics." In *Encyclopedia of Physical Science and Technology,* vol. 12. New York: Academic Press.

Maul, G. A. 1985. *Introduction to Satellite Oceanography.* Dordrecht, The Netherlands: Martinus Nijhoff.

McElroy, J. H. 1985. *NOAA Satellite Programs Briefing.* Washington, D.C.: National Oceanic and Atmospheric Administration.

—— 1987. "The Future of Earth Observation in the USA." *Space Policy* 3:313–25.

Morgan, J. 1981. *Introduction to the Meteosat System.* ESA SP-1041. Paris: European Space Agency.

NASA Office of Space Science and Applications. 1988. *NASA Geodynamics Program Summary Report: 1979–1987.* Washington, D.C.: National Aeronautics and Space Administration.

NASDA. 1982. *Marine Observation Satellite-1 (MOS-1).* Tokyo: National Space Development Agency.

Parkinson, C. L., J. C. Comiso, H. J. Zwally, D. J. Cavalieri, P. Gloersen, and W. J. Campbell. 1987. *Arctic Sea Ice, 1973–1976: Satellite Passive Microwave Observations.* Washington, D.C.: National Aeronautics and Space Administration.

Peters, E. R. 1983. "The Use of Multispectral Satellite Imagery in the Exploration for Petroleum and Minerals." In *The Study of the Ocean and the Land Surface from Satellites,* ed. J. T. Houghton, A. H. Cook, and H. Charnock. London: The Royal Society.

Ramanathan, V., R. D. Cess, E. F. Harrison, P. Minnis, B. R. Barkstrom, E. Ahmad, and D. Hartmann. 1989. "Cloud-Radiative Forcing and Climate: Results from the Earth Radiation Budget Experiment." *Science* 243:57–63.

Rao, R. K., S. J. Holmes, R. K. Anderson, J. S. Winston, and P. E. Lehr, eds. 1989. *Weather Satellites: Systems, Data, and Environmental Applications.* Boston: American Meteorological Society.

Rasool, S. I., ed. 1987. "Potential of Remote Sensing for the Study of Global Change." *Advances in Space Research* 7:1–97.

Research Coordination Bureau, Science and Technology Agency. 1988. *Space in Japan: 1986–1987.* Tokyo: Keidanren (Federation of Economic Organizations).

Robinson, I. S. 1985. *Satellite Oceanography: An Introduction for Oceanographers and Remote-Sensing Scientists*. New York: John Wiley and Sons.

Schiffer, R. A. 1989. *International Satellite Cloud Climatology Project Global Cloud Atlas*. Washington, D.C.: World Climate Research Program Radiation Projects Office.

Schwalb, A., D. Cotter, and W. J. Hussey. 1985. *Envirosat-2000 Report: GOES-Next Overview*. Washington, D.C.: National Oceanic and Atmospheric Administration.

Scientific Committee on Solar-Terrestrial Physics. 1988. *STEP: Solar-Terrestrial Energy Program 1990–1995: A Framework for Action*. Paris: International Council of Scientific Unions.

Smith, W. L., W. P. Bishop, V. F. Dvorak, C. M. Hayden, J. H. McElroy, F. R. Mosher, V. J. Oliver, J. F. Purdom, and D. Q. Wark. 1986. "The Meteorological Satellite: Overview of Twenty-five Years of Operation." *Science* 231:455–62.

Spot Image Corporation. 1986. *Spotlight: The Quarterly Newsletter from SPOT Image Corporation* 2 (1).

Stewart, R. H. 1985a. *Seasat Success Statement*. JPL D-2841. Pasadena, Calif.: California Institute of Technology Jet Propulsion Laboratory.

——— 1985b. *Methods of Satellite Oceanography*. Berkeley: University of California Press.

Stolarski, R. S. 1988. "The Antarctic Ozone Hole." *Scientific American* 258:30–36.

Stolarski, R. S., A. J. Krueger, M. R. Schoeberl, R. D. McPeters, P. A. Newman, and J. C. Alpert. 1986. "*Nimbus-7* Satellite Measurements of the Springtime Antarctic Ozone Decrease." *Nature* 322:808–11.

Stommel, H., and E. Stommel. 1983. *Volcano Weather: The Story of 1816, the Year without a Summer*. Newport, R.I.: Seven Seas Press.

University NAVSTAR Consortium. 1987. *UNAVCO Newsletter 5*, June. Boulder: University of Colorado.

——— 1988. *UNAVCO Newsletter 6*, Sept. Boulder: University of Colorado.

Untersteiner, N. 1989. *Report of the JSC Working Group on Sea Ice and Climate*. Geneva: World Climate Research Program.

Weisman, S. R. 1986. "India Carries Its Dreams into Space." *New York Times*, Dec. 23, C1.

Willson, R. C., and H. S. Hudson. 1988. "Solar Luminosity Variations in Solar Cycle 21." *Nature* 322:810.

Yates, H. W., D. J. Cotter, and G. Ohring. 1985. *Envirosat-2000 Report: Operational Satellite Support to Scientific Programs*. Washington, D. C.: National Oceanic and Atmospheric Administration.

Yates, H. W., A. Strong, D. McGinnis, Jr., and D. Tarpley. 1986. "Terrestrial Observations from NOAA Operational Satellites." *Science* 231:463–70.

Zwally, H. J., J. C. Comiso, C. L. Parkinson, W. J. Campbell, F. D. Carsey, and P. Gloersen. 1983. *Antarctic Sea Ice, 1973–1976: Satellite Passive*

Microwave Observations. Washington, D.C.: National Aeronautics and Space Administration.

4. Filling the Gaps in the 1990s

Akasofu, S.-I., and Y. Kamide. 1987. *The Solar Wind and the Earth*. Tokyo: Terra Scientific.

Blanchard, P. 1988. *U.S.-Soviet Relations: An Agenda for the Future*. Vol. 18. *Combined Remote Sensing Observations of the Earth from Space*. Washington, D.C.: Foreign Policy Institute, Johns Hopkins University.

Canadian Advisory Committee on Remote Sensing. 1985. *Ocean Satellite Data Opportunities for Canada: A Long-Term View*. Ottawa: Department of Fisheries and Oceans.

Cheng, Y. 1988. *An Outline of China's Space Activities*. Washington, D.C.: Embassy of the People's Republic of China.

Clarke, T. C., and F. P. Fanale. 1989. "Galileo: The Earth Encounters." *Planetary Report* 9, no. 5 (Sept.–Oct.):6–10.

Cockburn, W. F. 1989. "The Canadian Space Program." In *Space: National Programs and International Cooperation*, ed. W. T. Thompson and S. W. Guerrier. Boulder: Westview Press.

Committee on Earth Sciences, Space Sciences Board. 1988. *Strategy for Earth Explorers in Global Earth Sciences*. Washington, D.C.: National Academy Press.

CNES. 1988. *BEST: Tropical System Energy Budget*. Paris: Centre National d'Etudes Spatiales.

ESA. 1985. *Looking Down, Looking Forward*. Paris: European Space Agency.
——— 1988. *ERS-1—A Keen Eye on the Earth*. Paris: European Space Agency.

ESA Directorate of Earth Observation and Microgravity. 1988. *Objectives and Strategy for the Earth-Observations Programme of the European Space Agency*. Paris: European Space Agency.

Indian Space Research Organisation. 1986. *The Indian Remote Sensing System IRS*. Bangalore: Indian Space Research Organisation.

Instituto de Pesquisas Espaciais. 1989. *Activities of the Institute for Space Research—INPE*. San José dos Campos, Brazil: Institute for Space Research.

IRS Project Team. 1988. "The Indian Remote Sensing Satellite System." *Remote Sensing Yearbook 1988–89*, ed. A. Cracknell and L. Hayes, 59–72. London: Taylor and Francis.

Johnson, N. L. 1988. *The Soviet Year in Space, 1987*. Colorado Springs: Teledyne Brown Engineering.

Joint EOSAT/NASA SeaWiFS Working Group. 1987. *System Concept for*

Wide-Field-of-View Observations of Ocean Phenomena from Space. Lanham, Md.: Earth Observation Satellite Company.

Mayerchak, P. M. 1989. "Asia in Space: The Programs of China, Japan, and Indonesia." In *Space: National Programs and International Cooperation,* ed. W. T. Thompson and S. W. Guerrier. Boulder: Westview Press.

Morel, P. 1989. *Scientific Strategy for the Prediction of Global Climate Change.* Geneva: World Climate Research Program.

NASA. 1987. *Upper Atmosphere Research Satellite: Project Data Book.* Washington, D.C.: NASA/Goddard Space Flight Center.

—— 1989a. *UARS: Upper Atmosphere Research Satellite: A Program to Study Global Ozone Change.* Washington, D.C.: National Aeronautics and Space Administration.

—— 1989b. *Tropical Rainfall Measuring Mission.* Washington, D.C.: National Aeronautics and Space Administration.

NASA Office of Space Science and Applications. 1988. *NASA Geodynamics Program Summary Report: 1979–1987.* Washington, D.C.: National Aeronautics and Space Administration.

NASA Science and Mission Requirements Working Group for the Earth Observing System. 1984. *The Earth Observing System.* Washington, D.C.: National Aeronautics and Space Administration.

NASDA. 1988. *Earth Resources Satellite-1.* Tokyo: National Space Development Agency of Japan.

Parks, G., S. Shawhan, M. Calabrese, and J. Alexander. 1988. "Global Geospace Science Programme." *Journal of the British Interplanetary Society* 41:81–93.

Robinson, I. S. 1985. *Satellite Oceanography: An Introduction for Oceanographers and Remote Sensing Scientists.* New York: John Wiley and Sons.

Satellite Surface Stress Working Group. 1982. *Scientific Opportunities Using Satellite Surface Wind Stress Measurements over the Ocean.* Washington, D.C.: National Aeronautics and Space Administration.

Scientific Committee on Solar-Terrestrial Physics. 1988. *STEP: Solar-Terrestrial Energy Program 1990–1995: A Framework for Action.* Paris: International Council of Scientific Unions.

Simpson, J. 1988. *Report of the Science Steering Group for a Tropical Rainfall Measuring Mission (TRMM).* Greenbelt, Md.: NASA/Goddard Space Flight Center.

Stewart, R., L.-L. Fu, and M. Lefebvre. 1986. *Science Opportunities from the TOPEX/POSEIDON Mission.* Pasadena, Calif.: NASA/Jet Propulsion Laboratory.

Theon, J. S., and N. Fugano. 1988. *Tropical Rainfall Measurements.* Hampton, Va.: A. Deepak.

TOPEX Science Working Group. 1981. *Satellite Altimetric Measurements of the Ocean.* Pasadena, Calif.: Jet Propulsion Laboratory.

5. Mission to Planet Earth

Casey, D. 1989. "Frozen Orbits?" *The Earth Observer* 1(2) (May 1989). NASA/Jet Propulsion Laboratory newsletter.

Committee on Earth Sciences, Space Science Board. 1988. *Strategy for Earth Explorers in Global Earth Sciences.* Washington, D.C.: National Academy Press.

Dutton, J. A. 1989. "The EOS Data and Information System: Concepts for Design." *IEEE Transactions on Geoscience and Remote Sensing* 27:109–16.

Earth Systems Sciences Committee. 1988. *Earth System Science: A Closer View.* Washington, D.C.: National Aeronautics and Space Administration.

Edelson, B. I. 1985. "Mission to Planet Earth." *Science* 227:367.

ESA. 1986. *Report of the Working Group on Earth Observation Requirements for the Polar Orbiting Platform Elements of the International Space Station.* Paris: European Space Agency.

Goddard Space Flight Center. 1989. *Earth Observing System: 1989 Reference Information.* Washington, D.C.: National Aeronautics and Space Administration.

Jedlovec, G. J., G. S. Wilson, and J. C. Dodge. 1989. *A Status Report: NASA's Plans for an Earth Science Geostationary Platform.* From the GOES I-M Operational Satellite Conference, April 3–6, 1989. Washington, D.C.: National Oceanic and Atmospheric Administration.

McElroy, J. H. 1987. "On-board Processing and National Earth Observations Centers." In *Proceedings of the Twenty-first International Symposium on Remote Sensing of the Environment.* Ann Arbor: Environmental Research Institute of Michigan.

McElroy, J. H., and S. R. Schneider. 1984. *Utilization of the Polar Platform of NASA's Space Station Program for Operational Earth Observations.* NOAA Technical Report NESDIS 12. Washington, D.C.: National Oceanic and Atmospheric Administration.

——— 1985. *The Space Station Polar Platform: NOAA Systems Considerations and Requirements.* NOAA Technical Report NESDIS 22. Washington, D.C.: National Oceanic and Atmospheric Administration.

McElroy, J. H., S. R. Schneider, D. B. Miller, and J. W. Sherman III. 1985. *Envirosat-2000 Report: Plan for Space Station Polar-Orbiting Platform.* Washington, D.C.: National Oceanic and Atmospheric Administration.

NASA Earth Observing System Reports (1984–1987):

Vol. 1 and Appendix (1984): *Science and Mission Requirements Working Group Report.* NASA TM-86129.

Vol. 2 (1987): *From Pattern to Process: The Strategy of the Earth Observing System.* Science Steering Committee Report.

Vol. 2a (1986): *Data and Information System.* Data Panel Report.

Vol. 2b (1986): *MODIS: Moderate-Resolution Imaging Spectrometer*. Instrument Panel Report.

Vol. 2c (1987): *HIRIS: High-Resolution Imaging Spectrometer: Science Opportunities for the 1990s*. Instrument Panel Report.

Vol. 2d (1987): *LASA: Lidar Atmospheric Sounder and Altimeter*. Instrument Panel Report.

Vol. 2e (1987): *HMMR: High-Resolution Multifrequency Microwave Radiometer*. Instrument Panel Report.

Vol. 2f (1987): *SAR: Synthetic Aperture Radar*. Instrument Panel Report.

Vol. 2g (1987): *LAWS: Laser Atmospheric Wind Sounder*. Instrument Panel Report.

Vol. 2h (1987): *Altimetric System*. Instrument Panel Report.

NOAA and NASA. 1987. *Space-based Remote Sensing of the Earth: A Report to the Congress*. Washington, D.C.: U.S. Government Printing Office.

Rasool, S. I., ed. 1987. "Potential of Remote Sensing for the Study of Global Change." *Advances in Space Research* 7:1–97.

Ride, S. K. 1987. *Leadership and America's Future in Space*. Washington, D.C.: National Aeronautics and Space Administration.

Short, N. M., P. D. Lowman, Jr., and S. C. Freden. 1976. *Mission to Earth: Landsat Views the World*. SP-360. Washington, D.C.: NASA.

Task Group on Earth Sciences, Space Science Board. 1988. *Mission to Planet Earth. From the Space Science in the Twenty-first Century: Imperatives for the Decades 1995 to 2015*. Washington, D.C.: National Academy Press.

6. Preparing for the Twenty-First Century

Ad Hoc Committee on Remote Sensing for Development. 1977. *Resource Sensing from Space: Prospects for Developing Countries*. Washington, D.C.: National Academy Press.

Blanchard, P. 1988. *U.S.-Soviet Relations: An Agenda for the Future*. Vol. 18. *Combined Remote Sensing Observations of the Earth from Space*. Washington, D.C.: Foreign Policy Institute, Johns Hopkins University.

Committee on Earth Sciences. 1989. *Our Changing Planet: A U.S. Strategy for Global Change Research*. Washington, D.C.: Federal Coordinating Committee for Science, Engineering, and Technology.

Hodgins, K. O., J. M. Maclure, R. O. Masters, and R. B. Ciupek. 1985. "International Cooperation in Assuring Continuity of Environmental Satellite Data." *Space Policy* 1:415–22.

Marshall, E. 1989. "Landsats: Drifting toward Oblivion?" *Science* 243:999.

McElroy, J. H. 1987. "The Future of Earth Observations in the USA." *Space Policy* 3:313–25.

——— 1989. "Earth Observations: Technology, Commercial Opportunities, and International Cooperation." *Technology in Society* 11:3–14.

Newell, H. 1979. *Beyond the Atmosphere*. Washington, D.C.: National Aeronautics and Space Administration.

NOAA and NASA. 1987. *Space-based Remote Sensing of the Earth: A Report to the Congress*. Washington, D.C.: U.S. Government Printing Office.

Office of Technology Assessment, U.S. Congress. 1985. *International Cooperation and Competition in Civilian Space Activities*. Washington, D.C.: U.S. Government Printing Office.

Rasool, S. I., ed. 1987. "Potential of Remote Sensing for the Study of Global Change." *Advances in Space Research* 7:1–97.

Space Applications Board. 1985. *Remote Sensing of the Earth from Space: A Program in Crisis*. Washington, D.C.: National Academy Press.

Space Science Board. 1988. *Space Science in the Twenty-first Century: Mission to Planet Earth*. Washington, D.C.: National Academy Press.

Space Science Board Committee on Earth Sciences. 1982. *A Strategy for Earth Science from Space in the 1980s. Part 1: Solid Earth and Oceans*. Washington, D.C.: National Academy Press.

——— 1985. *A Strategy for Earth Science from Space in the 1980s. Part 2: Atmosphere and Interactions with the Solid Earth, Oceans, and Biota*. Washington, D.C.: National Academy Press.

——— 1988. *Strategy for Earth Explorers in Global Earth Sciences*. Washington, D.C.: National Academy Press.

Space Science Board Committee on Planetary Biology. 1986. *Remote Sensing of the Biosphere*. Washington, D.C.: National Academy Press.

Space Science Board Committee on Solar and Space Physics. 1984. *A Strategy for the Explorer Program for Solar and Space Physics*. Washington, D.C.: National Academy Press.

Uhlir, P. F. 1986. "The Public International Law of Civilian Remote Sensing: An Overview." In *American Enterprise, the Law, and the Commercial Use of Space*. Vol. 2. Ed. Phillip Mink. Washington, D.C.: National Legal Center for the Public Interest.

——— 1989. "Applications of Remote-Sensing Information in Law: An Overview." In *Proceedings of the First ABA Workshop on Remote Sensing*. Washington, D.C.: American Society for Photogrammetry and Remote Sensing and the American Bar Association.

Uhlir, P. F., and R. Shaffer. 1985. *Envirosat-2000 Report: International Coordination of and Contributions to Environmental Satellite Programs*. Washington, D.C.: National Oceanic and Atmospheric Administration.

Voute, C. 1986. "International and Regional Intergovernmental and Nongovernmental Co-operation in Remote Sensing." In *Remote Sensing Yearbook*. London: Taylor and Francis.

GLOSSARY

Active sensor: An instrument that produces pulses of radiation for probing the atmosphere and the surface of the Earth.

Aerosol: Fine particulate matter in the atmosphere.

Algorithm: A mathematical relation between an observed quantity (such as scattered radiation or ocean color) and the variable of interest (such as surface wind or biological productivity).

Altimeter: An active instrument that uses either radar or laser pulses to measure the distance from the satellite to Earth.

Altitude: The height of a satellite above the surface of the Earth.

Amplitude: The maximum value of a periodically varying quantity, such as an electromagnetic wave.

Antenna: A device that receives or radiates electromagnetic energy.

Antenna beam: The focused pattern of electromagnetic radiation that is either received or transmitted by an antenna.

Apogee: The point in a satellite's orbit at which it is farthest from the Earth's center.

Ascending node: The point in a satellite's orbit at which it crosses the Earth's equatorial plane from south to north.

Atmospheric constituents: The gases, suspended liquid, and solid material that make up the atmosphere.

Biogeochemical cycles: The movements through the Earth system of key chemical constituents essential to life, such as carbon, nitrogen, oxygen, phosphorus, and sulfur.

Biological productivity: The growth of new plant and animal life on Earth.

Bus: A term used for a satellite that includes the propulsion and stabilization systems but not the instruments or data systems.

Calibration: The act of comparing the measurement accuracy of an instrument to a known standard.

Coherence: A property of waves whose phases bear a constant relation to one another.

Cosine: In trigonometry, the ratio of the side adjacent to the angle to the hypotenuse of the triangle. This function of an angle varies from one to zero as the angle varies from 0 to 90 degrees.

Coupled system: Two or more processes that affect one another, as when sea surface temperature increases cause more rainfall over the ocean.

Data rate: The amount of information transmitted per unit of time.

Descending node: The point in a satellite's orbit at which it crosses the Earth's equatorial plane from north to south.

Detector: An instrument that senses radiation and can either record or transmit the information.

Diurnal: Those changes in the environment that occur daily, such as solar heating.

Dynamics: The study of the action of forces on bodies and the changes in motion they produce.

Earth system: The Earth regarded as a unified system of interacting components, including the core, mantle, lithosphere, oceans, atmosphere, cryosphere, and biosphere.

El Niño: The quasi-periodic oscillation of sea surface temperature in the Eastern Tropical Pacific Ocean that leads to global atmospheric changes.

Electromagnetic radiation: Electric and magnetic fields that vary in time and propagate through space at the speed of light.

Electromagnetic spectrum: The range of wavelengths or frequencies of electromagnetic radiation, from X rays and gamma rays at the short wavelength end to microwave and radio waves at the long wavelength end.

Equatorial crossing time: The time at which a satellite passes the descending node in its orbit.

Equatorial waves: Long waves that travel along the equator whose properties are governed by gravity and the Earth's rotation.

Field: The set of influences—electricity, magnetism, and gravity—that extend throughout space.

Geodesy: A branch of applied mathematics concerned with measuring the shape of the Earth and describing variations in the gravity field of the Earth.

Geoid: The shape of a level surface—one that is perpendicular to the force of gravity—on the Earth.

Geostationary orbit: The equatorial orbit whose radius (42,180 kilometers from the center of the Earth) permits a satellite to rotate with a period of 24 hours and thus remain continually above one spot on the Earth.

Global Telecommunications System: A global network of communications lines and links providing information about the environment from satellites and ground stations.

Greenhouse effect: The absorption and radiation of infrared radiation by molecules of carbon dioxide, water vapor, and other trace gases in the atmosphere that leads to warming.

Ground track: See Subsatellite track.

Imager: A satellite instrument that provides images of the Earth in various wavelength bands.

In situ: Latin for "in place." Measurements made on the ground or in the atmosphere or ocean, as opposed to remote-sensing measurements.

Inclination: The angle of the plane of a satellite orbit as measured in a counterclockwise direction from the equatorial plane of Earth.

Infrared: Electromagnetic radiation with wavelengths in the range of about 1 micrometer to about 1 centimeter.

Laser: An active instrument that produces discrete, coherent pulses of light (from Light Amplification by Stimulated Emission of Radiation).

Laser ranging: The use of lasers for measuring distance.

Launch vehicle: The rocket used to launch satellites into orbit.

Limb viewing (occultation): The process of viewing the atmosphere at a tangent to the Earth's surface. The viewing signal, from a star or another satellite, is "occulted" or obscured by the intervening atmosphere.

Mesoscale features: Those features in the atmosphere and the ocean of less than global scale but of high energy, such as storms in the atmosphere and eddies in the ocean.

Microelectronics: Solid state electronic systems such as transistors or integrated circuits.

Microwave emission: Radiation that issues from the Earth's surface or atmosphere in the microwave region of the electromagnetic spectrum.

Microwaves: Electromagnetic radiation with wavelengths in the range of about 1 centimeter to about 1 meter.

Mid-ocean ridges and vents: The geologic formations at the sea floor that occur near the edges of tectonic plates.

Model: A construction based on theoretical reasoning or observed data aimed at understanding and predicting phenomena.

Monitoring: Long-term observations aimed at describing phenomena on Earth and in space.

Multispectral scanner: An instrument that has the capability to observe and record at many different wavelengths of electromagnetic radiation.

Nadir: The point on the Earth's surface directly below a satellite (on the line between the satellite and the center of the Earth).

Occultation: See Limb viewing.

Off-nadir viewing: The capability of a satellite, such as SPOT, to aim its instruments at an angle to the nadir so that a larger area can be covered on a single pass.

Operational: A program in which there is a regular need for routine observations and forecasting, as in weather, that requires a long-term commitment.

Orbit: The path in space traced by a satellite.

Passive sensor: An instrument that receives and measures the properties of electromagnetic radiation from the Earth, the sun, or other bodies.

Perigee: The point in a satellite's orbit at which it is closest to the Earth's center.

Period: The time required for a satellite to make one complete orbit.

Phase: A measure of the time difference between an observed signal and a reference signal; for a wave, the position in its cycle at a specified time.

Photodissociation: The separation of a molecule into its constituent parts through interaction with light.

Photon: A quantum (smallest unit in which waves may be emitted or absorbed) of light.

Plankton: Microscopic plants that live in the ocean.

Plasma: A state of matter consisting of clouds of electrons and charged ions.

Plate tectonics: The concept that the Earth's crust is made up of rigid plates that move over a less rigid interior.

Platform: A satellite that can carry instruments (see Bus).

Polar orbit: A satellite orbit whose plane is perpendicular or nearly perpendicular to the Earth's equatorial plane.

Precession: The rotation in space of the axis of rotation of the Earth, or of the axis of rotation of a satellite orbit.

Process: As used here, the physical, chemical, biological, or geological activity that affects the state or change of the environment, or an association of phenomena governed by physical, chemical, or biological laws.

Process study: An organized, systematic investigation of a particular process that is designed to identify the key variables and their relationship.

Prograde: A satellite orbit that precesses in a clockwise direction (to the west).

Pulse: A discrete packet of electromagnetic energy.

Pushbroom sensor: A row of sensors aligned perpendicular to the path of the satellite.

Radar: An active instrument that produces pulses of radio waves (from RAdio Detection And Ranging).

Radiation budget: A measure of all the inputs and outputs of radiative energy relative to the Earth.

Radiometer: An instrument that measures electromagnetic radiation in one or more wavelength intervals.

Real-time: A term used for data that are transmitted within a few hours of the time they are collected.

Repeat cycle: The time it takes for a satellite orbit to repeat its track over the Earth.

Resolution: The measure of the ability of an instrument to discriminate objects in its field of view.

Retrograde: A satellite orbit that precesses in a counterclockwise direction (to the east).

Retroreflector: A device that reflects electromagnetic radiation, usually in the shape of a corner of a cube, so that signals are transmitted back in the direction from which they came.

Satellite: A free-flying object that orbits the Earth, the other planets, or the sun.

Satellite positioning: A procedure by which satellites are used to locate precisely objects or particular points on Earth.

Scanner: An instrument that scans on either side of the subsatellite track.

Scattering: The process by which radiation interacts with the molecules of the atmosphere or ocean and is retransmitted in many directions.

Scatterometer: An active radar instrument that uses scattered radiation from the surface to determine surface features.

Search and rescue: A satellite-based system that provides instantaneous receipt and relay of emergency signals in view of the satellites.

Side-looking radar: A radar system that can view on either side of the nadir as well as straight down from the satellite.

Solar cell: A device, usually made of silicon, that produces electric power from sunlight.

Solar output: The total amount of radiation and particles that emanates from the sun.

Sounder: A passive satellite instrument that receives radiation in the wavelengths emitted by the atmosphere at different levels.

Sounding: The process of measuring the properties of the atmosphere or ocean at different levels.

Spectral band: A range of wavelengths of electromagnetic radiation.

Spectral channel: See Spectral band.

Spectrometer: A passive instrument that measures radiation in different spectral bands.

Stratosphere: The region of the atmosphere extending from about 10–15 kilometers above the Earth to about 50 kilometers above the Earth. This region includes the ozone layer.

Subsatellite point: See Nadir.

Subsatellite track: The line on the surface of the Earth traced out by the movement of the nadir of the satellite; also known as the ground track.

Sunspot cycle: The periodic appearance of sunspots on the surface of the sun; associated with the release of highly energetic particles that can affect spacecraft.

Sun-synchronous orbit: An Earth-satellite orbit whose plane precesses in order to maintain a constant relation to the sun as the Earth moves in its yearly orbit around the sun.

Swath width: The width of the image either illuminated or observed on the surface by the satellite instrument.

Synoptic: A summary or synopsis of the state of the Earth at a particular time, such as a synoptic chart of the weather or of ocean waves.

Synthetic aperture radar: A high-resolution ground mapping technique that takes advantage of the forward motion of a satellite-carried active radar sensor to synthesize the equivalent of a very long array of antennas.

Three-axis, body stabilized: The new configuration for geostationary satellites now being used for the Indian meteorological satellite and proposed as the replacement for the United States system. Stabilization is provided by two spinning reaction wheels inside the satellite.

Trace species: Atoms or molecules present in minute or trace amounts in the oceans, atmosphere, or other components of the Earth system.

Triangulation: A surveying technique that involves direct measurements of the lengths and angles of the sides of triangles.

Tropical orbit: A satellite orbit whose inclination is in the range of 20 to 30 degrees (thus providing coverage of the tropics).

Troposphere: The lower atmosphere, to a height of about 10 to 15 kilometers above the Earth, where the air is most dense and where most weather occurs.

Ultraviolet: Electromagnetic radiation with wavelengths in the range of about 0.01 to about 0.4 micrometers.

Wavelength: The distance between two adjacent peaks or troughs of a wave.

Window: A term used to denote a region of the electromagnetic spectrum where the atmosphere does not absorb radiation strongly.

LIST OF ILLUSTRATIONS

1. Photograph of the Earth taken from the Apollo 10 spacecraft. Courtesy of the National Aeronautics and Space Administration (NASA).

2. NOAA geostationary weather satellite view centered on the United States on August 8, 1980. Courtesy of the National Oceanic and Atmospheric Administration (NOAA).

3. The symbol of the International Geophysical Year as adopted in 1955. Courtesy of the University of Michigan Press.

4. Polar and geostationary orbits for NOAA satellites. Courtesy of NOAA.

5. Details of the sun-synchronous polar orbit used by the Landsat satellites. Courtesy of NOAA.

6. A sun-synchronous orbit. Courtesy of NASDA.

7. The electromagnetic spectrum. Courtesy of NASA.

8. Schematic representation of the Multispectral Scanner Sensor (MSS) used on the Landsat satellites. Courtesy of NOAA.

9. "Limb viewing" of the atmosphere by satellite. Courtesy of NASA.

10. Schematic representation of the operation of a satellite altimeter. Courtesy of NASA.

11. Schematic representation of NASA's Nimbus-7 satellite, which was the last of an Earth-observing series testing new concepts of measurement. Courtesy of NASA.

12. Location and areal coverage of receiving stations for the Landsat series of satellites. Courtesy of NOAA.

13. The current civil operational environmental satellite system, which includes satellites from five different countries and the European Space Agency. Courtesy of NOAA.

14. Mean daytime surface temperature for January 1979 using data from the infrared and microwave sounders on the NOAA polar-orbiting satellite. Courtesy of NASA.

Color Plates

INDEX